The Annabel Williams Book of
Wedding and Portrait Photography

RotoVision

A RotoVision Book

Published and Distributed by RotoVision SA
Route Suisse 9
CH-1295 Mies
Switzerland

RotoVision SA
Sales, Editorial & Production Office
Sheridan House, 112/116A Western Road
Hove BN3 1DD, UK

Tel: +44 (0) 1273 72 72 68
Fax: +44 (0) 1273 72 72 69
E-mail: sales@rotovision.com
Web: www.rotovision.com

10 9 8 7 6 5 4 3 2

ISBN 2-88046-779-9

Original design by Kate Stephens

This edition designed by Pod Design

Reprographics in Singapore by ProVision Pte. Ltd.
Tel: +65 6334 7720
Fax: +65 6334 7721

Printing and binding in Singapore by Provision Pte. Ltd.

The Annabel Williams Book of
Wedding and Portrait Photography

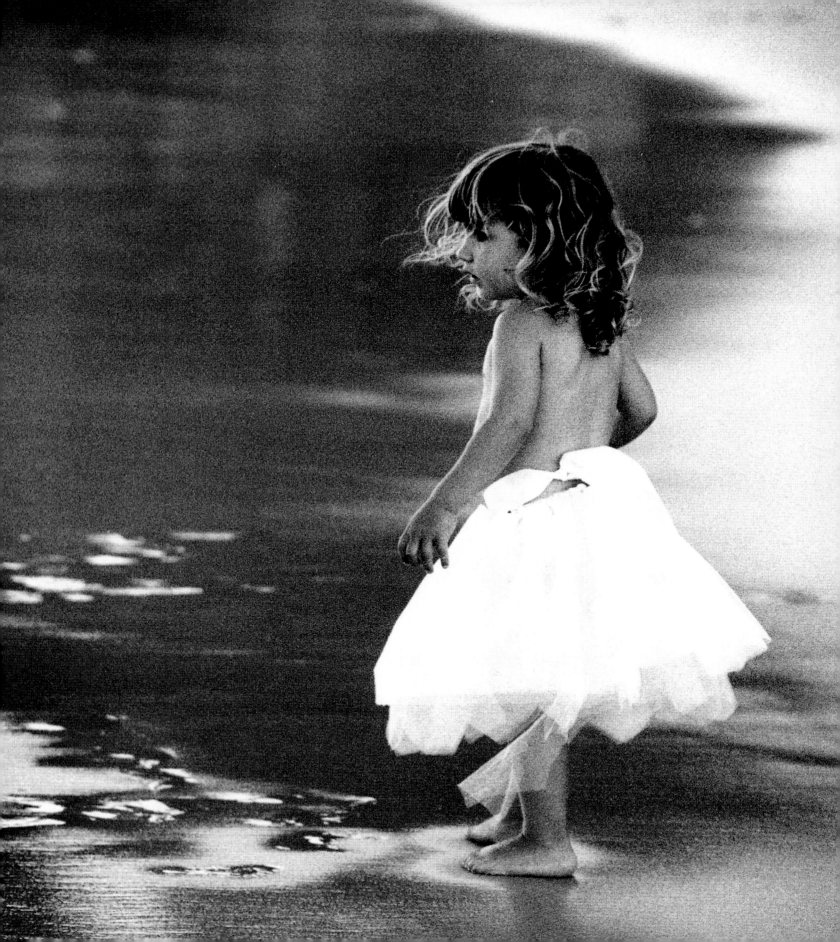

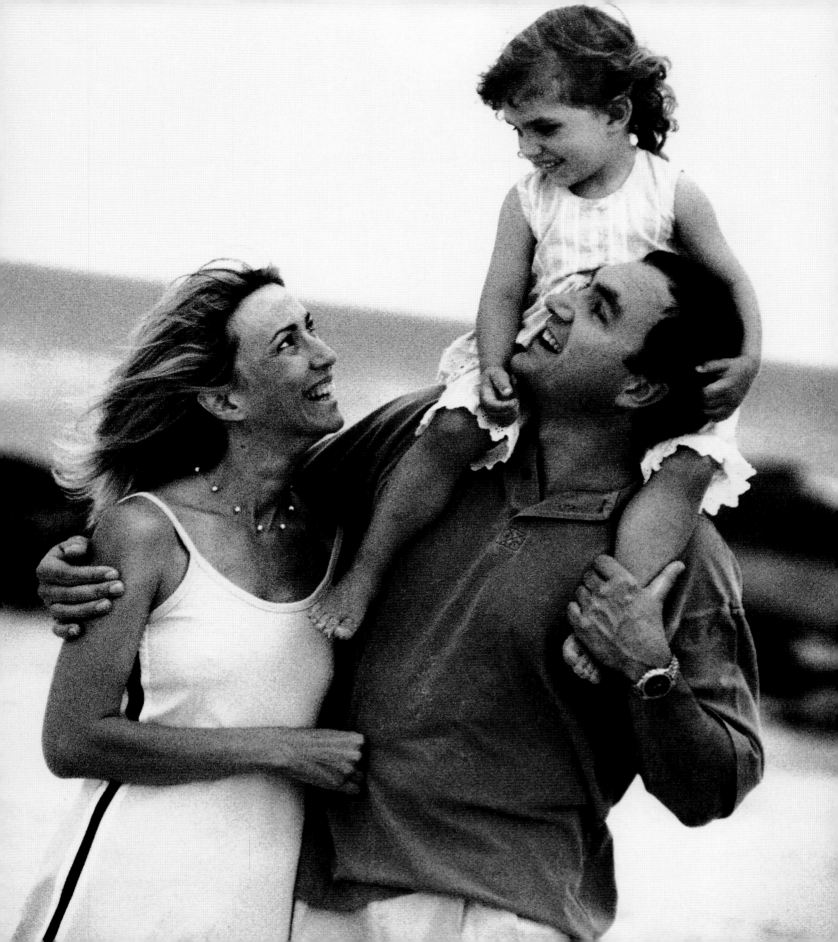

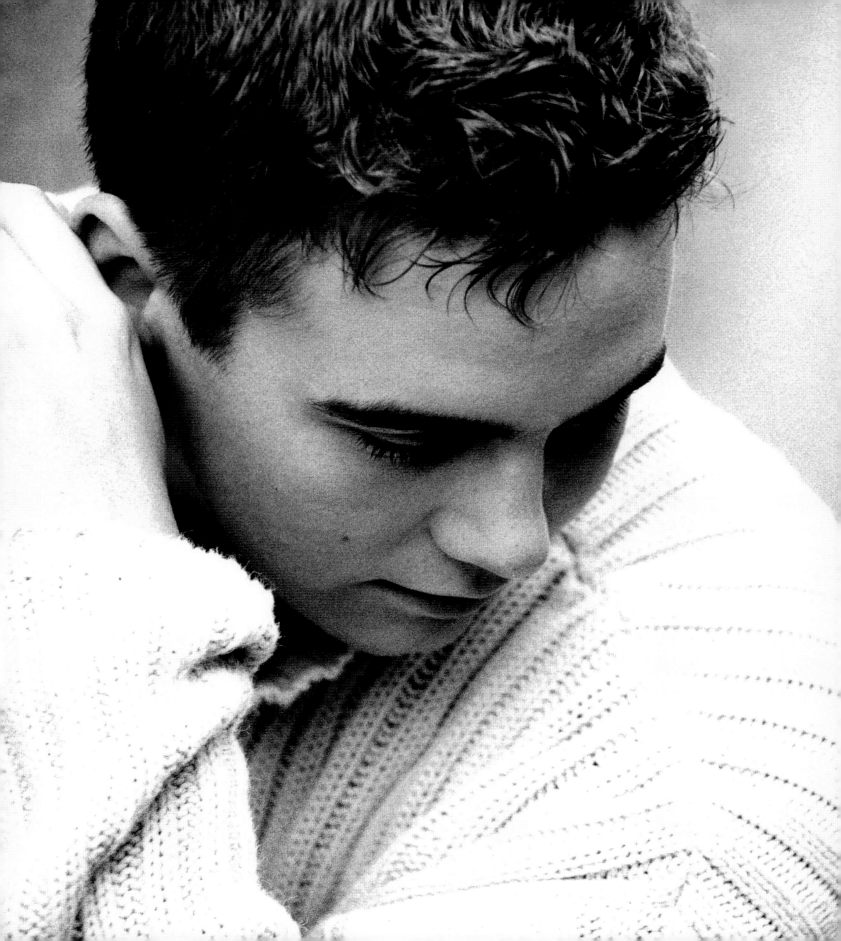

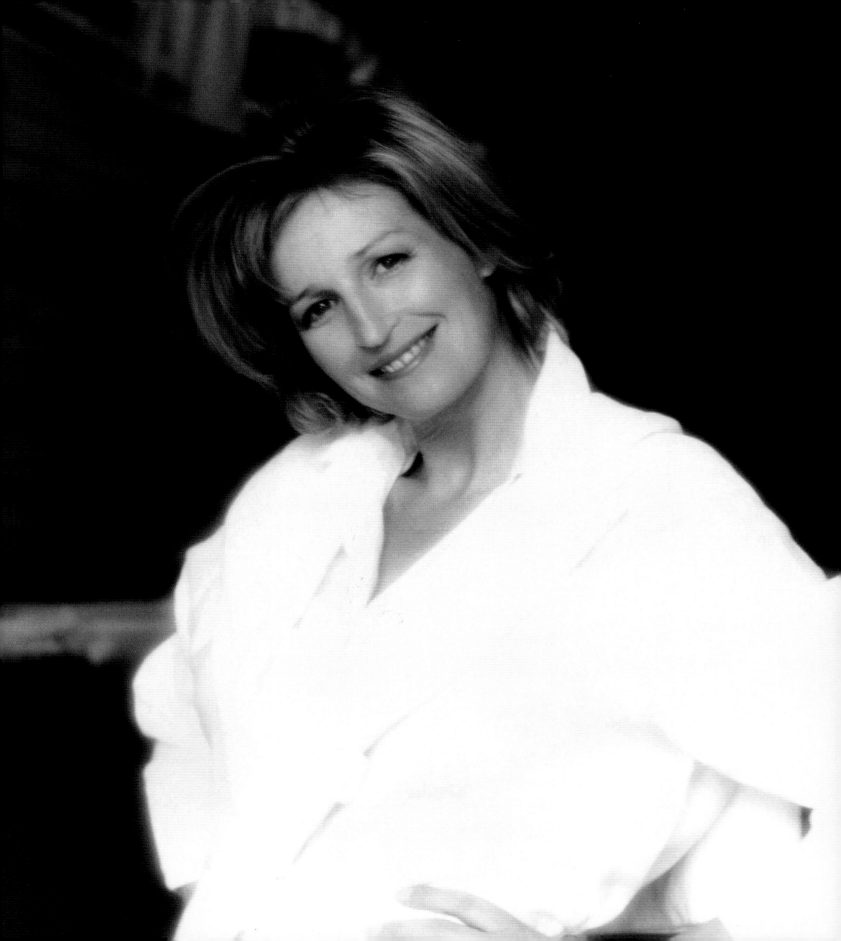

Portraits

1 contemporary lifestyle photography 16

2 developing the client relationship 28

3 location, lighting, and technique 38

4 make-up, clothes, and colour analysis 56

5 art directing and creating relaxed poses 74

6 real-life shoots 86

7 working with children 98

8 editing and shooting for versatility 114

9 creating furniture for walls 124

10 maximising your market 134

Weddings

11 contemporary wedding photography 144

12 planning and preparing 166

13 make-up and styling 186

14 a real-life wedding 196

15 location and lighting 220

16 editing an album 244

17 marketing for wedding photography 254

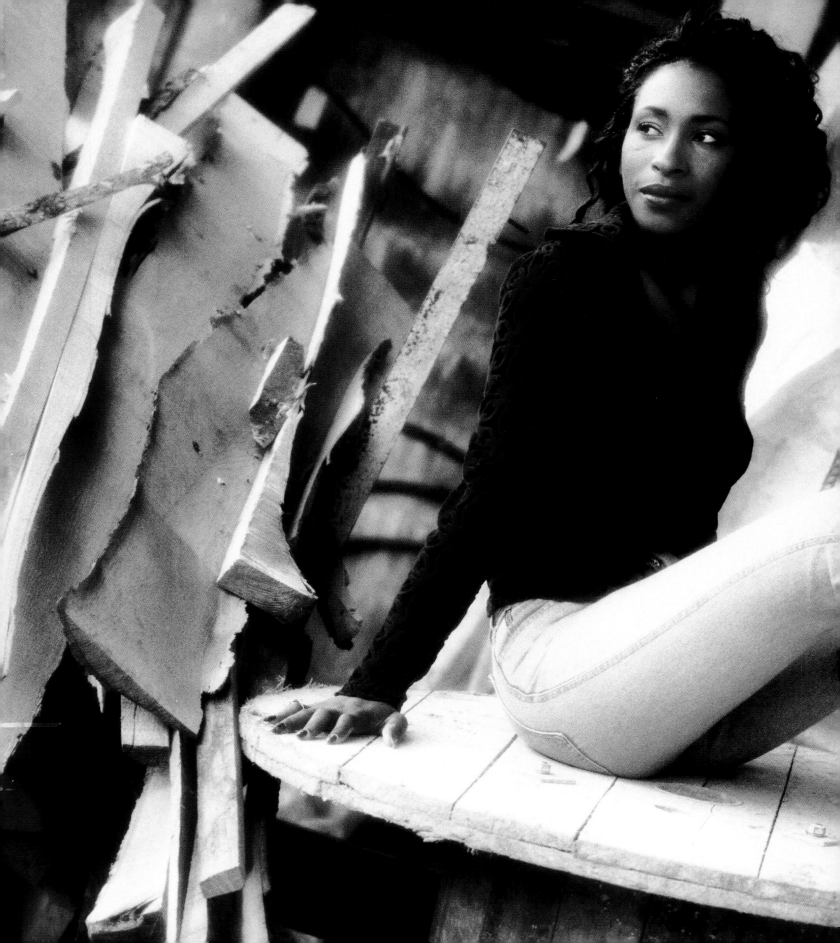

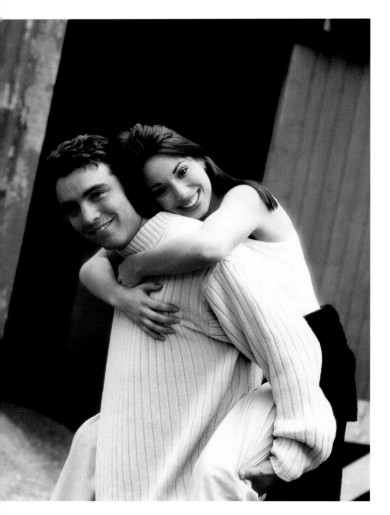

Contemporary lifestyle photography is the art of depicting people as they really are. However, "real life" often needs to be enhanced in order to create the pictures that fulfil the vision we have of ourselves. In truth, we need to take the "snapshot" one stage further to make it a professional picture. Most people see moments they want to capture every day, but are disappointed when the resulting image shows objects which went unnoticed at the time; for example they wanted to capture the child's expression but the finished picture includes the reality of everything that was happening in the background.

To create beautiful images, we need to look closely at the detail and develop a greater understanding of people and the effect of light. Eventually this will become second nature, and then it's possible to work in a truly relaxed style, concentrating on what you should be concentrating on, namely recording your subjects in a way that's still flattering to them, but totally natural. It will be an image of themselves that they're far more likely to recognise, and their reaction to it will be much more positive as a result.

My clients are not professional models, but they usually want to feel and look as if they are. Both these pictures were taken as part of commissioned portfolios, taken on location employing an informal approach.

*Left: Mamiya RZ 67, 150mm soft focus lens, Fujifilm Provia 400, cross-processed. Exposure 1/60sec at f/5.6
Right: same details, but exposure 1/500sec at f/8*

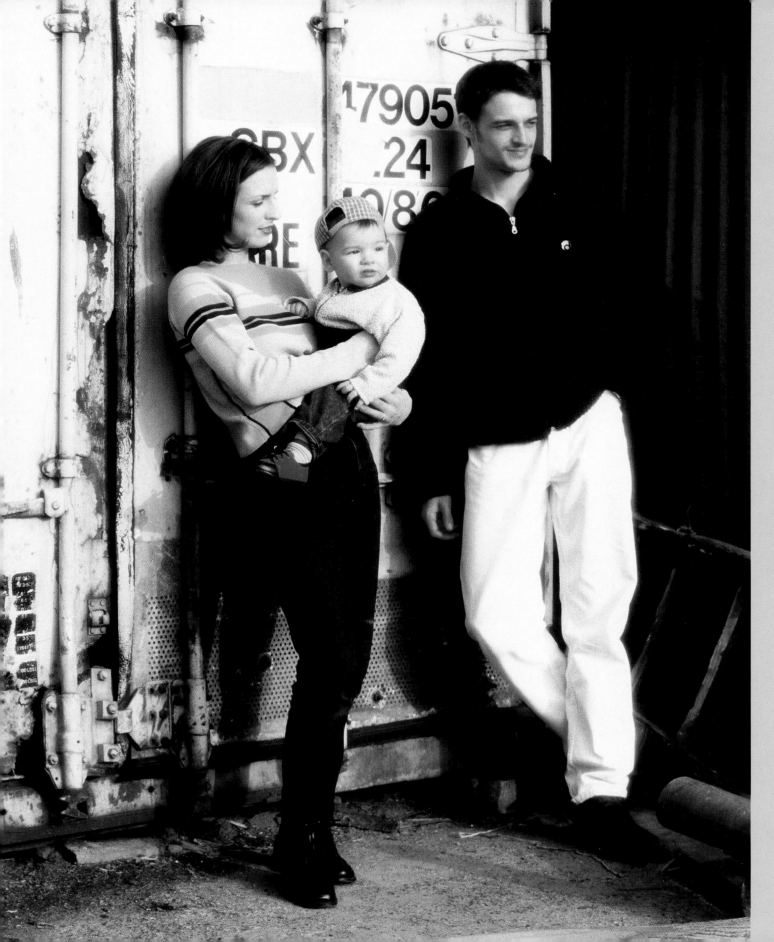

Take time out to look at the detail in a scene. What inspires you? Colour, texture, light? Consider the texture of the flaking paint and worn shapes of the wood. Look at the vivid blue colours blending with the natural tones of the boat and a contemporary image starts to emerge.

This is what you'll need to develop an eye for: in time this approach will almost become second nature, and you'll find yourself intuitively looking for detail wherever you go. As you'll see throughout the book, even some of the most unpromising locations can yield interesting and exciting pictures. It's simply a case of opening your mind and looking for ways that you can use a scene to your advantage.

These details on the beach in Madeira intrigued me, and I spent some time walking around to establish the best angle from which to photograph them. Colours and textures are particularly important elements to note in any scene and, once you're sure of how you're going to tackle your shoot, you can introduce your subject.

Cross-processing is a useful technique which can produce amazing results, and it's something that I often use on shoots. I shoot primarily on negative stock because this gives me the greatest flexibility in terms of exposure. However, as I love bright, saturated colours, using transparency film and processing it through chemistry normally used for negative films achieves the desired results. Cross-processing can produce pictures that have weird and wacky colours, however, I ask my lab to print the flesh tones as accurately as possible, and the result is a picture that has lovely strong colours, and yet it still looks very natural. The clients often won't notice the difference, but they'll like the picture more because subconsciously, the colours will be more pleasing to them.

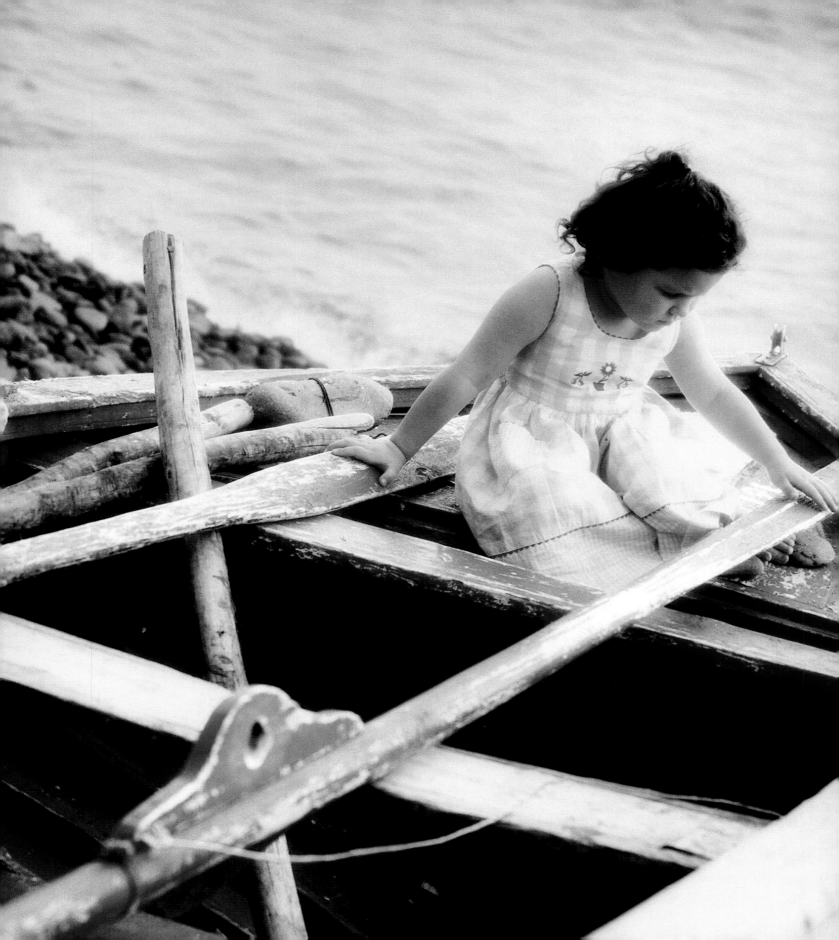

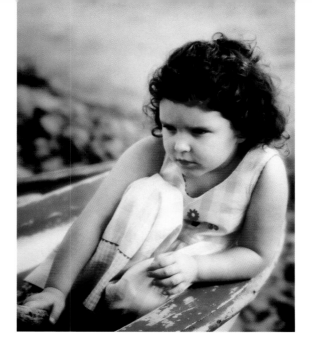

If we do not consider the background details first, we may get carried away by the antics of the child. By making the background an attractive image on its own, we can then introduce the subject and record anything that happens, in the knowledge that the environment will work and result in inspirational pictures. Trying to pose a young child can be very restricting and produce rigid results. Setting up the background first, and allowing the child the freedom to play anywhere within an area, will result in natural, spontaneous and relaxed pictures. The child will also enjoy the experience and develop a relationship with the photographer through play, which allows them to feel comfortable and secure, and be themselves. At this point it is up to the photographer to record what is happening, rather than impose formal restrictions that most young children find threatening and cannot relate to.

Now that I have set the scene using the boat and the beach, I can introduce the subject to the picture. Time spent on getting the basics of the picture right before getting into the photo shoot properly can pay real dividends.

Mamiya RZ 67, 150mm soft focus lens, Fujifilm Provia 400, cross-processed. Exposure 1/60sec at f/5.6

I usually take pictures to serve as establishing shots with a medium-format camera, and for these I'll often use colour film. The majority of my pictures are however, taken on a 35mm camera which I'll use to zoom in closer and take a whole series of more informal black and white pictures throughout the session. It's an extremely flexible format and the Canon EOS 5 I use is easy to hand-hold so that I can move around quickly and shoot a variety of pictures without the need for me to stage manage my subject.

The use of a zoom lens is also designed to give me maximum flexibility. It means I can change my framing very quickly, and can play around with the relationship between the subject and the background, as here. Fast black and white film, usually Fujifilm Neopan 1600, gives me a fine grain which enhances the pictures and allows me to take pictures when the subject is moving, without blurring.

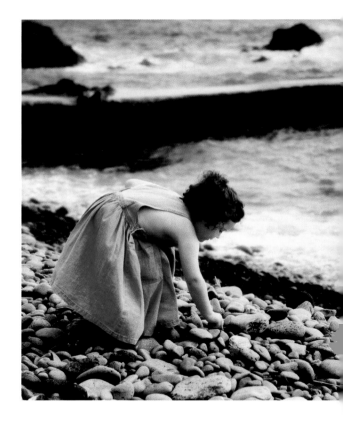

"I'll use a 35mm camera to enable me to move in and to take a whole series of informal pictures throughout the session."

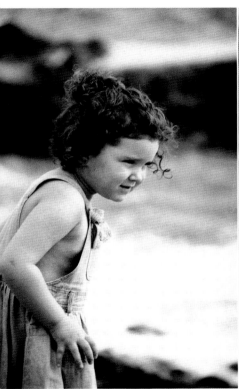 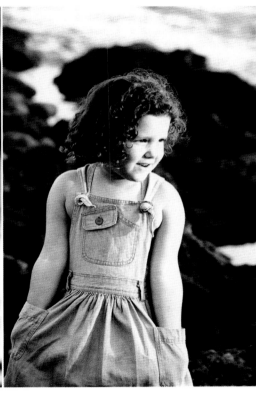 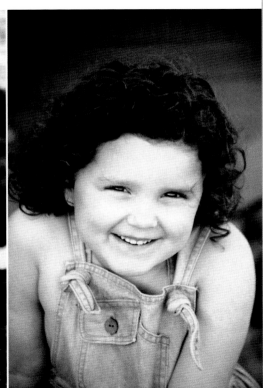

These pictures, to me, are the essence of what portraiture should be about. The little girl is relaxed and natural, and has been allowed to be herself and to enjoy her photograph being taken. It's important to allow children to be themselves, and for them to get a great deal of fun out of the session too.

Colour picture: Mamiya RZ 67, 150mm soft focus lens, Fujifilm Provia 400, cross-processed. Exposure 1/60sec at f/5.6 Black and white pictures: Canon EOS 5, 75–300mm zoom, Fujifilm Neopan 1600, shot on aperture priority

" The world of reality has its limits; the world of imagination is boundless. "

Jean-Jacques Rousseau

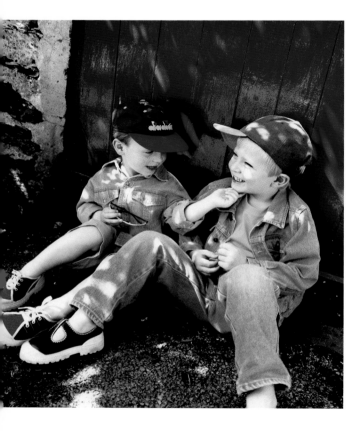

Both these pictures show children being themselves, and this is how the most natural and uncontrived pictures should be taken. I've made things as simple as possible, and given myself every chance to work quickly with my subjects, and with the minimum of interference.

Right: Mamiya RZ 67, 150mm soft focus lens, Fujifilm Provia 400, cross-processed. Exposure 1/500sec at f/5.6
Above: Hasselblad, 120mm lens, Fujifilm Provia 400, cross-processed. Exposure 1/500sec at f/5.6

I love this quote, because to me it really says everything about the way that a photographer should approach a session. If you use your imagination, then there really is no limit to the kind of pictures that you can achieve in any situation, however uncompromising it may look initially.

These two pictures, for example, were taken in places that the portrait photographer would traditionally overlook. You don't always have to set pictures of children in pretty places: they're often really happy if you let them sit in the backyard and just play.

The two little boys were photographed against the doors of a garage at the back of a pub, while I arranged the girl by the metal doors of a factory – she's sitting here on a plain concrete floor. Both pictures, I feel, have managed to say something special: the boys, for example, are comfortable and happy, and very much at ease in front of the camera; the girl, meanwhile, is concentrating on what she's doing, and is taking the photo session very much in her stride. She's not intimidated by the camera or me and is relaxed and very natural.

Allow yourself the freedom to be creative, by thinking ahead.

Set the scene by utilising the elements around you and by looking at the detail.

Use the equipment that is most appropriate for the task, allowing you to be flexible.

Use consistent lighting to enable you to concentrate on the subject.

Don't be afraid to experiment and to take risks.

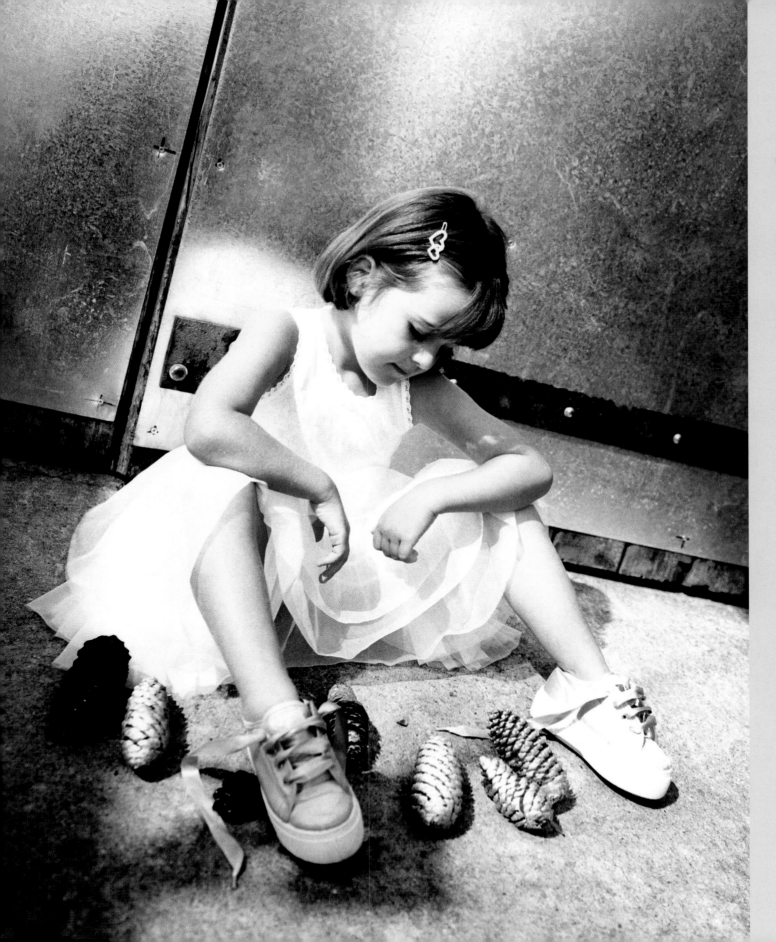

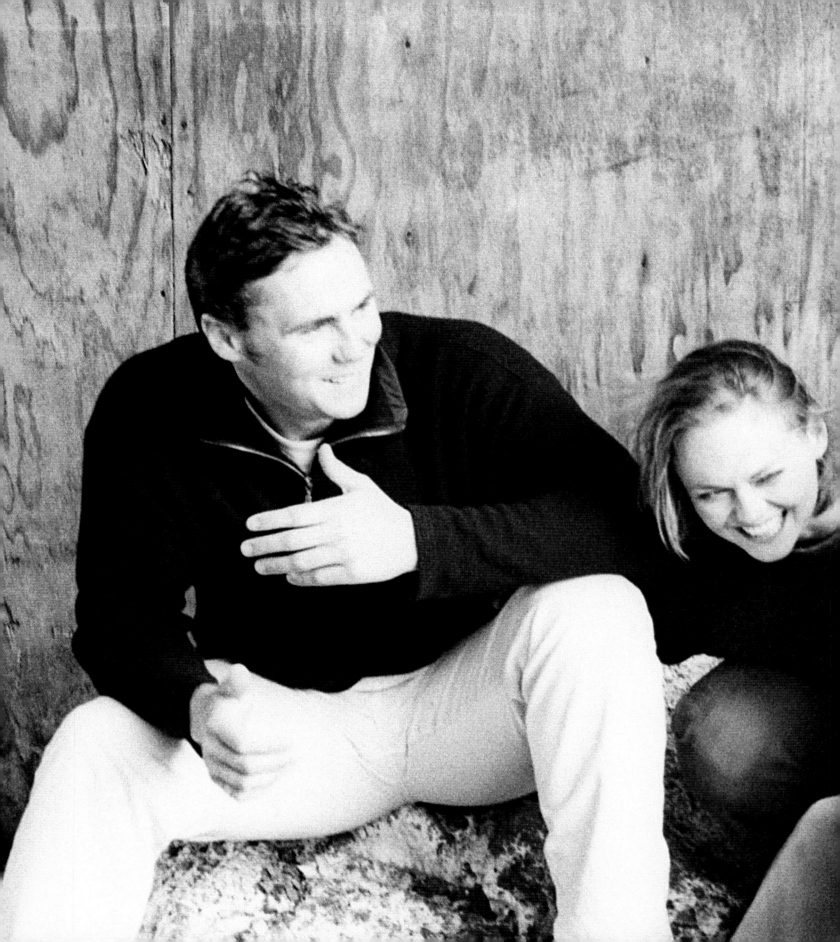

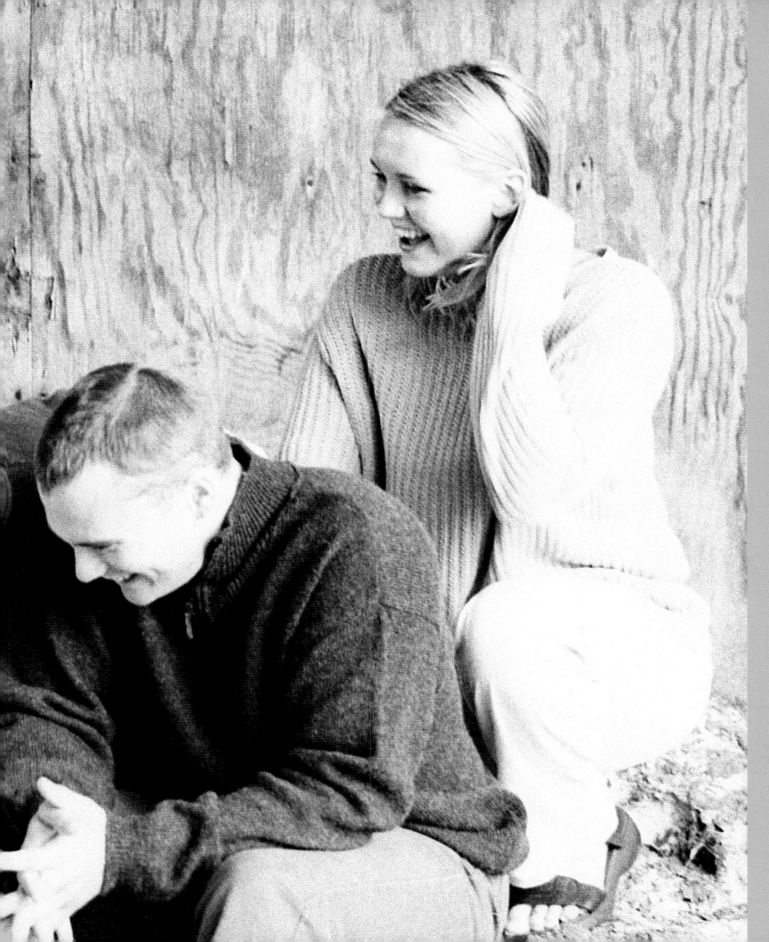

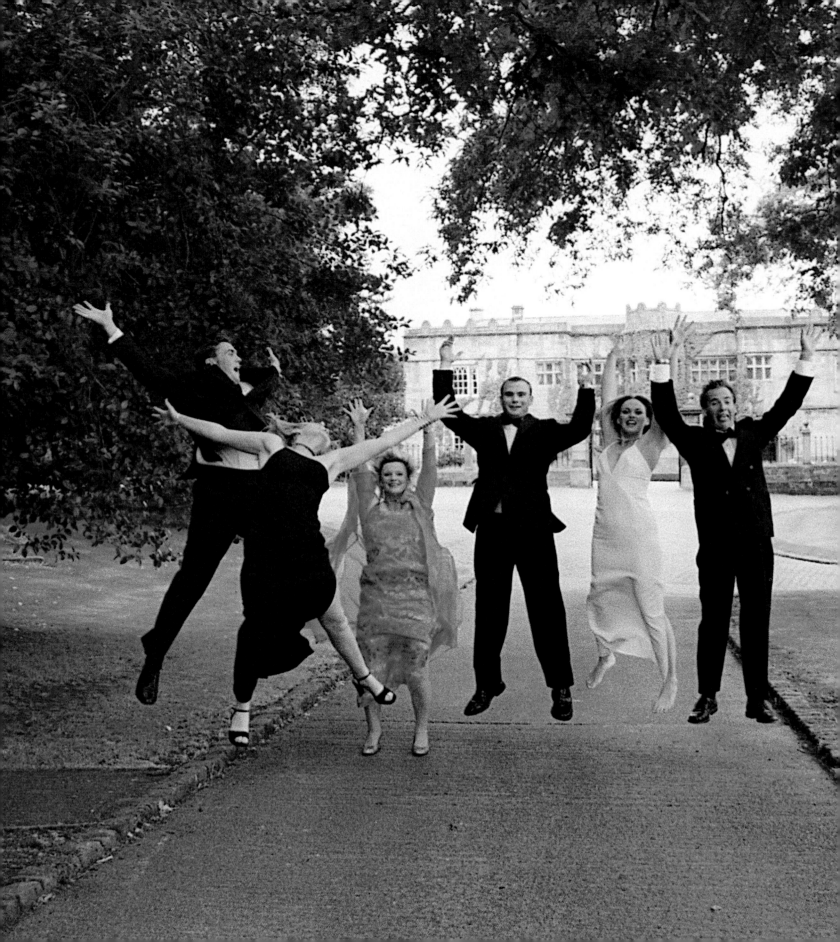

Turning an essentially formal shot into an informal and happy picture such as this one doesn't just happen. There is an enormous amount of work that the photographer will need to put in leading up to this point, in terms of putting people at ease, establishing a rapport with them and making sure that they feel completely at ease in front of your camera. Only when you have the trust of your subjects can you expect them to go along with fun ideas such as this one. This chapter tells the story behind this particular shoot, which, in terms of approach, very much outlines the way that I like to work.

These are the elements that you should always consider when you arrive to carry out a shoot such as this:

Assess the environment carefully

Choose a selection of different clothes

Think about the client's personality

Consider the client's feelings

Observe how people interact together and with you

Keep an open mind

Think on your feet

Talking on the telephone: The relationship with the client begins from the very first conversation on the telephone. Chatting on the phone helps me to find out how many people will be involved in the shoot, the names and ages of the children, the kind of location their home is situated in. Is it rural? City? On a housing estate? Is there a park or rural location nearby? Or would they prefer me to choose another location? Do they have a specific reason for having the photographs taken i.e. is it for a special occasion – a birthday, for example?

Arriving on location: Having established on the telephone the kind of environment in which the client lives, I prefer to see the location on the actual day of the shoot. If I check out the location before, I run the risk of losing the buzz I get when I see a place for the first time. I much prefer an element of surprise, and sometimes a challenge!

Meeting the client: Most clients are usually nervous about having their photo taken. Therefore I leave most of my equipment in the car at this stage, because cameras can actually be quite frightening to many people. Besides, there is so much to do, before I even start putting film in the camera!

The family has asked for a formal picture as it is Richard's 21st birthday. The house is selected as a background due to its imposing grandeur and formal gardens, which complement the family's formal attire.

Mamiya RZ 67, 150mm soft focus lens, Fujifilm NHG 800, straight-processed. Exposure 1/125sec at f/5.6

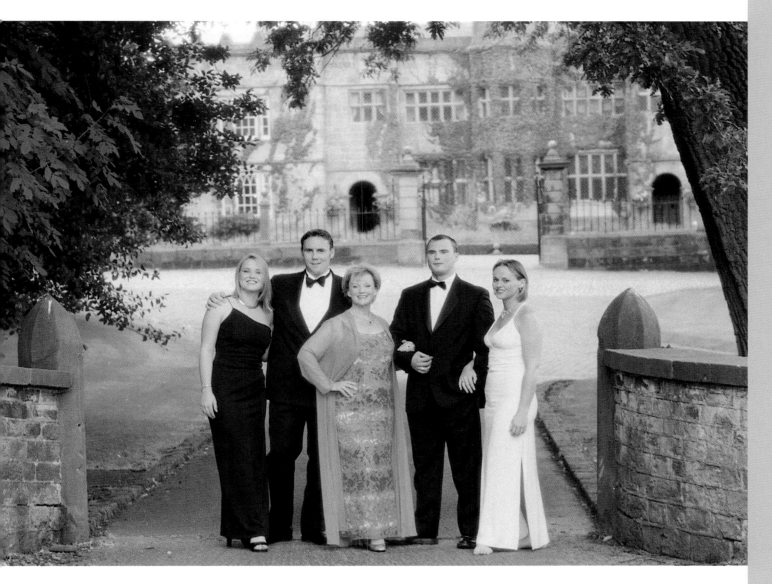

Relaxing the client: It is important that the client starts to relax right from the beginning. Having a coffee gives us the opportunity to chat and get to know each other. I need to find out more about the family so that I can ensure that their personality is reflected in the photographs. How? Over coffee, I ask Eileen all about her job, and chat with her family about what they do. This helps to build up a picture of their lifestyle, and helps us to begin to relate to each other.

Discussing the client's ideas: During coffee, we might look through some magazine pictures to get an idea of the kind of images the client likes. This tells me several things: a) whether they prefer black and white, or colour, or both, b) whether they like formal photos or very relaxed images and c) the kind of feeling they want to see in their photos.

Make-up: Having their hair and make-up done is a very relaxing experience, and makes the clients feel good about themselves, which in turn will ensure they look good in the pictures.

As they start to relax into the shoot we can begin to relax the clothes. It is always better to work from formal to casual, because if the clients are still slightly nervous at the beginning of the shoot, it won't matter when they are wearing formal clothes, and by the time they are really relaxed they will be wearing their casual clothes.

Here, the family are wearing clothes which are still quite smart, but casual enough that they can sit on the doorstep of the front porch and not worry about getting dirty!

Canon EOS 5, 75–300mm zoom, Fujifilm Neopan 1600. Exposure 1/250sec at f/5.6

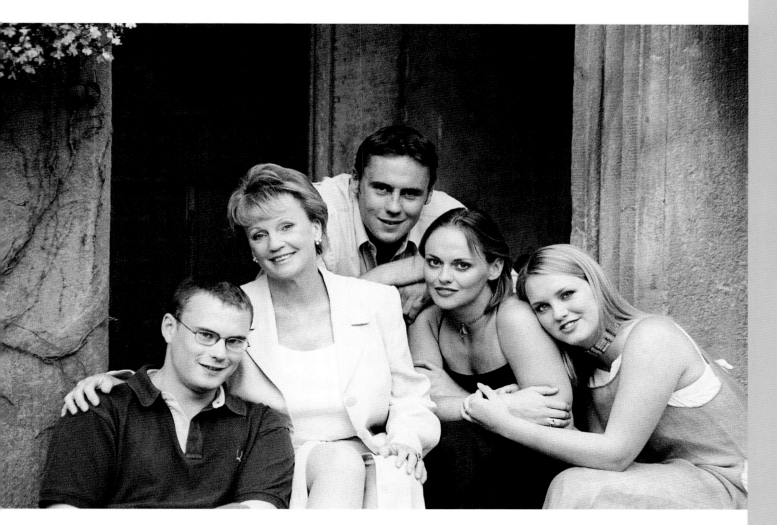

Choosing clothes: It is important that the client feels comfortable and their clothes should reflect the way they feel. Clothes should flatter the client, so choose those that are loose and flowing, rather than tight. Select colours that blend together and work with the background, and change their outfits for each location. In this case we start with formal, move into smart/casual and finally to very casual.

Choosing backgrounds: Deep in conversation, we wander outside to start looking for locations. In this case, there were many choices, and now is the time to narrow them down, so that the clients will not be hanging around or getting confused by all the options later on. It is much better to pick a few places and keep the shoot simple. For this shoot I have selected three different locations.

Interaction: This initial process helps to form the friendly, relaxed relationship with your client that is essential to produce natural and spontaneous pictures. When everyone is enjoying the experience, the interaction between the subjects themselves, and between the subjects and the photographer will be fun and enjoyable. In turn this will create plenty of opportunity for pictures that really reflect individual personalities.

By the end of the shoot the family is very relaxed and can now wear everyday clothes. Many people would not want to wear these at the beginning of the shoot, as they would not feel they had made enough effort to look their best, but in fact it is the casual photos which I know they will prefer.

Canon EOS 5, 75–300mm zoom, Fujifilm Neopan 1600. Exposure 1/60sec at f/5.6

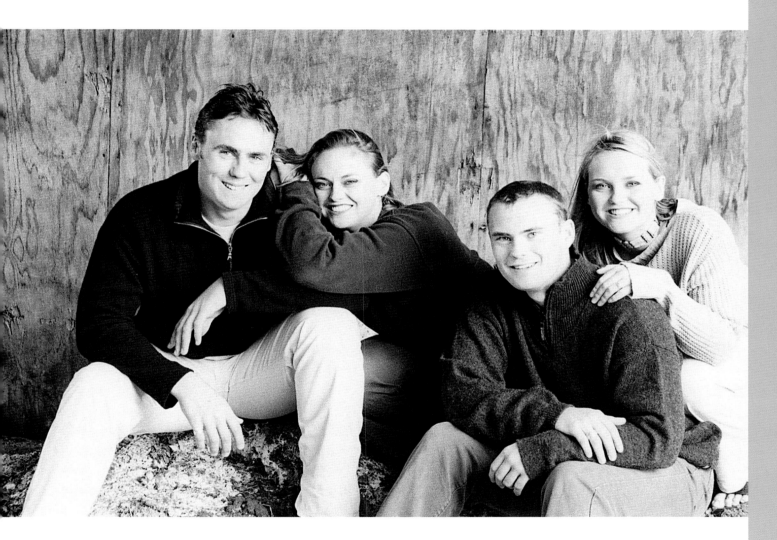

I nearly always work with people who have commissioned me to take their picture, and yet those who see my work often assume that I'm using professional models. By shooting in a style that echoes that used by photographers working for the fashion and lifestyle markets, I'm able to give my pictures a vibrancy that is often lacking in social photography.

Canon EOS 5, 75–300mm zoom, Fujifilm Neopan 1600. Exposure 1/1000sec at f/5.6

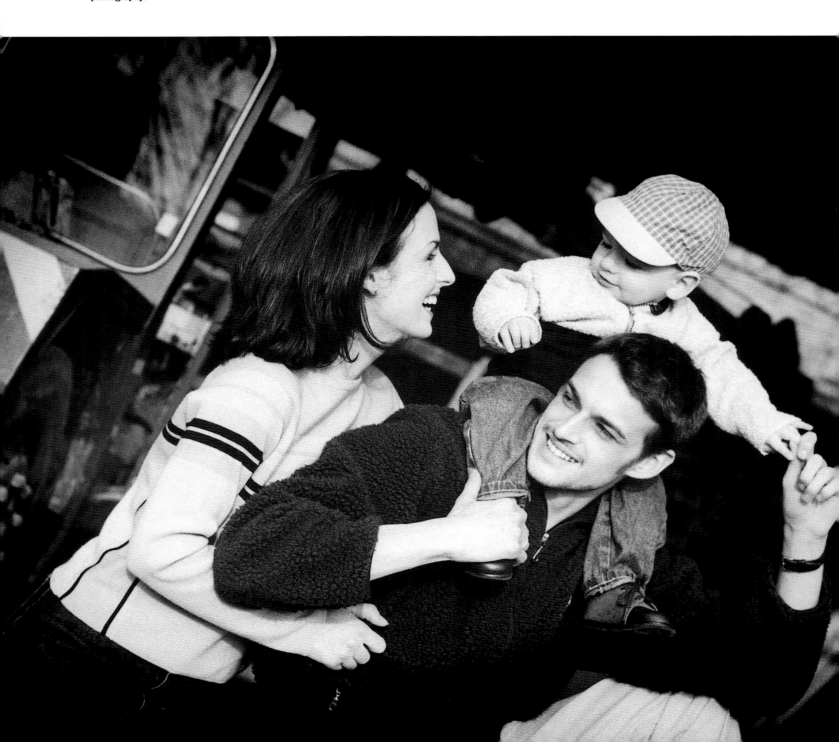

> **"A painting is never finished, it simply stops in interesting places."**
> **Paul Gardner**

This couple had booked me to photograph their wedding, and when I'm doing this I like to set up a pre-wedding shoot three to four months beforehand so that they understand the concept of being photographed. It builds up their confidence and self-esteem and helps them to relax when the wedding day itself arrives, as they know that I don't work in an intimidating way.

I love to take pictures such as this on location and I look for interesting places, such as this factory that's near to my studio, and is full of shapes and textures which can be used in the background. It's fascinating to see people's reactions when they walk into a place like this: the "what are we doing here?" looks. They can't imagine that they will sit in front of a crane, and yet, with the right viewpoint and a subtle tilt of the lens, such a location will result in a picture like this.

This was a great setting because I was able to use natural light in a really interesting way. We used a building that was shaped a little like an aircraft hangar in that it had doors at each end that were open. By placing this couple and their little boy in the light by the door at the front of the building, I was also able to position myself so that I could feature the light from the door at the other end as an out-of-focus element. This led to an interesting highlight in this area of the picture.

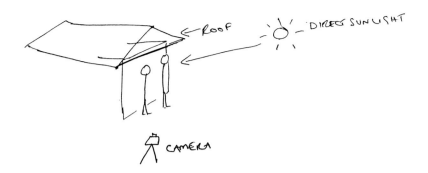

Outdoor lighting is ideal for contemporary lifestyle photography, as today's clients want pictures that are natural and simple. People tend to feel more comfortable and less intimidated outdoors, which adds to the relaxed look of the pictures. However, even daylight has to be very carefully controlled in order to achieve a flattering picture. Lighting from direct sunlight can often be harsh and unflattering, but when used in a controlled way it can create stunning images. When the sun is overhead, as here, if the subject was looking directly at the camera, harsh shadows would be created and this would cause the subject to squint in a very unflattering way. By asking this couple to face away from the camera, however, I was able to achieve this very effective result.

Some photographic rules are made to be broken, such as the one that dictates portraiture outside is best undertaken only at the start and end of the day, when the angle of the sun is low. This picture was taken at midday and yet, positioning the subjects looking away from the camera produces a result that is still flattering and well lit.

Mamiya RZ 67, 150mm soft focus lens, Fujifilm Provia 400, cross-processed. Exposure 1/500sec at f/11

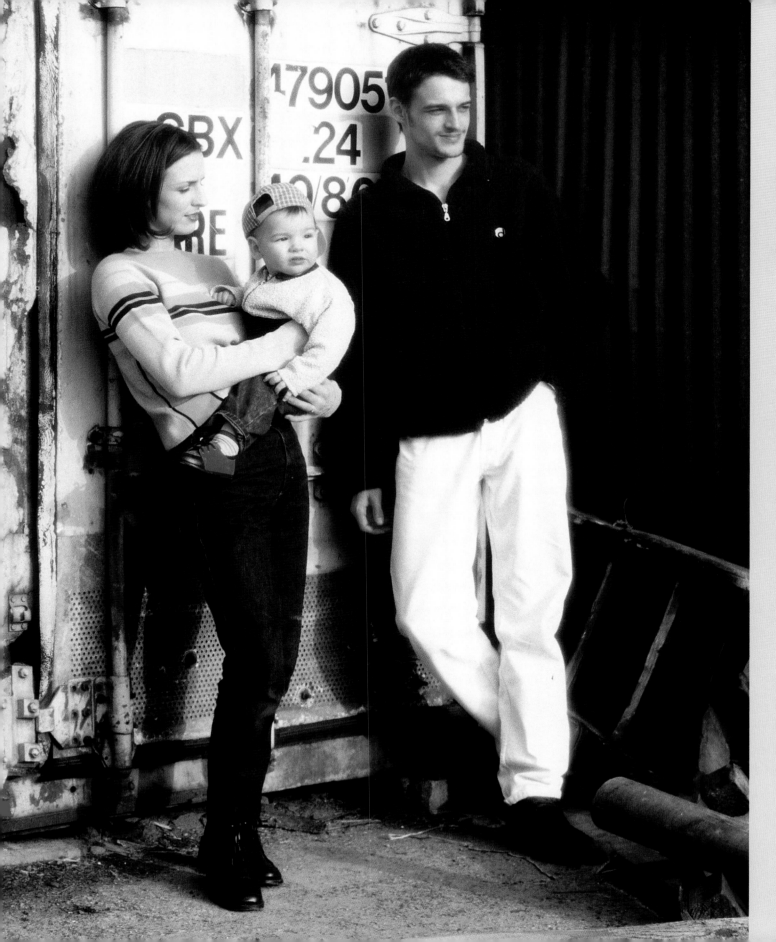

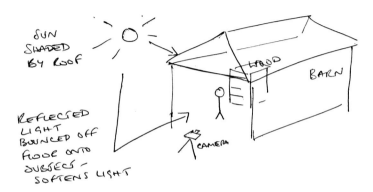

SUN SHADED BY ROOF

REFLECTED LIGHT BOUNCED OFF FLOOR ONTO SUBJECT – SOFTENS LIGHT

WOOD BARN

CAMERA

The most flattering way to deal with bright sunlight is to use top shade. By placing the subjects under some kind of natural shade, such as a porch roof or a tree, the light becomes softer over the face, but still maintains clarity and brightness from the reflected light of the sun (see picture below). Patches of light on the background or clothes often enhance the feeling of warmth and add depth to the picture.

The lighting for this picture is well balanced, even the area under the girl's hat that normally would have been in shade. It was simply a question of selecting the right lighting in the location: I positioned her in a space that was shaded by the roof of this building, and natural fill-in was provided by the light that was reflecting up from the floor in front of her.

Mamiya RZ 67, 150mm soft focus lens, Fujifilm Provia 400, cross-processed through C41 chemistry. Exposure 1/500sec at f/11

If it's not possible to find any top shade, ask your subject to move into an area where there's some shadow. The face is the important part of this picture to get correctly exposed, so take a reading from this area. Any highlight areas that are technically overexposed as a result will only add to the effect.

Canon EOS 5, 75–300mm lens, Fujifilm Neopan 1600. Exposure 1/250sec at f/5.6

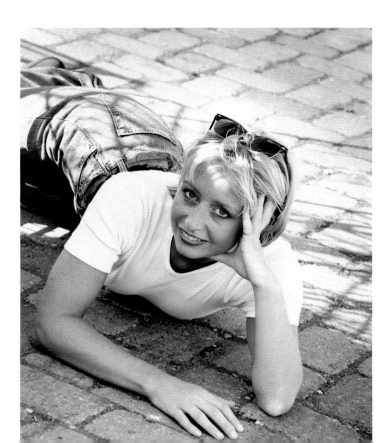

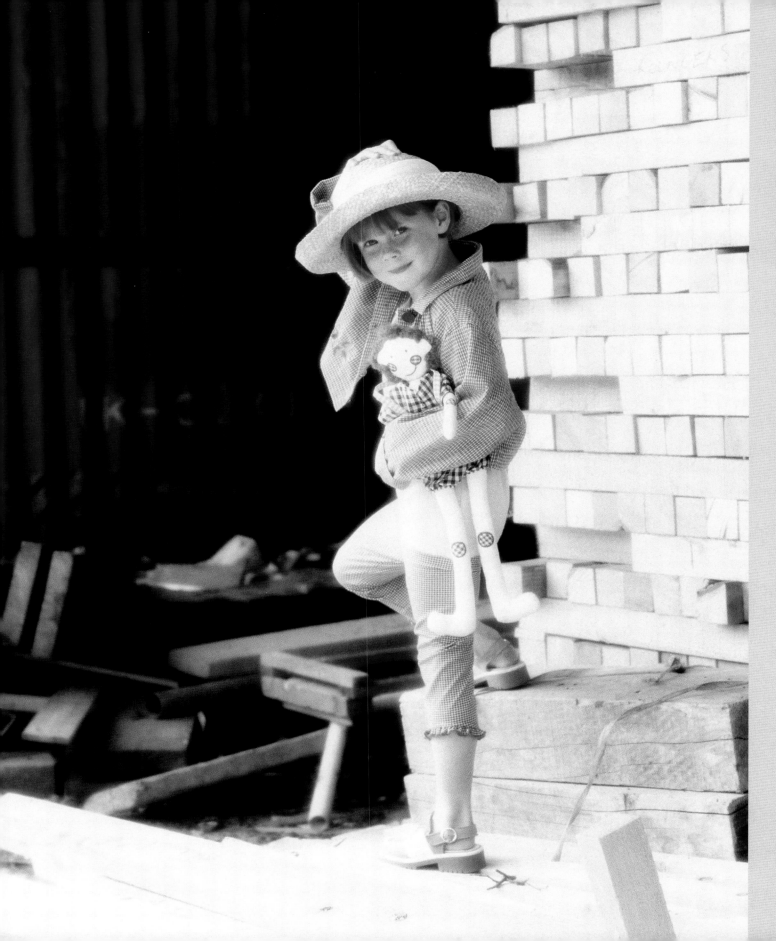

Many photographers imagine that once you venture into the studio, there is no alternative to using artificial light, but in fact the natural light that might enter the room through a window or a skylight can be just as effective if used carefully.

I also have a great aversion to fill-in flash, and never use it because I think it looks so artificial. I'm also reluctant to use reflectors because they tend to get in the way, although I will use one on occasions. I've tried to introduce natural reflection into my studio by painting the walls a neutral white, and this ensures that the maximum amount of natural light is spread around the room.

You must be careful, if you intend to shoot colour, to use only white on your walls. Light reflected from coloured walls will take on the colour, and will give your picture a cast. I also take care to position my subject well away from the window where the light is entering because, although this will mean that a longer exposure is required, it will even out the light that's falling on the face.

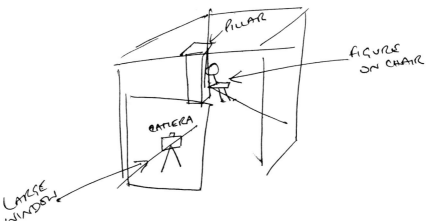

Although I had to use quite a slow shutter speed for this picture, it was still fast enough for the subject to be able to pose naturally. Modern emulsions can offer incredibly fast speed, and yet quality is still equivalent to that which you might have expected from a slow film just a few years ago.

Canon EOS 5, 75–300mm lens, Fujifilm Neopan 1600. Exposure 1/15sec at f/5.6

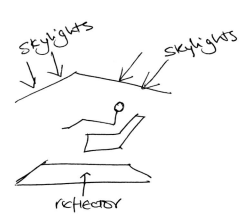

skylights　skylights

reflector

Overhead daylight, provided by a skylight or the glazed roof of a conservatory, can allow dramatic effects to be produced, enhancing not just the subject but the whole picture. I aim to keep the lighting in the area around the subject consistent, so that they have the chance to move around a little and relax without there being the need constantly to change things around and to interrupt the flow of the shoot. This is one of the major benefits of natural light: because you're not working with a bank of artificial lighting, you have the opportunity to see exactly what's going on, and to work with what you're being given. Often I'll work with the natural light exactly as it is, but here I did use a reflector on the floor in front of the chair to bounce some light back on to my subject. I've found small reflectors don't really throw back enough light when working with wider angles, so I use one called a Californian Sunburst which is six by four feet. Covered with gold and silver zig-zags, the light it throws back is very even and slightly warmed.

I find that I have to increase my exposure times to compensate for the fact that natural lighting has far less intensity than that provided by flash. Even so, I can usually work at around 1/15sec or above, which when I'm not trying to catch action is perfectly adequate. The pay-off is that the session is far more informal when natural light is used, and this is reflected by the way that my subjects react to the camera.

Chloe had booked a photo shoot to mark her 18th birthday. Before we started the picture session she went through make-up and had her hair styled, and was generally pampered to make her feel good. This helped to give her great confidence in herself before the camera ever appeared.

Mamiya RZ 67, 150mm soft focus lens, Fujifilm Provia 400. Exposure 1/15sec at f/5.6

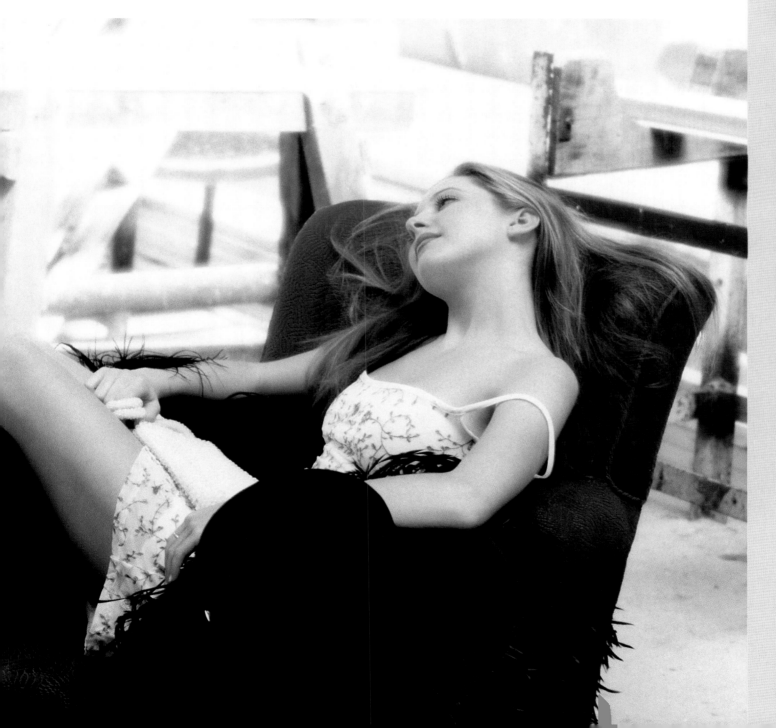

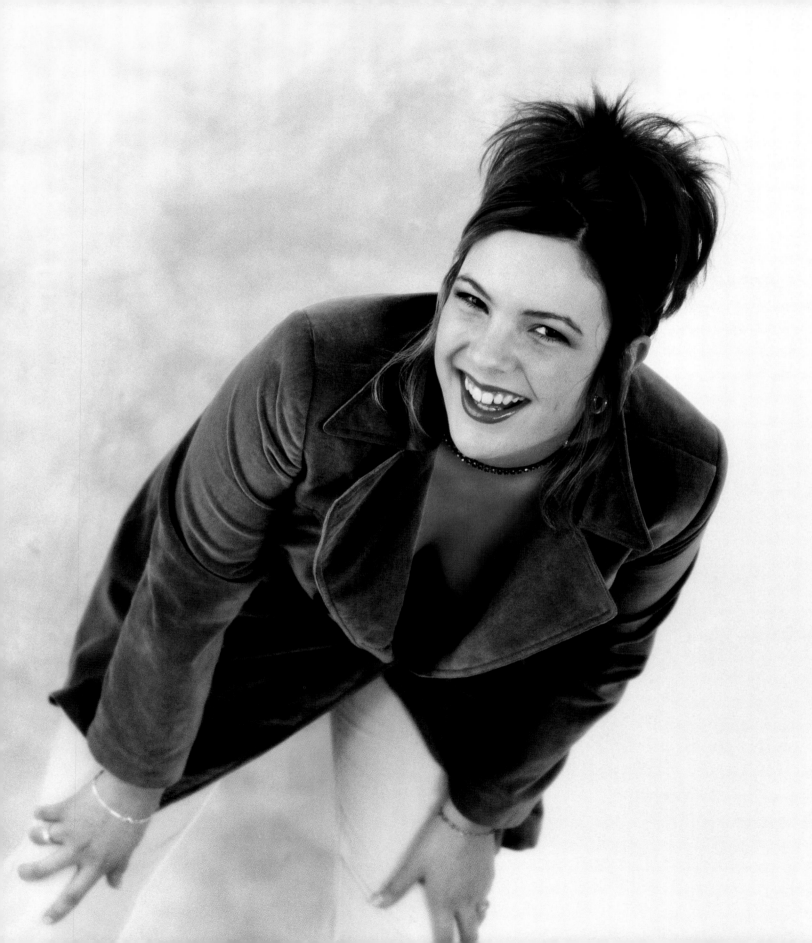

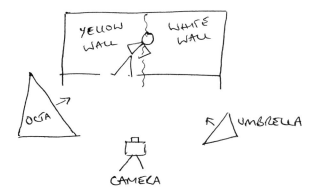

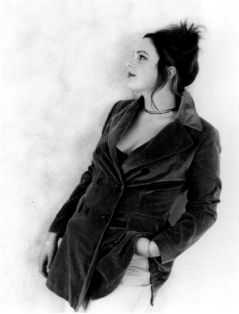

Studio lighting by its very nature can be intimidating to someone who is not used to being photographed, and is often perceived as creating a formal and artificial environment.

I try to make the studio as friendly and welcoming as possible by setting up lighting that is simple and unobtrusive. This will remain constant throughout the shoot so that I don't have to take time out from talking to the subject to change lights around and to check exposures. Instead I concentrate on the expressions I'm getting and making sure my subject is enjoying the session.

The main light I use is a very large softbox, an Octa, in combination with an Elinchrom 500. With a diameter of around five feet, the Octa is capable of throwing out a very consistent light over a large area. To soften the shadows I use a fill light, an Elinchrom 250, which is bounced back on to the set from an umbrella, ensuring that this light, too, is soft and even. The white walls of my studio also contribute to the even nature of the lighting I'm providing, giving me a wide area within which to work. This means that my subject has the freedom to move around instead of having to stay rooted to one point; this arrangement allows great flexibility too. If any shadows do find their way on to the background, this simply serves to add depth to the picture.

Because my lighting is so consistent, I find that I can work quickly and can produce pictures that have a very different feel while maintaining my camera position. This gives me a good variety of shots from a single session.

Mamiya RZ 67, 150mm soft focus lens, Fujifilm Provia 400. Exposure 1/30sec at f/5.6

"Go shopping! Look at window displays, furnishings and kitchen utensils to ascertain the colours and shapes that are influencing the latest generation."

Studio backgrounds need careful planning to create the right mood and atmosphere. The background should not take over, but rather complement the subject.

Historically, studio photographers used canvas backgrounds depicting clouds, outdoor scenes, library books etc., often because the Victorians saw this as a way of displaying wealth. Now we need to create images that remind us of our way of life today. Many current looks are dictated by trends in the media – ideas taken from magazines, CDs and videos can all be used to create contemporary pictures.

Whilst most photographs have traditionally been rectangular in shape, the trend is now towards square pictures, probably influenced by the shape of CD covers.

The board that I used against the background helped to break up the uniform colour, and saved the image from being boring. For added impact I placed my subject so that her head was seen against the light tone of the board, and then tilted the camera slightly to create some interesting angles.

Hasselblad, 50mm lens, Fuji Astia 100 slide film, cross-processed through C41 chemistry. Elinchrom 500 with Octa softbox and Elinchrom 250 with white umbrella. Exposure 1/30sec at f/5.6

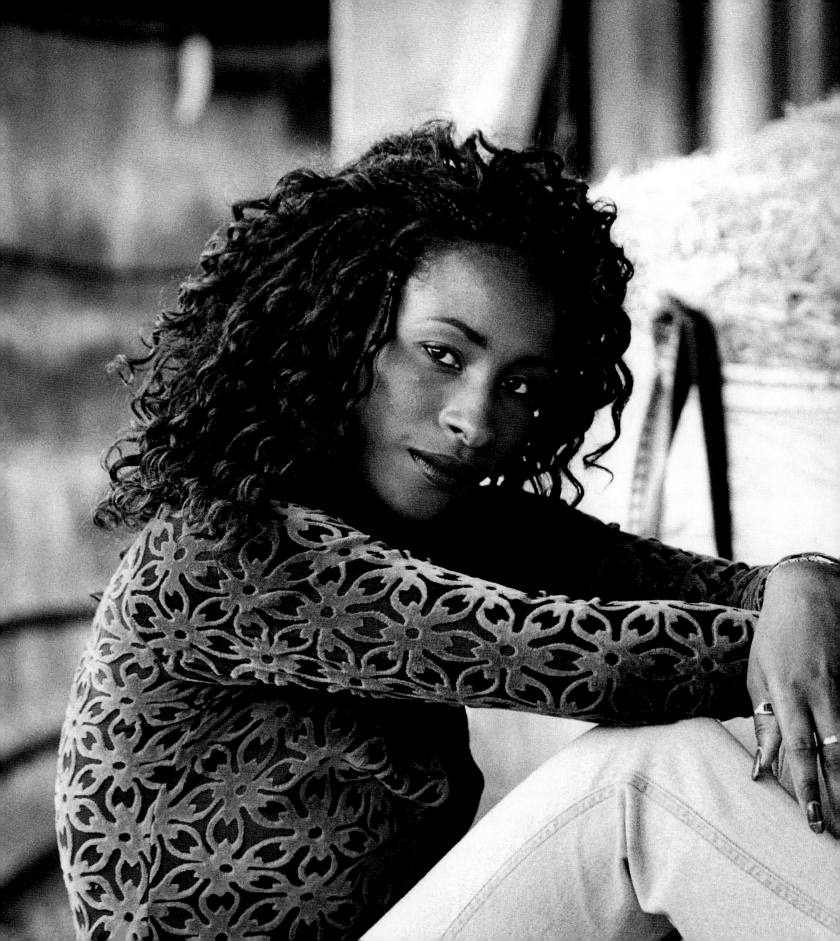

There is almost nothing that cannot be used in a picture. Here the background is made up of rubbish and items that might individually be seen as unacceptable. However, if we look at the background as nothing more than a series of shapes and textures, rather than letting the reality of what's really there cloud our vision, then it's possible to see the potential in virtually everything.

Here I used a 75–300mm zoom to move in closer to my subject. The natural tendency of the telephoto to compress perspective has brought up the shapes behind her, while the characteristic narrow depth of field that a long lens provides ensured that it was soft enough to be unrecognisable. The colour version of the picture gives more away.

Here you can see that what's actually behind my subject are piles of wood shavings and broken pieces of plasterboard, while the girl herself is sitting on a wooden cable container. The image still works, because it's so up-front that it's clear the surroundings were intentional, while the look of the girl is confident and she's clearly relaxed.

Same situation, two very different final results, and that's what it's possible to achieve if you think clearly about what a particular background can offer you. It took very little time to move between these two looks, and I was able to leave my subject undisturbed in her position while I changed cameras.

Colour: Mamiya RZ 67, 150mm soft focus lens, Fujifilm Provia 400, cross-processed through C41 chemistry. Exposure 1/60sec at f/5.6

Black and white: Canon EOS 5, long end of a 75–300mm zoom, Fujifilm Neopan 1600. Exposure 1/250sec at f/5.6

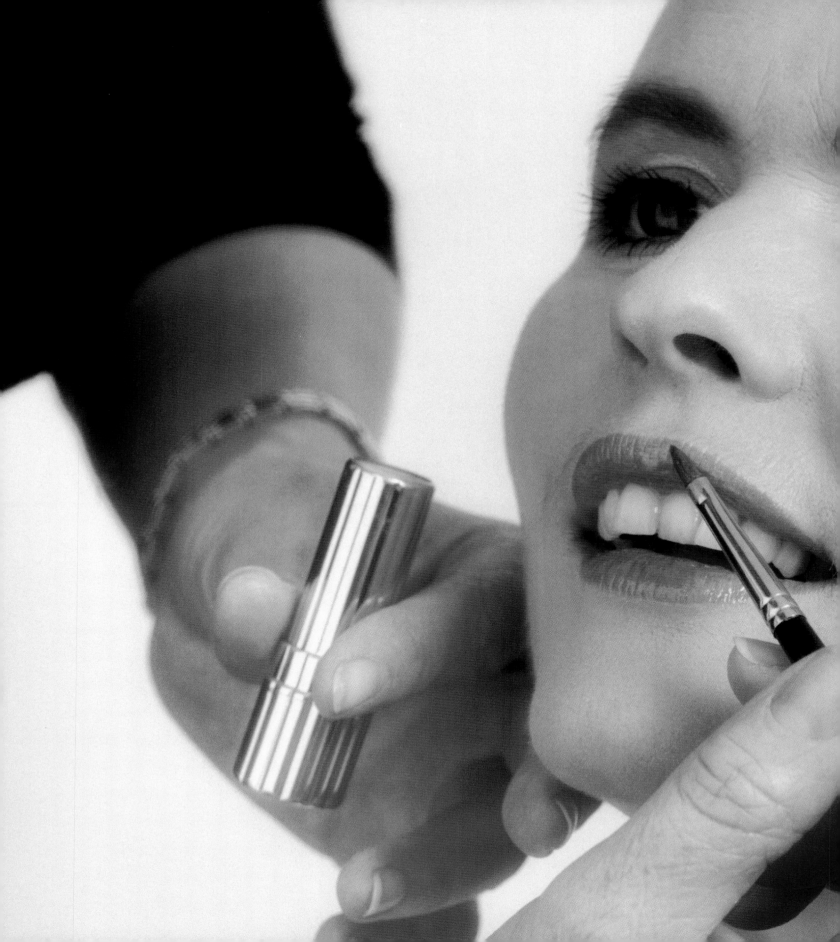

make-up, clothes, and colour analysis

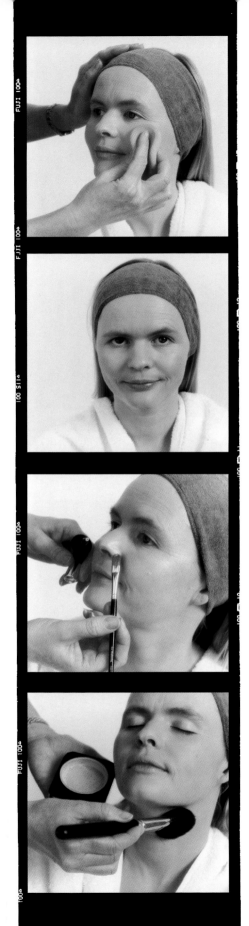

Hilary has arrived in the studio and without any make-up applied, I take a "before" picture of her. This is the kind of snapshot people usually hate of themselves, because most snapshots are taken in unflattering positions with no effort to enhance the subject's best features.

Involving a make-up artist in the shoot makes an enormous difference to the way that a subject feels about themselves. It could, in theory, be done in 15 minutes, but we make it last between 45 minutes and an hour simply because this is the ideal time to talk to the subject, to reassure them about the way they look and to make them feel pampered and relaxed. By the time I'm ready to start shooting, Hilary will look special and feel really good about herself, and that's exactly the frame of mind I want her to be in so that she feels confident in front of the camera.

9.30a.m. Hilary's face has been cleansed ready to start her make-up. The foundation is applied very lightly over the neck and face using a sponge.

Foundation evens out the skin tones, and acts as a base for the rest of the make-up.

9.40a.m. After applying foundation, Lucinda "retouches" any darker areas with a concealer to hide any problem areas such as broken veins, spots etc.

She then applies a matt translucent powder over the whole area to alleviate shine from the foundation, which would otherwise be unflattering under studio lighting.

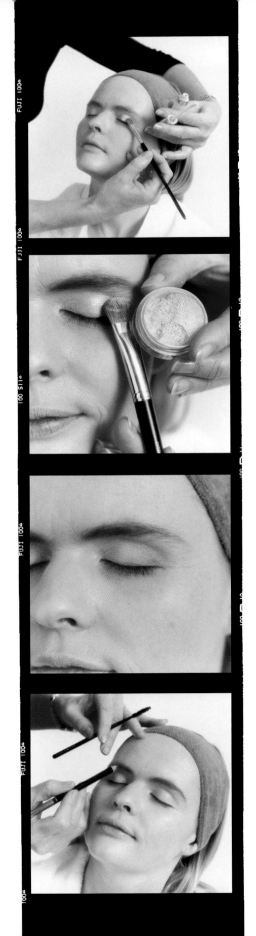

I've mentioned already that I always start the session with the most formal look, and this is the way that I began with Hilary. As the session progressed, I knew that she would become more relaxed and happy about being in front of the camera, and this would suit more closely the look that I was after as her clothes and appearance became more casual.

9.50a.m. Eyelid foundation helps to create a smooth base for the eyeshadow.

A light pink eyeshadow is applied as a base colour, followed by a darker grey eyeshadow on the outer area of the eye, which is then blended subtly.

A soft brown eye pencil is used to define the eyebrows, which will enlarge the eye area.

Positioning is very important; turning sideways on to the camera is more flattering than facing it. The film has been overexposed to lose the detail in the skin, which most women do not want to see!

Mamiya RZ 67, 150mm soft focus lens, Fujifilm Superia 100. Lighting from Octa softbox and umbrella fill. Exposure 1/30sec at f/5.6

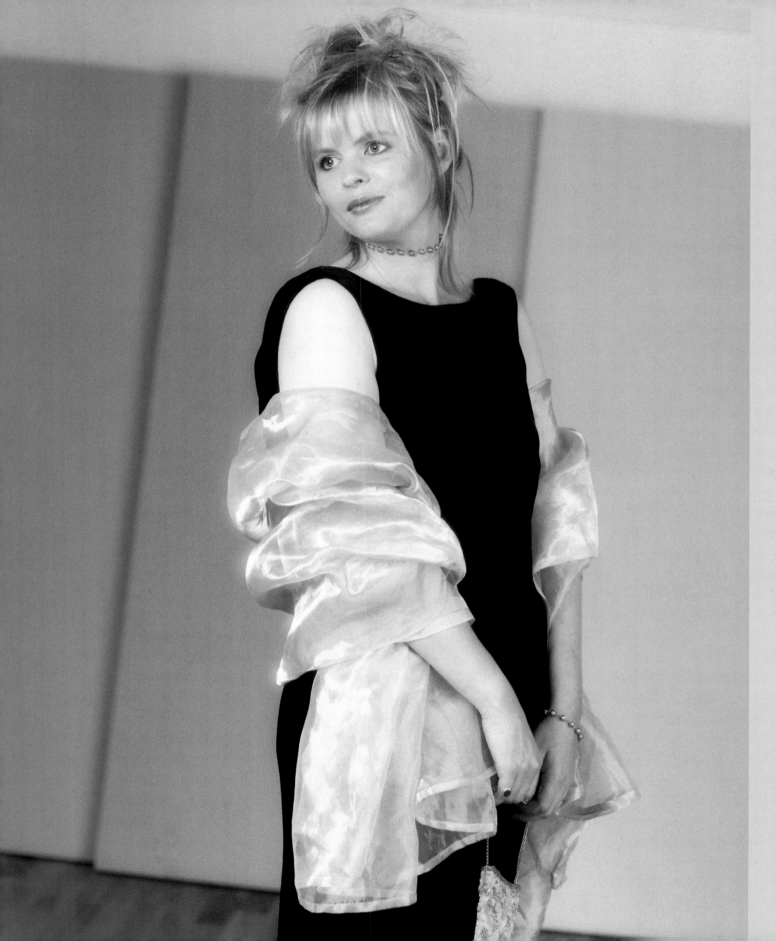

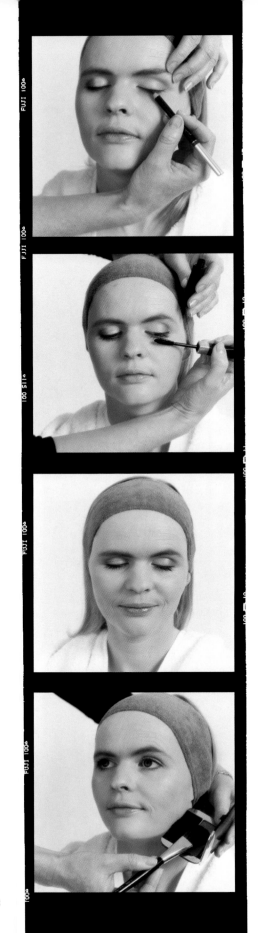

Hilary wore a long top that was the same colour as her skirt, and the combination of the two items helped to stretch her figure and to make her look taller.

Canon EOS 5, 75–300mm zoom, Fujifilm Neopan 1600. Lighting from the modelling lights of two Elinchrom flash heads. Exposure 1/30sec at f/5.6

10.00a.m. Soft brown eye-liner is applied to the outer edge of the eyelid to define the shape of the eye. Mascara is used to define and lengthen the eyelashes.

Blusher is applied to emphasise Hilary's cheek-bones and enhance her naturally good bone structure.

Very few people have perfect figures, and when I'm shooting clients in my studio I often have to work a little to make sure that their best features are emphasised while those that are not so good are disguised. After all, I want them to be happy with the results, and I think it's very important that whoever I'm shooting looks like themselves but also feels like a model.

Long, flowing clothes, for example, can hide the shape of hips, while a shorter top will emphasise that feature. Long jumpers will suggest a more slender figure, and can make a person look taller. I always ask people to bring a bigger selection of clothes with them than we're likely to need, and this gives me an opportunity to select things that I feel will help a person to look their best.

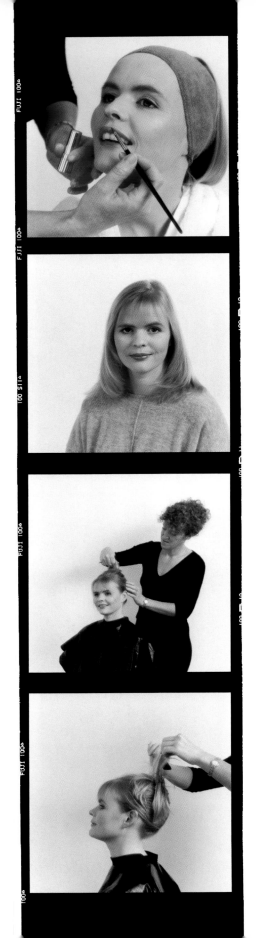

With long hair, I always start the shoot with the most difficult hairstyle as it is easier to take the hair down throughout the shoot, rather than put it up. The style here has been designed to be changed quickly and easily into other less formal styles, so that there is as little interruption to the shoot as possible.

Canon EOS 5, 75–300mm zoom, Fujifilm Neopan 1600. Lighting from the modelling lights of the two Elinchrom flash heads. Exposure 1/30sec at f/5.6

10.10a.m. The lipstick is applied using a lip brush to define the lip shape.

The make-up is now complete, and the client by now should feel happy and relaxed, and ready to face the camera. She will have seen the look coming together, and will know that she's looking beautiful, and this is an essential part of the day. Hair styling comes next and since the formal look is shot first, this is the style that will be worked on first and takes about 15 minutes to complete. As the session progresses and the approach progressively becomes more relaxed, the hair will be reworked, so that by the time the final set of pictures is being taken, the look will be a more natural one.

10.15a.m. Styling the hair for the first look, by twisting it up.

Backcombing the ends of the hair allows it to stand up on end giving height to the style.

10.30a.m. Ready to go!

For the more casual photos I used the 35mm camera and zoom lens, and very quickly took a sequence of very informal pictures. Invariably, despite all the quality that a medium-format can offer, these are the pictures that the subject will like the best, because these are the photographs that show them as they really are.

Canon EOS 5, 75–300mm zoom, Fujifilm Neopan 1600. Lighting from the modelling lights of two Elinchrom flash heads. Exposure 1/30sec at f/5.6

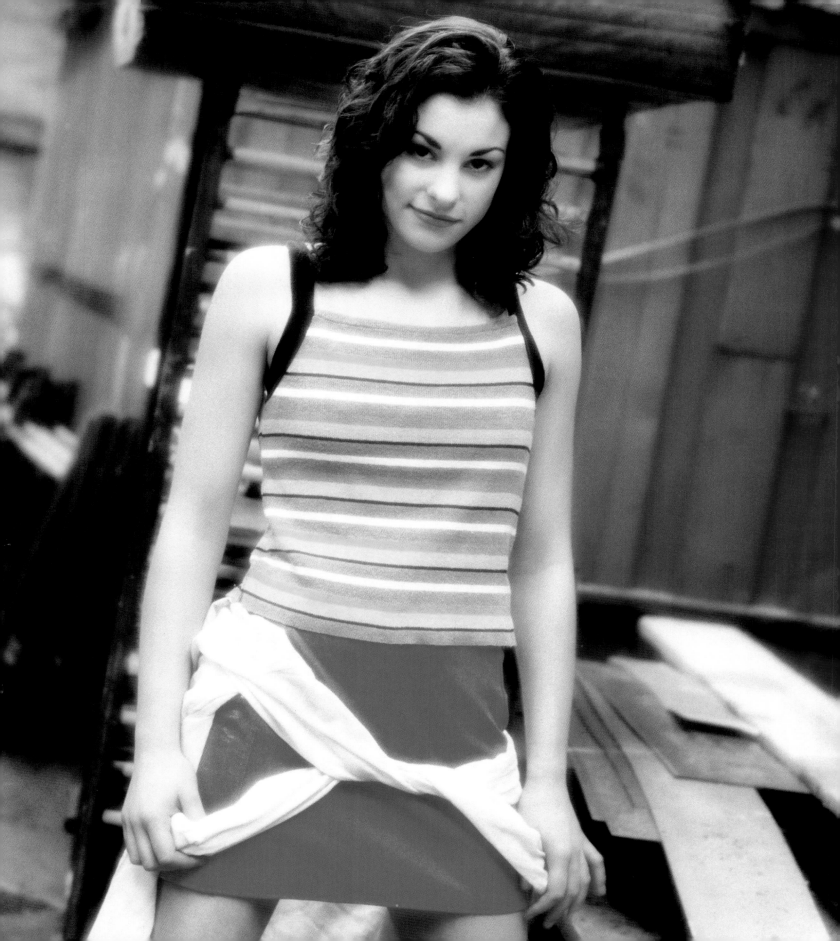

The way that a subject will work with their background is key to the success of a picture, and colour has a vital role to play in this. If the result is to have harmony, colours should be complementary, not fighting against each other, and this is equally true whether colours are bright or more subdued. Here the red of the girl's skirt, opposite, has echoed the colour of the container behind her. The sandy colour of the boy's trousers, below, is picked up by the hue of the wall behind him. When I go to locations I make it up as I go along and simply try to think on my feet. I'm looking for areas such as this that I know will work well with a particular subject and the clothes they're wearing.

Both these pictures have made use of an unusual setting, but on each occasion the image is successful because the colours have worked together and created a good overall effect.

Both pictures: Mamiya RZ 67, 150mm soft focus lens, Fujifilm Provia 400. Exposure 1/30sec at f/5.6

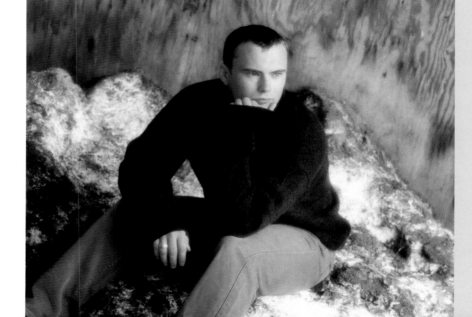

I don't often use props in pictures, but when I do I like them to be something that relates to the person I'm photographing. The parents of the girl with the tea cups and dolls, for example, run a shop that sells unusual items such as these. The result is a picture that's full of colours and textures, and involves objects which are familiar to the clients. The other picture uses a brightly coloured doll which complements the bright clothes and tiled floor.

The right prop can complement the colour in a scene, and can serve as inspiration for the final picture. If I use props at all, I'll usually find these around the house of the person that I'm photographing, so their use will be spontaneous.

Mamiya RZ 67, 150mm soft focus lens, Fujifilm Provia 400. Exposure 1/500sec at f/5.6

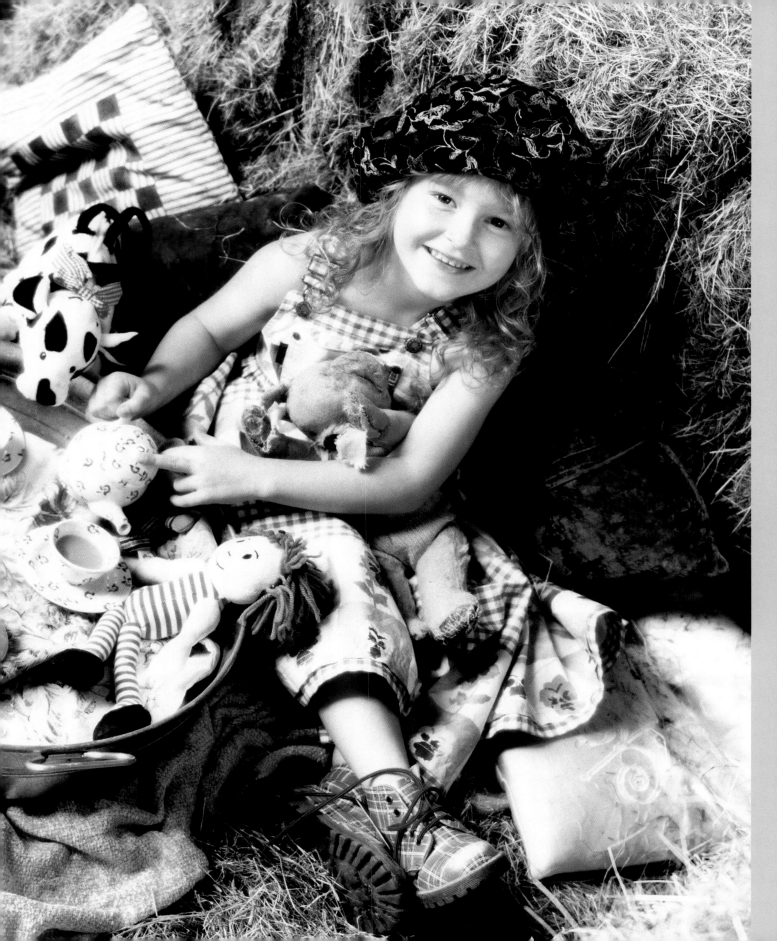

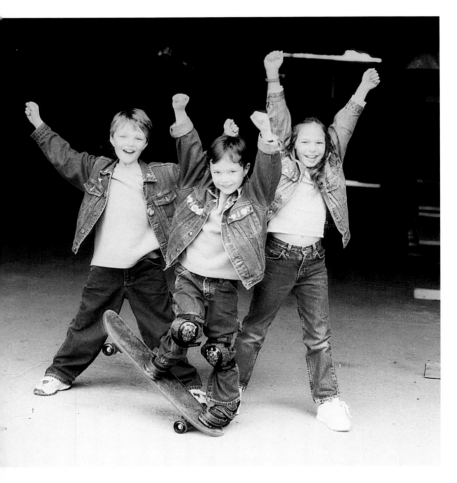

The colour of the clothes that the subjects are wearing should complement not just the surroundings, but also each other, so that there are no clashes in the picture. For the image of the couple on the right, I knew that their tastes were towards light and pale colours because of the décor of the house. It was a simple decision to ask them to dress in light clothes, and the beige and white work well together and also in the context of the setting, for a bright and airy picture.

Generally I like my clients to wear clothes that they are comfortable and happy with, but I'll advise when I feel that something isn't going to work in the picture. Had one of the couple, right, wanted to wear denim, for example, this would have ruined the harmony of the colours in the picture.

Mamiya RZ 67, 150mm soft focus lens, Fujifilm 800. Lighting: natural, from a set of French windows. Exposure 1/500sec at f/5.6

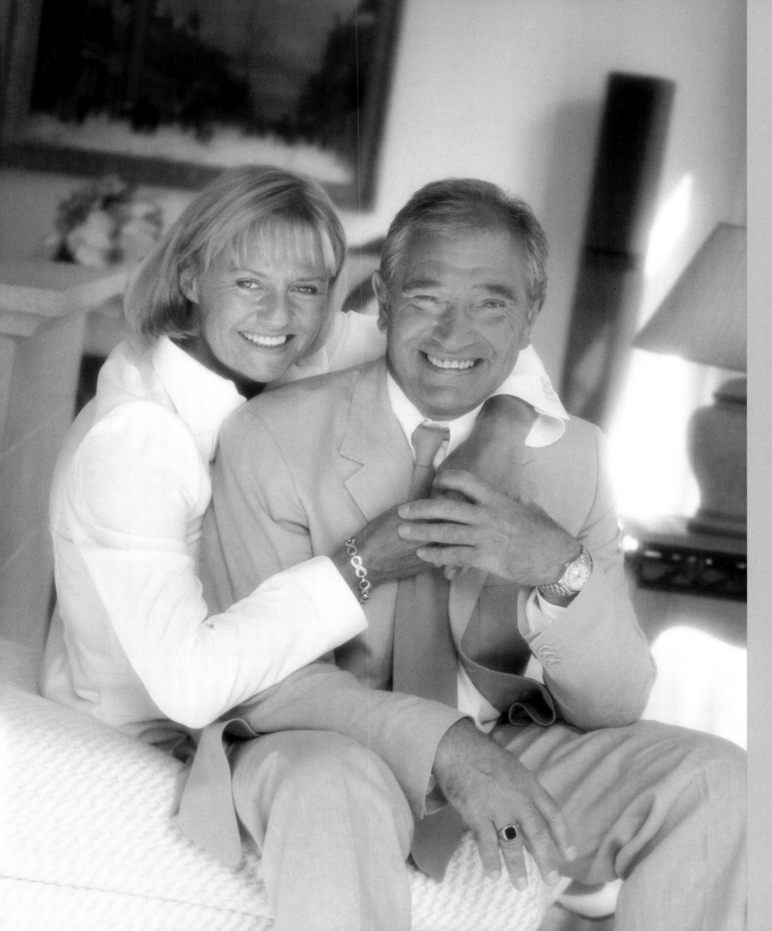

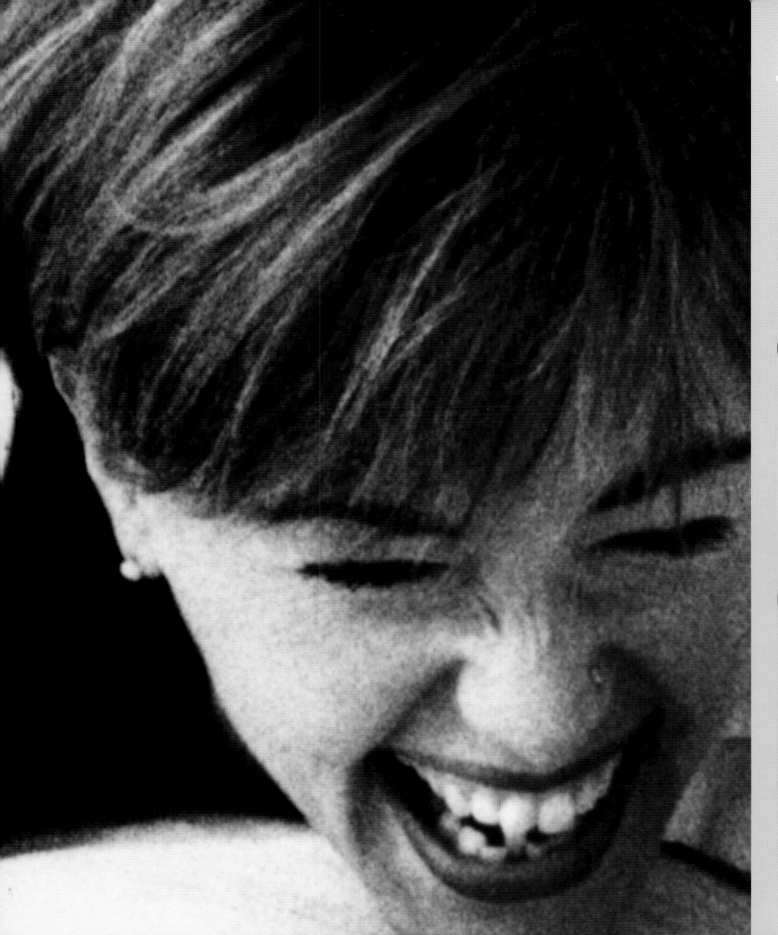

"The essence of a relaxed picture is the result of understanding how a person feels as well as how they look."

Careful positioning of the person is the key to a successful photograph. Today's clients want to look natural and unposed, but without careful positioning the photographs will enhance the very features they want to hide. Therefore we have to be acutely aware of placing certain parts of the body to enhance the subject's best features and detract from those they dislike; whilst keeping the result from looking false or over posed. When people look at photographs of themselves, they tend to be very self-critical, and no matter how good the lighting, clothes, make-up and backgrounds are, if their posture and expression are not attractive they will not like the photograph.

Positioning a subject so that their body is at a slight angle will give a more flattering result, and will also lead to more vibrancy and life in the picture.

Canon EOS 5, 75–300mm zoom, Fujifilm Neopan 1600. Exposure 1/250sec at f/5.6

The Warmsley sisters could not appear more relaxed as they stand together in the garden, arms around each other. By photographing them together, they feel more confident and relaxed – safety in numbers!

Canon EOS 5, 75–300mm zoom, Fujifilm Neopan 1600. Exposure 1/250sec at f/5.6

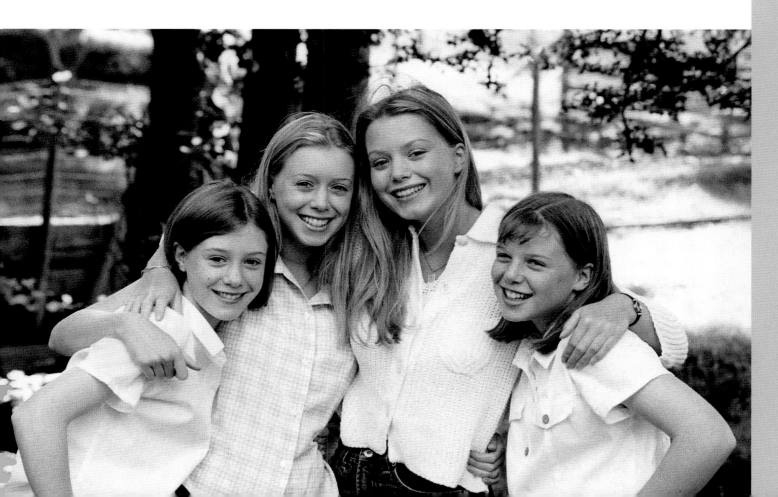

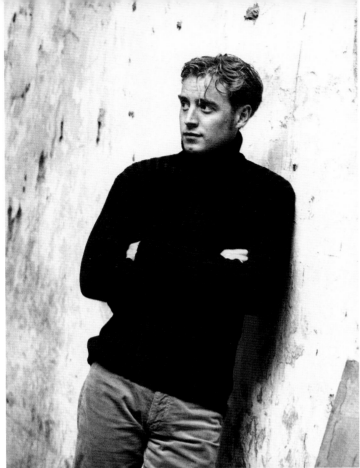

In order for the client to feel comfortable and relaxed we need to direct them into positions which feel natural to them, i.e. leaning on a wall, hands in pockets, lying on the floor, sitting with their feet under them, lying on a sofa hugging a cushion – doing things they are used to doing every day. Sitting people in an alien environment – for example on high stools or standing them in open spaces – causes tension and anxiety as they feel exposed and unsure about what you expect of them.

Right: When I'm positioning subjects, I like to start by asking them to do something that they would almost certainly do naturally. With this little girl, it was easy for her to lay on the floor like this and to flick her legs up behind her, because that's how she relaxes at home.

Canon EOS 5, 75–300mm zoom, Fujifilm Neopan 1600. Exposure 1/30sec at f/5.6

Left above: Andrew has the security of a wall to lean on, whereas had he been standing in an open space he would have looked less natural.
Left below: Grace sat in an armchair and instinctively relaxed, able to relate immediately to an everyday situation.

Both pictures: Canon EOS 5, 75–300mm, Fujifilm Neopan 1600. Exposure: top picture 1/15sec at f/5.6, and bottom picture 1/250sec at f/5.6

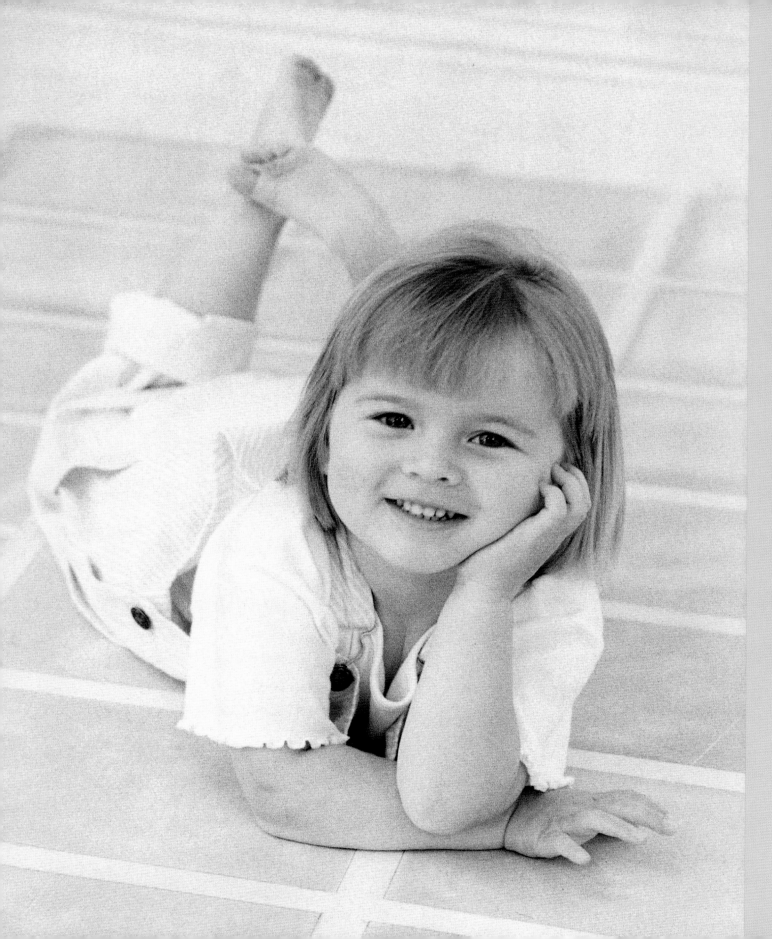

1 Nobody likes double chins! Always ask the client to push her chin forward slightly, which will create a firmer jaw line.

2 Lying the subject down will create a much more relaxed head shot than photographing them standing, facing the camera.

3 Leaning on one hand and turning around slightly makes the subject look slimmer. Most clients love this pose, and you can adapt it by asking them to move to their left or right, which will allow you to enhance or to take attention away from features.

4 To make small people appear taller, crop the photograph through the thigh, to give the impression that the legs are much longer. A full-length shot of a small person will only make them look smaller.

5 Bare skin against black clothes will make the client appear larger. Careful positioning of similar coloured clothing, such as a shirt, will slim the body down.

6 Women can look wider than they actually are when photographed facing straight towards the camera. Avoid this by turning them slightly sideways and creating an "S" shape.

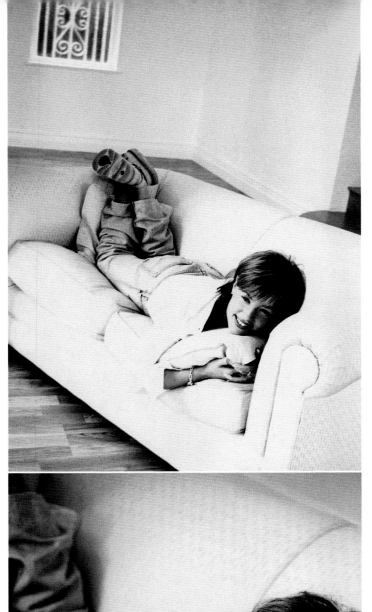

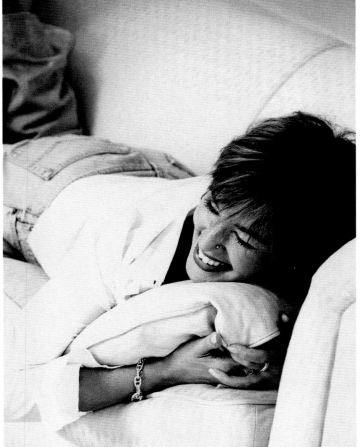

When people are enjoying themselves and starting to relax in the studio, make sure that you're ready for spontaneous shots with a 35mm camera, because these are the ones that will inevitably be the most in demand later. Something just appealed to my subject here, and she suddenly burst into fits of laughter. It was a wonderful sequence, and I just grabbed my camera and took pictures. The use of a zoom lens is invaluable in these situations because it allows such a rapid change of focal length, and the fact that I was able to hand-hold the camera because of the fast film I was using was also critical. With pictures like this, even a little blur would be acceptable: it's the moment that will captivate people, not the technical quality.

Geraldine started off by trying to pose, but was so relaxed that she soon found herself laughing uncontrollably. The sequence of shots tells a story and shows her in natural, unforced circumstances.

Canon EOS 5, 75–300mm, Fujifilm Neopan 1600. Exposure 1/30sec at f/5.6

"Each of these images is equally powerful, because they are saying different things about the same subject. Whilst one is a classic portrait, the others are more relaxed and spontaneous versions."

The classic portrait on the right, is the one that most people expect they will want. It shows two happy and relaxed people, while the inclusion of the couple's dogs in the picture adds the final touch. This is the picture that has to be taken, but once it's in the bag you should always try to produce some variations, which will often appeal more to the subjects because they show a more informal side of them. Try to introduce some action into your pictures, and make your pictures say something about the relationship between the subjects that you're photographing.

Mamiya RZ 67, 150mm soft focus lens, Fujifilm Neopan 400. Exposure 1/500sec at f/5.6

9.30a.m. It's the start of the day, and Lisa and Scott are arriving for their session feeling excited but a little nervous. The first step is to make them feel comfortable and to start the process of relaxing them, and a simple cup of coffee helps them to settle into their surroundings.

9.45a.m. Moving through to the studio, the couple meet stylist Lucinda Hayton, who chats through clothing that will be worn for the shoot and the kind of look that Lisa and Scott are hoping to achieve. For the session in the studio it's decided that both of them will wear black tops, which will ensure a stylish and contemporary look. Black is always in fashion, and usually flatters the wearer, and by asking the couple to dress the same it has given harmony to the picture and emphasised the relationship between the two of them.

The black clothing that Lisa and Scott chose to wear has ideally suited the black and white film used here. Had one of the couple worn a lighter shade, there would have been the chance that the picture would have looked very disjointed.

Canon EOS 5, 75–300mm zoom, Fujifilm Neopan 1600. Illumination from an Octa softbox and umbrella fill, but only modelling lights used. Exposure 1/30sec at f/5.6

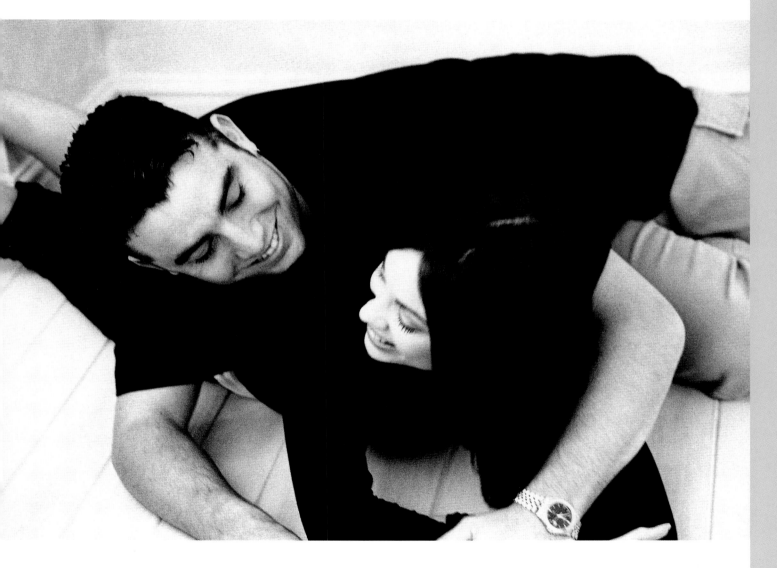

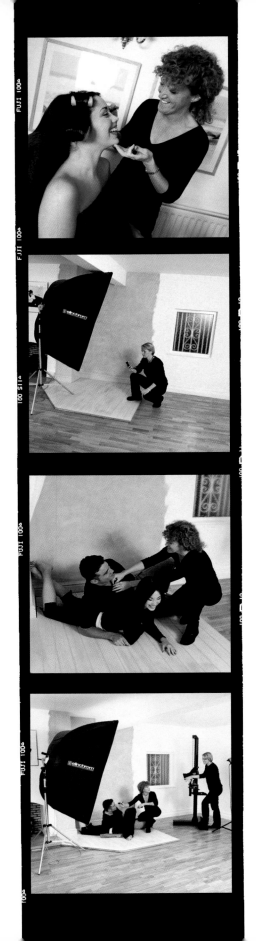

10.00a.m. The make-up session follows next, and this should be a relaxing and enjoyable part of the day. This is an opportunity to get all those fears out of the way, so that any worries and tension have disappeared by the photo stage. Having make-up applied by a professional make-up artist is a very relaxing experience and makes the clients feel completely pampered.

Meanwhile, Annabel checks all her lights and sets, so that she can concentrate on the client rather than the equipment during the shoot.

Annabel positions Lisa and Scott on set while Lucinda checks the make-up under the studio lighting and makes final adjustments to the clothing.

11.00a.m. The first photos are taken lying on the floor, to allow the clients to settle into the shoot, and to gain confidence. The positioning is simple and natural so the clients can relax and realise that it's not going to be hard work!

By asking the couple to lay on the floor for the first set of pictures, I was able to take an elevated view and use the floor itself as a simple, uncluttered background for this picture.

Canon EOS 5, 75–300mm zoom, Fujifilm Neopan 1600. Illumination from an Octa softbox and umbrella fill, but only modelling lights used. Exposure 1/30sec at f/5.6

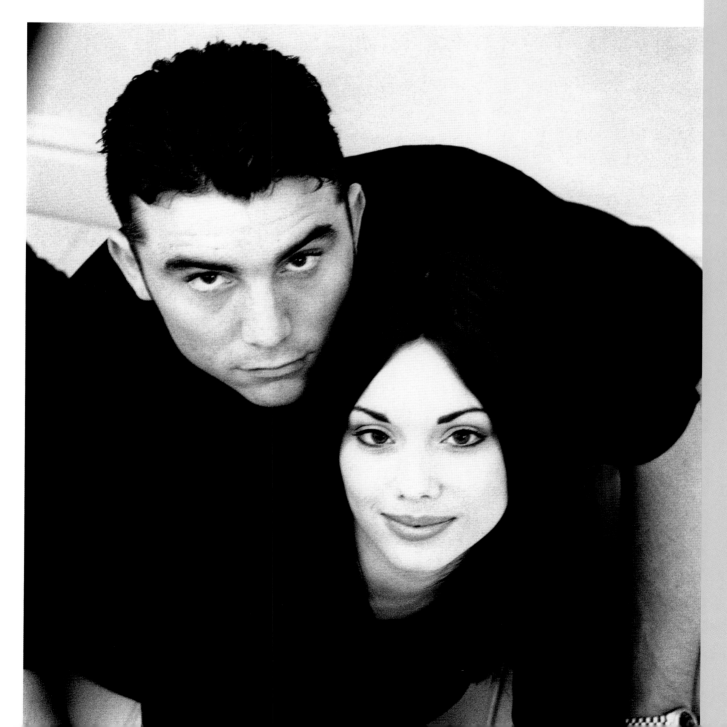

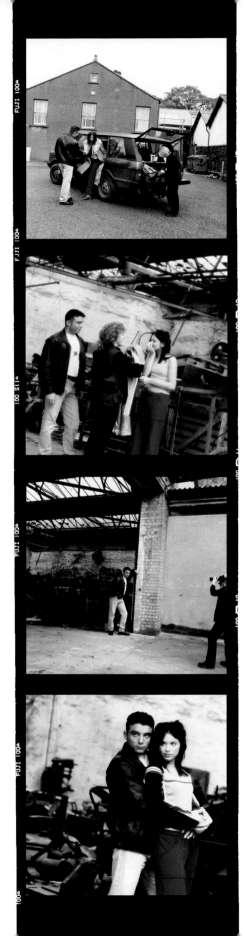

Even though this session took place in November, I still went outside for location pictures, because the light at that time of year can be fantastic. The downside is the cold, but if clients are enjoying themselves they will be quite happy to co-operate and to brave the elements.

Canon EOS 5, 75–300mm zoom, Fujifilm Neopan 1600. Exposure 1/30sec at f/5.6

11.30a.m. Then it's off on location! Today, it's an old bobbin mill and industrial estate, full of amazing potential, adding a new dimension to the shoot – it's not everyday you have your photos taken against a rubbish tip, or pile of sawdust!

Lisa and Scott are now really enjoying the shoot, as working in this location is new and exciting and they don't quite know what to expect next. Lisa is freezing, so Lucinda allows her to wear her jumper: providing it suits the feel we're trying to achieve, there's no problem adding elements like this to the picture. It's obviously easier to handle in black and white as well, because there's no danger of a colour clash.

The colour pictures set the scene, and the 35mm black and white allows movement and variety in the shots.

Standing further away with a long lens throws the background out of focus, placing more emphasis on Scott, and the use of black and white grainy film turns the junk into a series of interesting shapes and textures.

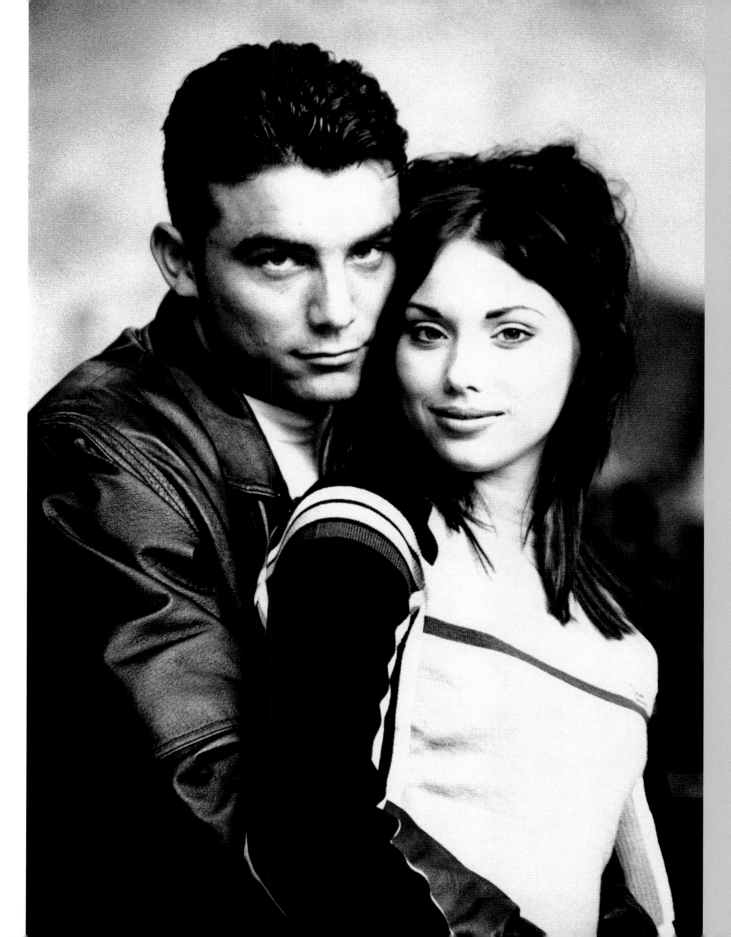

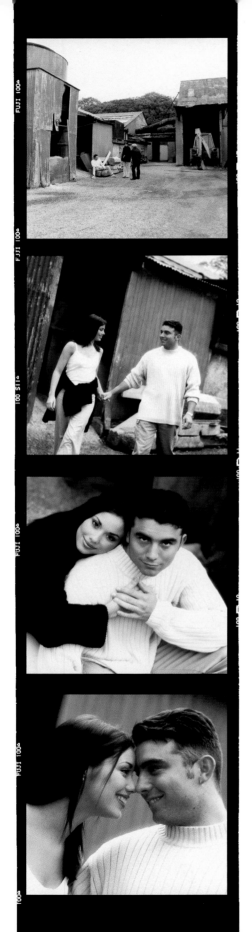

The juxtaposition of the two heads and the touch of the hands suggest a close relationship, a feel that's been emphasised through the use of the long end of the zoom lens to compress the perspective and a tight crop in-camera.

Canon EOS 5, 75–300mm zoom, Fujifilm Neopan 1600. Exposure 1/30sec at f/5.6

12.00p.m. It's always good to have a few changes of clothes to hand, so that other ideas can be tried out throughout the session. Lisa and Scott also needed to wear something outside that would keep them warm and comfortable, although for short periods it is possible, even in November, to wear some lighter clothing. On location the only changing facility to hand is generally the back of the car and today is no exception, but fortunately the session is going so well that no one complains.

Annabel directs Lisa and Scott into an area chosen for the warmth of colours in the background, which will complement the feeling of warmth in the fluffy jumpers. Lisa and Scott are still enjoying every minute, despite occasionally being blasted with sawdust from a fan close by!

The pictures to the left show how the colour side of the shoot developed throughout this period. The style is still informal; although it's medium-format the camera is still hand-held, and the aim has been to establish the relationship between the couple through the intimacy of their body language. The chance has been taken to add extra vibrancy to the pictures through subtle tilting of the camera. At times, straight lines can look too conventional, while angles within a picture suggest a contemporary feel.

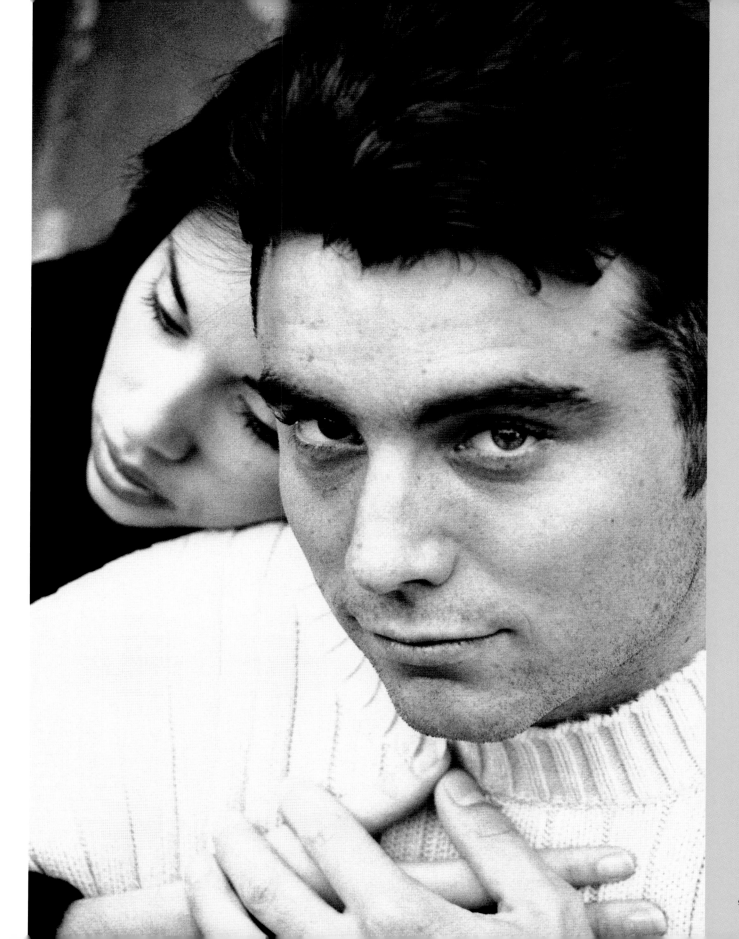

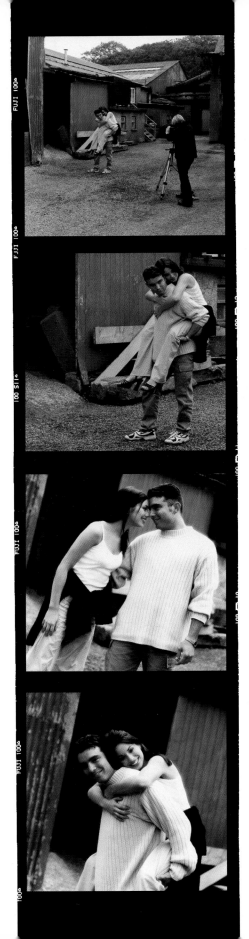

12.45p.m. Some of the best shots from a session often occur right at the very end, when everyone is at their most relaxed. Annabel keeps her camera to hand and her shooting instincts on alert so that, even when Lisa and Scott think it's all over, there's still the chance of more pictures. Annabel is still mixing colour with black and white to ensure that she gets the overall coverage that the couple is looking for and, when a picture is working particularly well, she makes sure that she shoots versions on both.

The session ends on a high note, with the clients feeling exhilarated and declaring that they want to come and do it all again soon. It's how it should be: when a shoot becomes a chore or never moves beyond the stage where the participants are feeling mildly embarrassed throughout, then it's going to show and results are never going to be satisfactory.

1.00p.m. Time for lunch!

A tight crop and the use of a doorway as a natural dark background has made this a strong picture in black and white as well as colour. The final element is a slight twist to the camera to allow the angles of the doorway to move away from the vertical. If the subjects are enjoying the shoot then it's possible, even in winter, to shoot without layers of clothing.

Canon EOS\5, 75–300mm zoom, Fujifilm Neopan 1600. Exposure 1/30sec at f/5.6

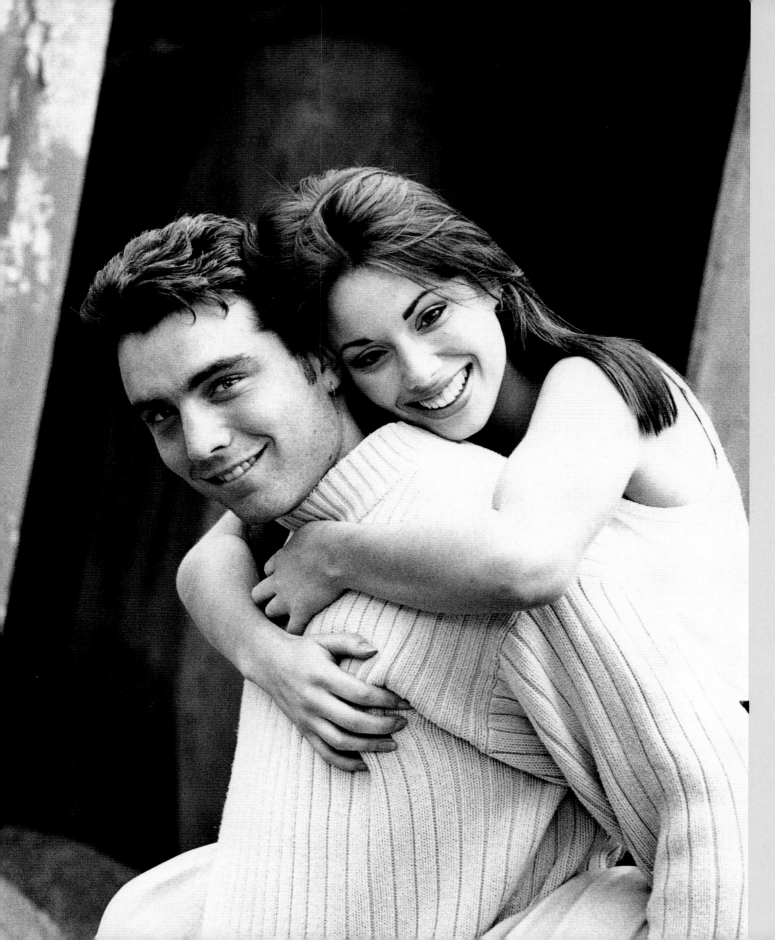

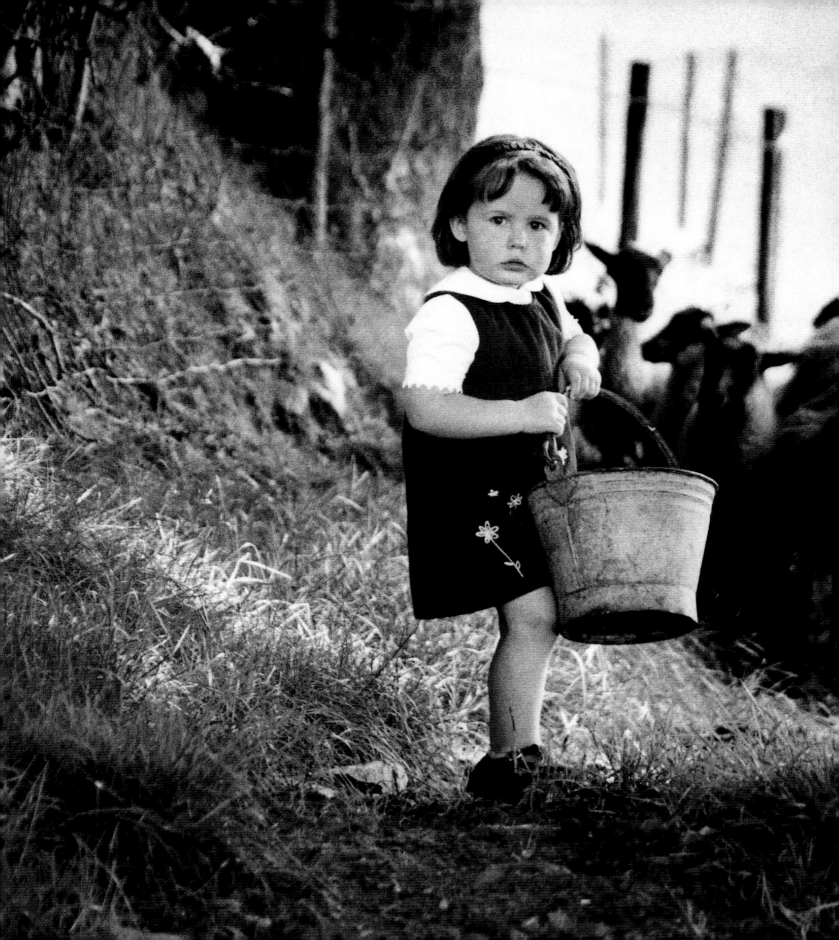

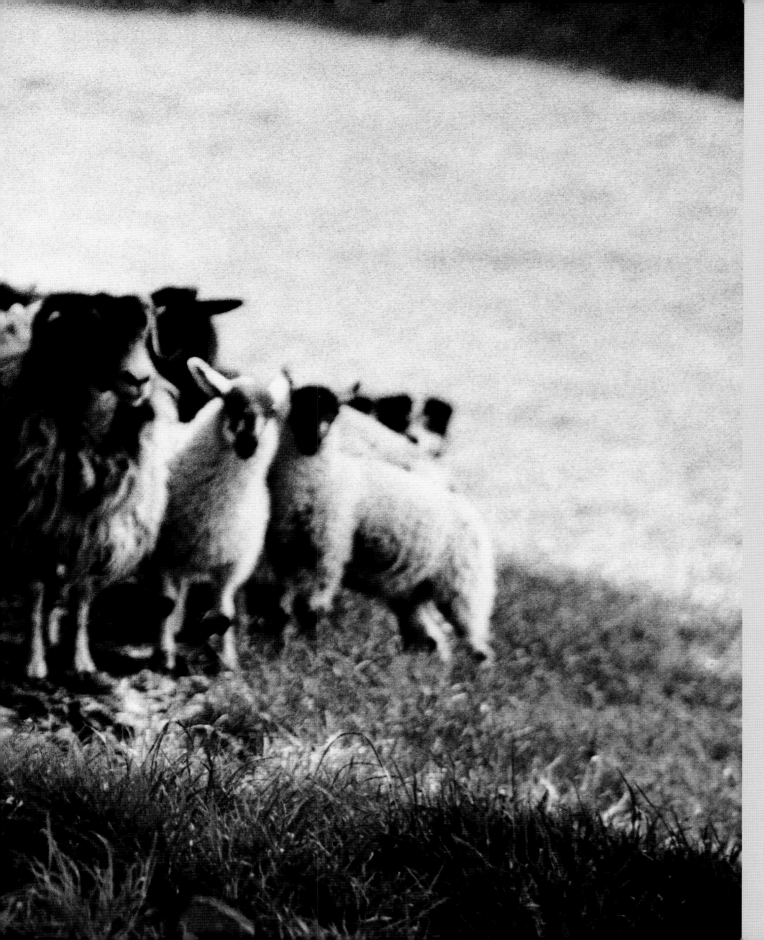

Great photography has less to do with the equipment you're using than it does with your approach to your subject. How quickly you can build a rapport with someone you may never have met face to face before is what will decide how successful the pictures are going to be.

These skills may well be tested still further if the subject you're photographing happens to be a child, and if you've decided that you're going to be taking your pictures on location. With the set of pictures featured throughout this section I even managed to add one further unpredictable element, a dog, and so I really had taken on a challenge!

To break the ice at the start of the session you have to take it slowly and be prepared to spend time getting to know your subject. See things from their point of view: to a child particularly as you'll be a stranger and a little frightening as a result, while posing for pictures sounds as though it's going to be boring. You have to be friendly and to try, in a subtle way, to "sell" the idea of the session to them, and to make it sound like fun and something that they can contribute to.

Once things start it invariably gets easier, and the up-side is that children and animals will often react with each other so well that they serve to put each other at ease. You can help things along by varying the location you use and the clothes that the child is wearing.

"Don't talk down to your subject because they happen to be a child. It's important that you make them feel involved and that you listen to what they have to say, and make what you're planning to do sound like fun."

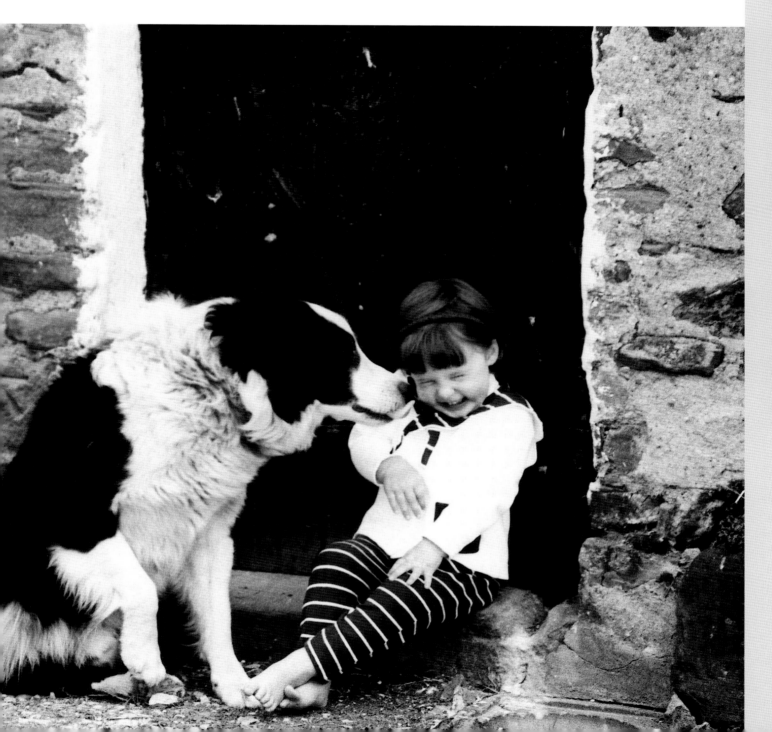

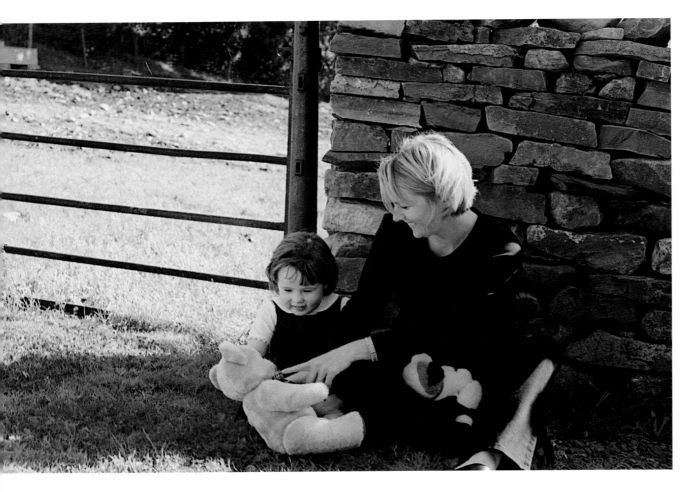

The way you react with a
child within the first five
minutes of meeting them,
will directly affect the
results you will achieve later.
Patience is the key to
getting them on your side.

1 Leave your cameras in the car – meet the family first and allow the child to see you as a person, rather than a photographer.

2 Try not to be too enthusiastic with the child as soon as you meet them. Talk to the parents, and slowly allow the child to become interested in you for themselves. If you try to force things they'll keep their distance.

3 Start to show interest in the child when you feel they are getting used to you, and ask them to show you their favourite toys and clothes. This will make the child feel involved.

4 Sit on the floor so that you come down to the child's level. It's a simple action but one that is incredibly important, and which will make it clear that you're approachable and easy to talk to. You've still not taken a picture: the name of the game is patience.

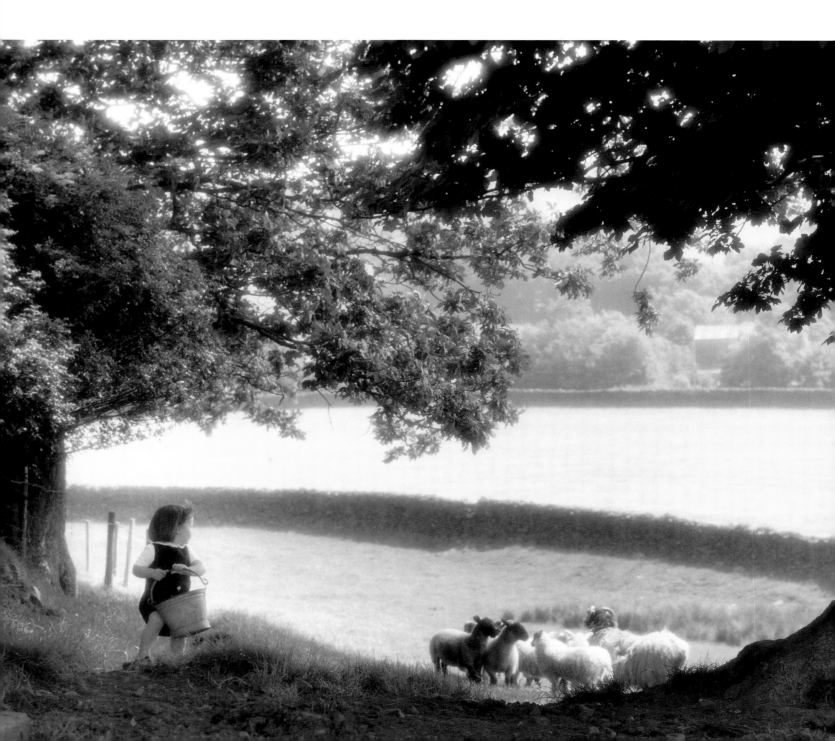

"I believe that pictures should show a time in a child's life: a time that will become even more important in the future, as they grow up."

1 Start by considering the final product and ask yourself some pertinent questions. What do the parents want?

2 Consider what kind of picture your clients are likely to hang on their walls? Will they want something in the upright or vertical format? Do they want a formal or informal approach?

3 Agree on the format. Do your clients prefer colour or black and white, or would they like a mixture?

4 Discuss how important the environment is to the client, and how they want it shown. This little girl lived on a farm and her parents wanted this aspect shown.

This picture showed Rebecca on her family farm, and was deliberately shot in a romantic style to evoke an element of nostalgia. It looks very natural but, as the background pictures opposite show, a lot of effort was spent in getting the sheep into exactly the right position.

Mamiya RZ 67, 150mm soft focus lens, Fujifilm NHG 800. Exposure 1/500sec at f/5.6

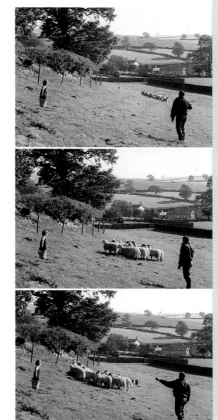

1 Set the scene and allow the child to do whatever they like.

2 Use a hand-held 35mm camera with a zoom lens to give yourself the freedom and flexibility necessary to capture spontaneous, natural shots.

3 Capture pictures which are totally natural and unposed by following your subject around at a distance and shooting with a zoom lens.

4 Shoot black and white film to add a new dimension to your pictures. These pictures were taken at the same time as the picture on the previous page and yet, because I've moved in and shot with a 35mm camera, the feel is quite different.

In colour these pictures would look like snapshots, but in black and white they highlight the child's individual features and add a new dimension to the shoot.

Canon EOS 5, 75–300mm lens, Fujifilm Neopan 1600. Exposure 1/60sec at f/5.6.

1 Vary the location. This helps maintain the interest of the subject as well as giving you the opportunity to try out new ideas and to find fresh angles to explore with your subject.

2 Look close to home and don't discard locations because there are certain aspects of them that don't appeal to you. Choice of camera angle and time of day can transform even the most ordinary setting. The picture here looks like it was taken in a totally rural setting, but it was actually just a few feet away from a busy main road.

3 Complement the location you're using with the clothes your subject is wearing. The two must work together and be in harmony, and together they will serve to inspire you and to give you a theme for your pictures.

Few settings are totally perfect. There's usually something just out of shot to spoil the illusion, such as an electricity pylon or, as here, a busy road, but your choice of camera angle will help you create a scene that looks idyllic. Learn to develop an eye for situations like this, and frame a scene carefully to crop out unwanted details in-camera. Make sure the child's parents are on guard in any potentially dangerous situations for obvious reasons!

Canon EOS 5, 75–300mm zoom, Fujifilm Neopan 1600. Exposure 1/250sec at f/5.6

These results could never have been achieved by "posing" the child. The most effective way to take natural pictures is to compose an attractive scene, ensure that the light will be consistent and allow the child to play.

Canon EOS 5, 75–300mm lens, Fujifilm Neopan 1600. Exposure 1/250 sec at f/5.6

In some ways it sounds strange, but producing a picture to hang on the wall of a room should be done with the same consideration that one might apply to the purchase of a piece of furniture, a concept that's explained in more detail in section 9. It has to fit in with its environment and look right in the place where it's hung: not only the content of the picture but the presentation that's been applied to it have to be in keeping with the surroundings.

The picture here of the little girl was taken against a stone wall, which complements the wall it's been hung on, and it's been presented in a plain wooden frame that perfectly matches the old and rustic feel of the house and its furnishings.

Often my starting point for a picture such as this is the room where it's ultimately due to hang. That way I get an idea of what the client wants and what they're going to be happy with, before a single picture has been taken. It helps to give me a clearer idea of the final result that I should be aiming for.

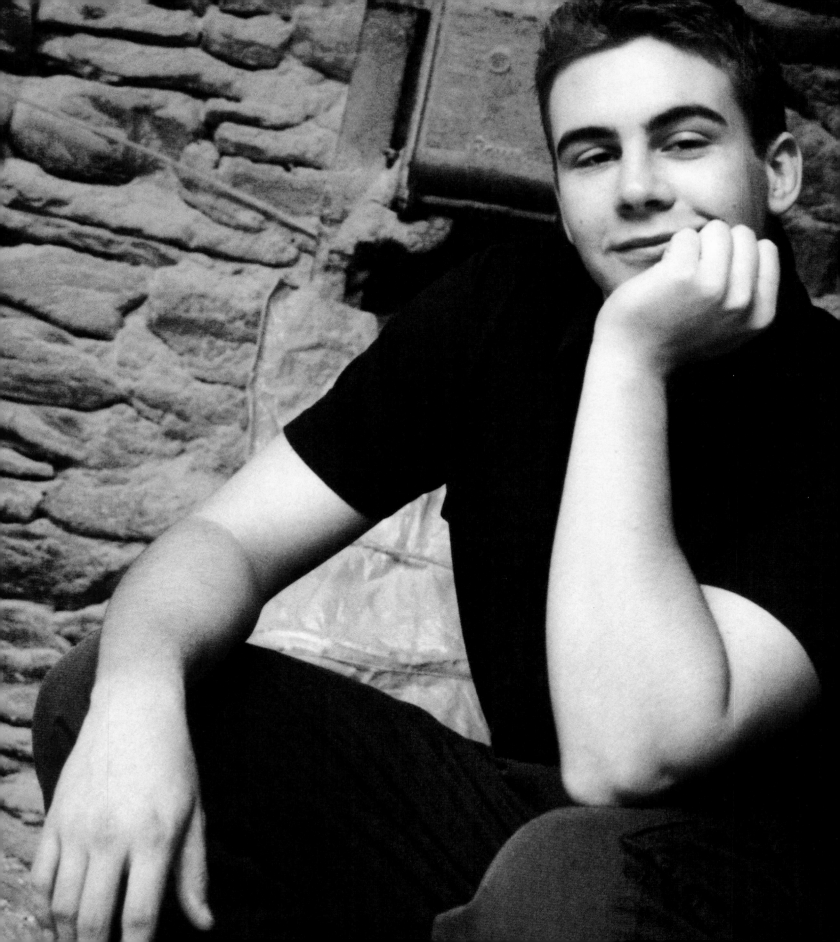

editing and shooting for versatility

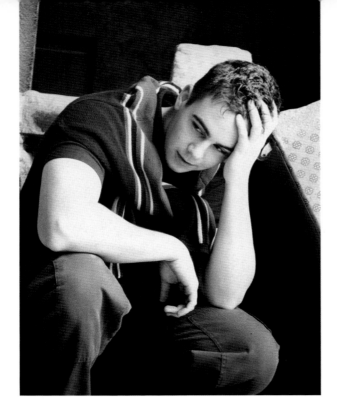

Taking too many pictures using the same set-up, the same lighting and the same clothes will give your client very little in the way of choice, and it will leave you uninspired. Try to achieve a set of pictures full of variety – there are several ways to do this.

You should be looking to work with more than one camera format, because cameras will impose a certain way of working on you and your subject. The formality that a medium-format camera will bring with it may be ideal for some situations, but the flexibility of 35mm will give you an alternative way of working that will be suitable for most people. I find that colour suits the larger format, whereas black and white film is an ideal companion for 35mm, being fast enough to allow hand-held pictures even when I'm using the longer end of my 75–300mm zoom.

I also try to work with available light and – wherever possible – without the encumbrance of reflectors. This gives me the flexibility to move in close, and to change my camera position quickly. I want to capture how people feel, not just the way they look, and the only way to do this is to relax them and work quickly. If they're sitting there waiting for you to get the technical details right, then you'll miss the moment every time.

Changing the look that you're achieving sounds hard to do, but can in fact take a matter of seconds, especially if you're fully prepared and have two different camera formats with you. The picture on the previous page is an establishing shot taken with a medium-format camera, and is a logical starting place for your session. You can move on quickly from here, however, to create looks that are dramatically different, and it may just involve swapping cameras and moving your position a matter of a few yards. With the black and white images I took the opportunity to move closer to my subject, and I added what amounted to a natural prop at one stage by asking him to throw a jumper around his neck. Immediately the feel of the picture was different, and this gave me another angle to explore.

Colour: Hasselblad 6x6cm, 50mm lens, Fujifilm Provia 400, cross-processed. Exposure 1/60sec at f/5.6

Black and white: Canon EOS 5, 75–300mm zoom, Fujifilm Neopan 1600. Exposure 1/250sec at f/5.6

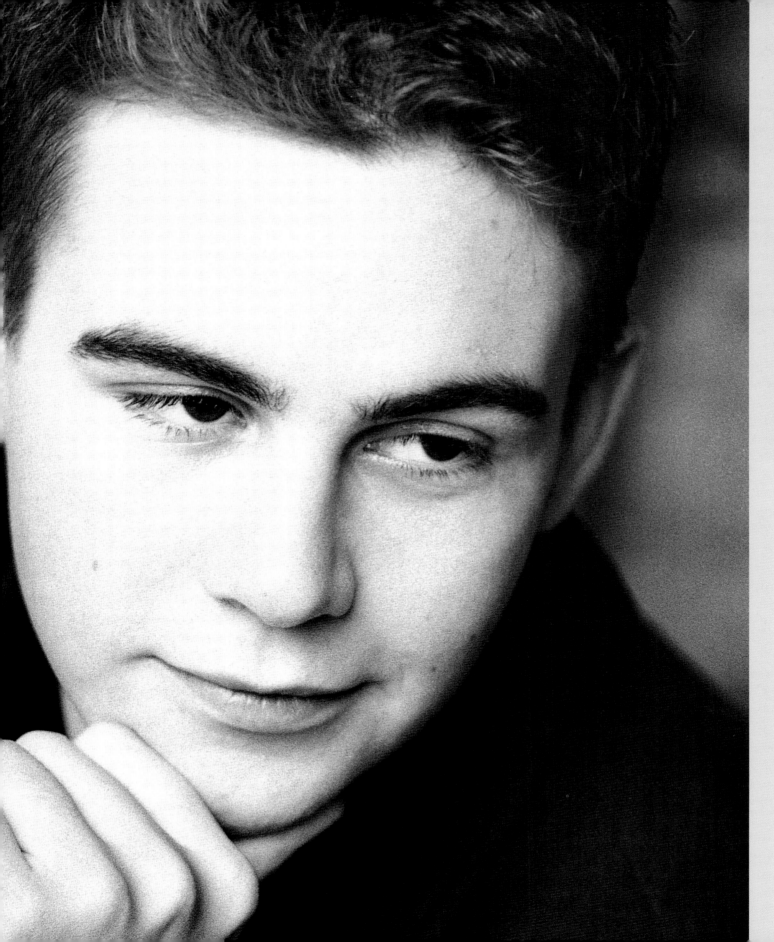

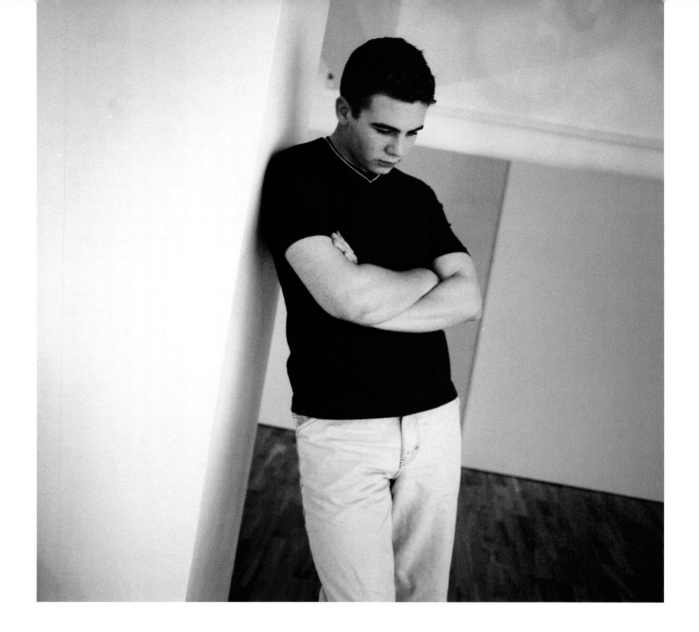

With a little care there's no reason why you shouldn't be able to achieve the crop you want in-camera, which will make subsequent printing more straightforward.

Some medium-format cameras, such as my Mamiya RZ 67, will offer a format that's bigger but still in ratio to that offered by a 35mm camera, and the rectangular format is also popular and very versatile. An alternative, however, is offered by the Hasselblad, which gives a square format. This, too, has its advantages, and will often give a quite different feel to a picture, one that will call for subtle changes to the composition.

Square format

The square format can be seen used in everyday life in a variety of ways: just think CDs and car brochures. It can be seen as quite a formal format, and it does impose a certain way of working compositionally on the photographer, but it still has a lot to offer in terms of striking contemporary photography.

Hasselblad, 120mm lens, softar 1, Fujifilm Provia 400. Exposure 1/8sec at f/5.6

Rectangular format

The chief advantage of the rectangular format is that it allows the photographer to switch from horizontal to vertical format almost instantly. When you're working quickly and trying to produce a variety of pictures from a set situation, this is an extremely useful facility.

Canon EOS 5, 75–300mm zoom, Fujifilm Neopan 1600. Exposure 1/30sec at f/5.6

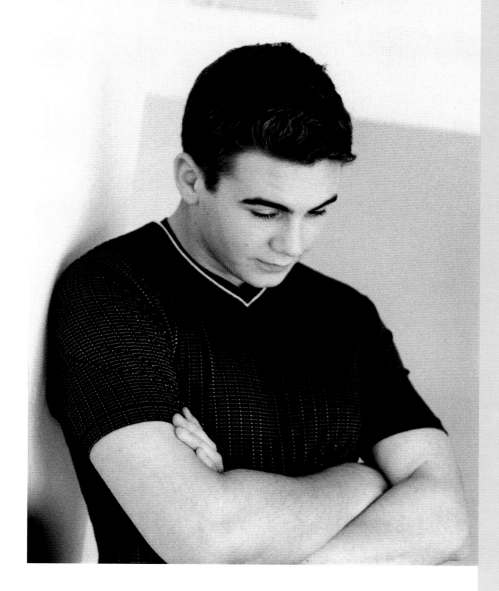

Work with the format that you have, and try to make your decisions about composition at the shooting stage, excluding extraneous detail and concentrating purely on what the important elements are within a picture. Your instinct as a photographer will tell you what looks right through the viewfinder and what doesn't, and you have to learn to work quickly but accurately.

119

As has been shown many times already in this book, tilting the camera is a very simple, but highly effective way of making your pictures more interesting and visually dynamic. The important thing is to make the effect subtle, and to leave the subject looking normal and not as though they're about to fall over. The vertical lines in two of the pictures here make it clear the kind of movement you can get away with: straight lines tend to look too conventional and boring, and the eye loves things that are at an angle. If you get your subject to lean away from the direction you're tilting in – with me I tilt automatically down to the right which makes my subject appear to be leaning towards the left – this will further help to make them look normal within the picture, while everything around them is on the move.

Slanting Angles
The fact that the camera has been tilted is often not apparent immediately, as the emphasis is on the subject. Here he's helped the effect of normality still further by leaning away from the tilt.

High angles
Raising the angle of the
camera considerably is more
flattering for the subject, as
it makes the eyes appear
larger and removes weight
from the jawline.

Zooming in
Picking up a 35mm camera
and cropping in very tightly
again adds a new dimension.

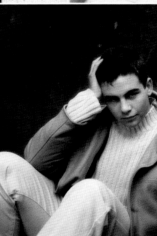
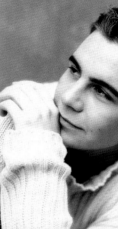

Framed photographs should be seen as furniture for walls, and the same consideration should be given to them as would be when choosing a sofa. It is important that they are framed in a sensitive way, that complements the style of the room and the furnishings within it.

The photographic shoot has been a wonderful experience for the clients, and living with the finished results should add another dimension to that experience. Considerable thought needs to be given to the choice of images and where they will be placed, as well as presentation.

Many people are afraid of selecting a large picture, for fear that it will take over the room, and if it is framed without thought for its surroundings it can indeed be very overpowering. However, if it is framed in a sensitive way, it will actually enhance the room, where a smaller picture might otherwise be lost.

The "driftwood" feel of this hand-made frame complements the natural beige tones of the sofa fabric, while the ceramic flowers complement the terracotta shades of the cushions.

To match the décor perfectly, picture frames can be hand-painted, after selecting colours from the room. This works most successfully if the image itself also includes those colours. In the example, right, the dramatic yellow of Amaia's coat over denim blue has been designed to match the soft blues and yellows of the kitchen. The beauty of photography is that it can be hung anywhere, from the grandest living room to the most humble rooms in the house. People love living with their pictures, and as such, care should be taken to display them in a prominent place – such as the kitchen, as here – where the maximum number of people can enjoy them.

One word of warning, however: colour photographs particularly are susceptible to fading if hung in an area that receives large amounts of direct sunlight, so care should be taken to choose an area that enjoys more subdued lighting. If you hang your picture with this in mind, it should survive to be appreciated for many years.

The kitchen provides the
perfect hanging space for a
picture, as this is often the
room where people spend
most of their time together,
and will therefore get the
most enjoyment from it.

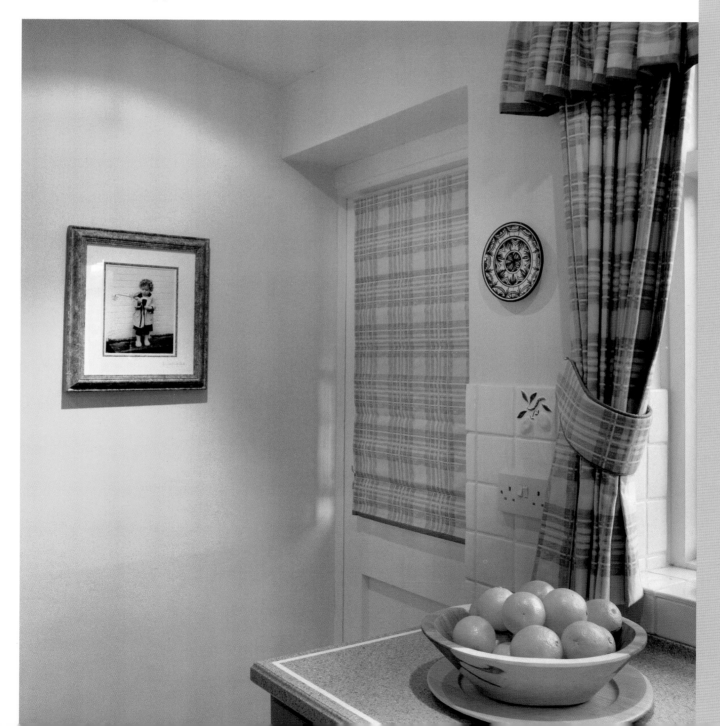

The pale limed-oak frame of this picture has blended with the finish of the desk, and allowed it to become an accessory rather than a feature in the room. Over the fireplace, meanwhile, a multi-frame presentation allows a sequence of images to be displayed.

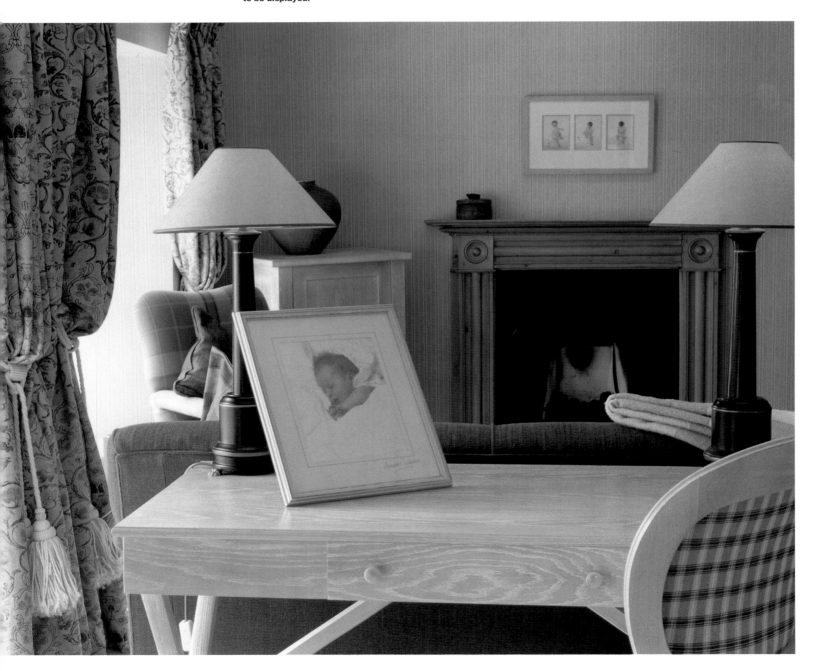

There are many ways to present your images, and sometimes small can be exquisitely beautiful, although if displayed on its own it is possible for a picture to be overwhelmed by its surroundings. In the room, seen left, the client has chosen a sequence of pictures that has been displayed in a multi-frame over the fire surround. This serves as a good compromise between small and large: this way the picture is still prominent, and yet it still has the beauty of a miniature, while the potential is there to run pictures as a sequence.

The picture in the room, right, blends supremely into its surroundings, and is a feature in its own right. This has been done through a warm pine, chosen to match the colour of the wooden fire surround.

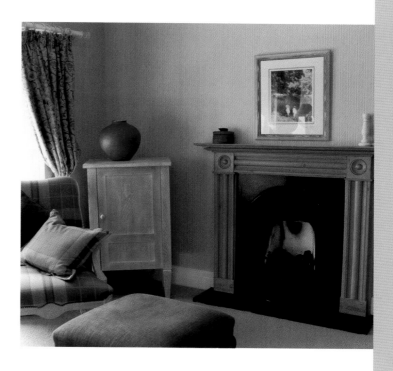

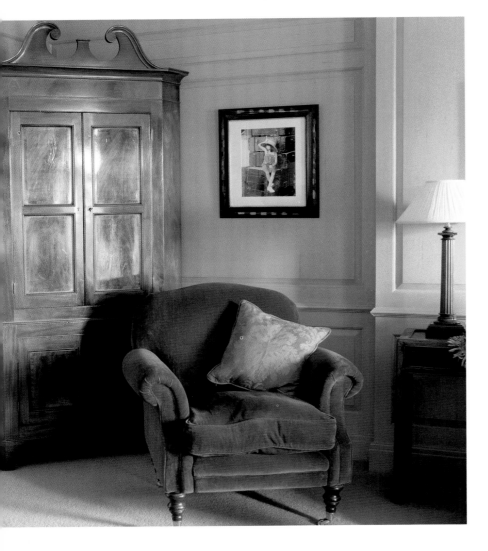

The choice of a contemporary frame, seen on the left, works well with the antique cupboard, as today's interior design tends to lean towards complementary looks rather than exact matches. The dark wood blends with the walnut cupboard, whilst the light touches of paint on the frame reflect the brass lamp and the colour of the walls. The image itself contains lines and rectangles from the boxes, which complement similar lines in the cupboard. Each of these elements works together to ensure the image fits beautifully within the room.

There is so much happening within this room, seen right, in terms of colours and patterns, that the image does not need an elaborate frame. In this case, it is the sepia tones of the print that complement the colours of the wallpaper, while the metal frame allows this relationship to be fully exploited.

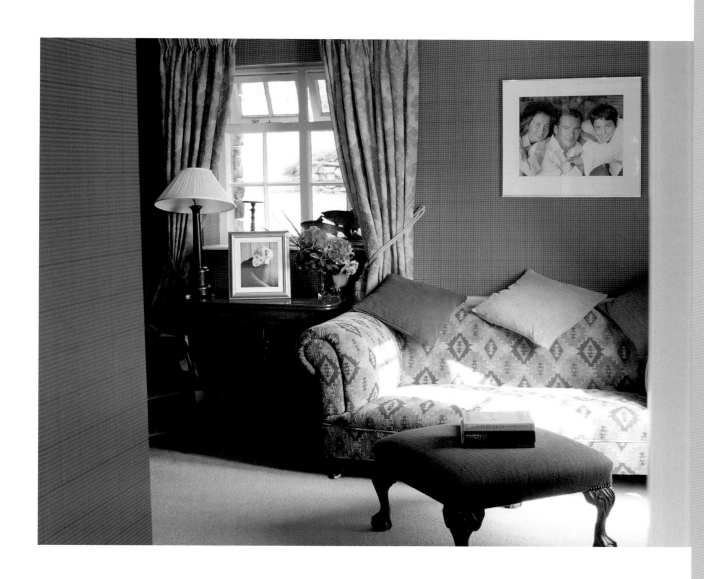

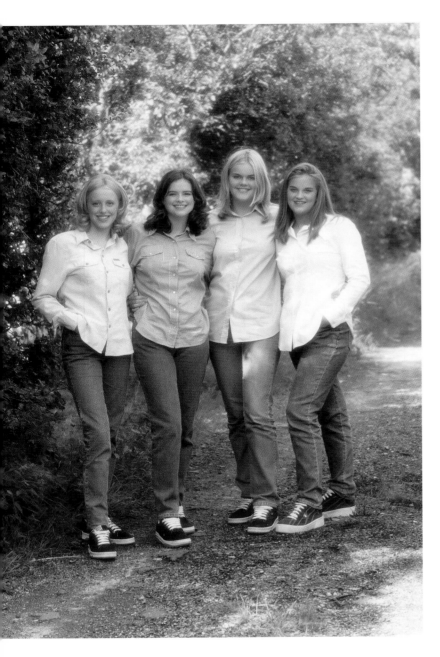

When we are asked to do a family shoot, we need to consider who the pictures are actually for. A family portrait can mean many different things to different people, so while a nice happy smiling picture may suit one member of the family, other members may prefer something more spontaneous.

Historically, many parents tended to choose predominately colour pictures. Today, however, they are veering much more towards black and white, because they have been influenced by the media, and exposed to more variety than their own parents were.

Conversely many grandparents still prefer colour pictures, as when they were young, colour was seen as being exciting and modern, while black and white was looked on as being something that was old-fashioned.

Shooting pictures in a lot of different ways allows plenty of choice for all the family members, but sometimes people will choose a variety of styles because each picture has its own meaning for them.

In the case of the images here, the parents would probably choose all three of these pictures, as they would all appeal in different ways.

This picture would appeal to the parents because they can see their children's faces close up. The black and white film enhances the details which all parents love about their own children, i.e. the shape of their eyes, their freckles, etc.

Canon EOS 5, 75–300mm zoom, Fujifilm Neopan 1600. Exposure 1/1000sec at f/5.6

The interaction between the girls makes this picture appealing as parents love to see their children all getting on happily together – whether or not this is usually the case!

Canon EOS 5, 75–300mm zoom, Fujifilm Neopan 1600. Exposure 1/1000sec at f/5.6

In my experience most women, if photographed on their own, like to see themselves in a picture that looks as if it wasn't posed. They like to be looking off camera, and often prefer themselves not smiling, something they consider looks more natural. It's important that you shoot some pictures that fit this brief, but also try to shoot a few where the woman is looking into the camera, because men will often have a preference for a more direct pose like this.

Strangely enough, women too will prefer an image of their partner where he's looking directly at them. The picture that starts this section is the one that I produced for this couple, and it was an extremely successful image.

These two pictures would appeal in a variety of ways. The colour shot is more likely to be chosen by the couple's parents who are of the generation that prefer the realism of colour. The black and white shot would suit the couple's children, who would prefer the more contemporary lifestyle feel of this image.

Top: Canon EOS 5, 75–300mm zoom, Fujifilm Neopan 1600. Exposure 1/500sec at f/5.6

Left: Mamiya RZ 67, 150mm soft focus lens, Fujifilm NHG 800. Exposure 1/250sec at f/5.6

When photographed on their own, women often prefer to look away from the camera, and smiles tend to be natural and unforced. This picture would have great appeal to the subject, although you should try to shoot some extra pictures for her husband, where she looks towards the camera.

Right: Canon EOS 5, 75–300mm zoom, Fujifilm Neopan 1600. Exposure 1/500sec at f/5.6

When the family includes teenagers, it is vital to consider their needs, as unlike little children, they are old enough to make decisions about the way they want to look.

If they are unhappy with the way they look in the photographs this will definitely influence their parents when selecting photographs, as they will not allow their parents to put their pictures on the wall! This is an important consideration, and so you should be careful that you're working with your subjects and that you always have their requirements firmly in mind. Allow them to be themselves as much as possible: they should select their clothes, for example, so that they are happy with the way that they look in front of the camera.

Teenagers like to look sophisticated and up to date. Allowing them to wear the clothes they want, and considering their individuality will satisfy their needs and make everyone happy.

Facing page: Canon EOS 5, 75–300mm zoom, Fujifilm Neopan 1600. Exposure 1/1000sec f/5.6

This page: Mamiya RZ 67, 150mm soft focus lens, Fujifilm Provia 400, cross-processed. Exposure 1/500sec at f5.6

The girls' own choice of pictures will be more sophisticated, and will make them appear grown up.

Even though I am usually asked to photograph all the children together, I always photograph them individually as well. More often than not, when viewing the pictures, the subjects like different group shots depending on how they look in them, regardless of what their siblings look like. However, when photographed individually, you have the chance to make each person fulfil their own potential, and therefore please everyone.

Just as the girls' mother will prefer different pictures of herself from those her parents would choose, so will her daughters.

It takes a lot of time and effort to ensure that everyone is thrilled with their pictures.

The parents, however, will choose the pictures where they look young, happy and natural.

Take your time to get to know your clients, who they are, what they want, and how they feel. Learn to listen to them and interpret what they say into pictures that suit their individual needs. Above all else enjoy it – because if you do, they will too – and the essence of good photography is being able to relax with people and experience a time in their lives which will mean something to them forever.

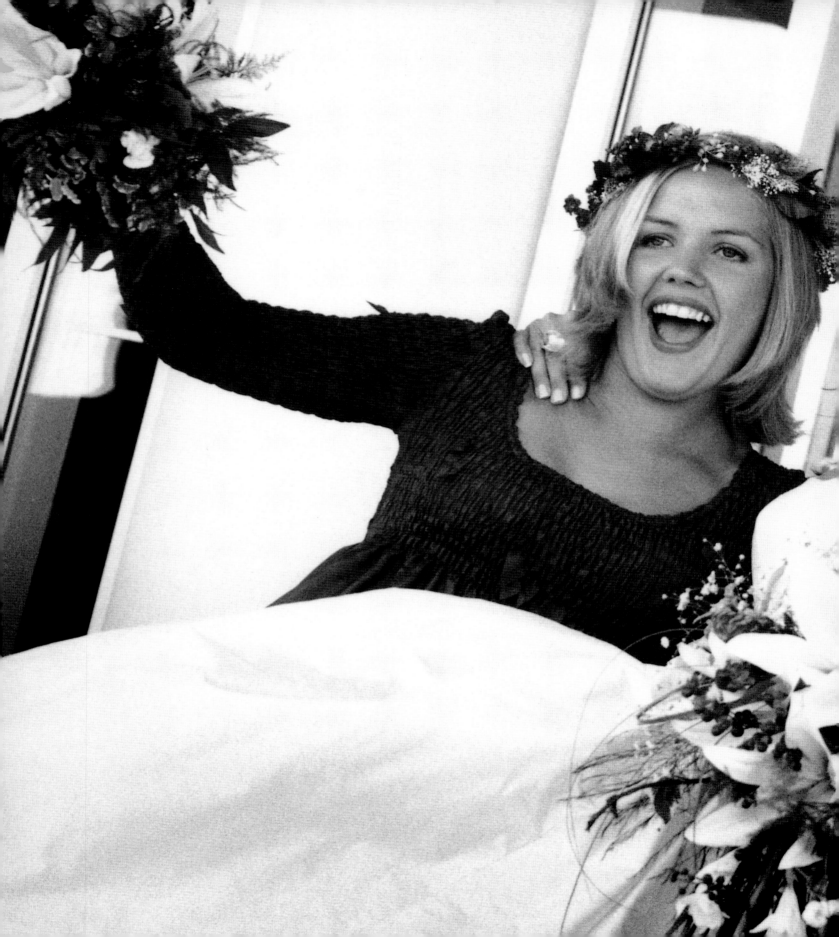

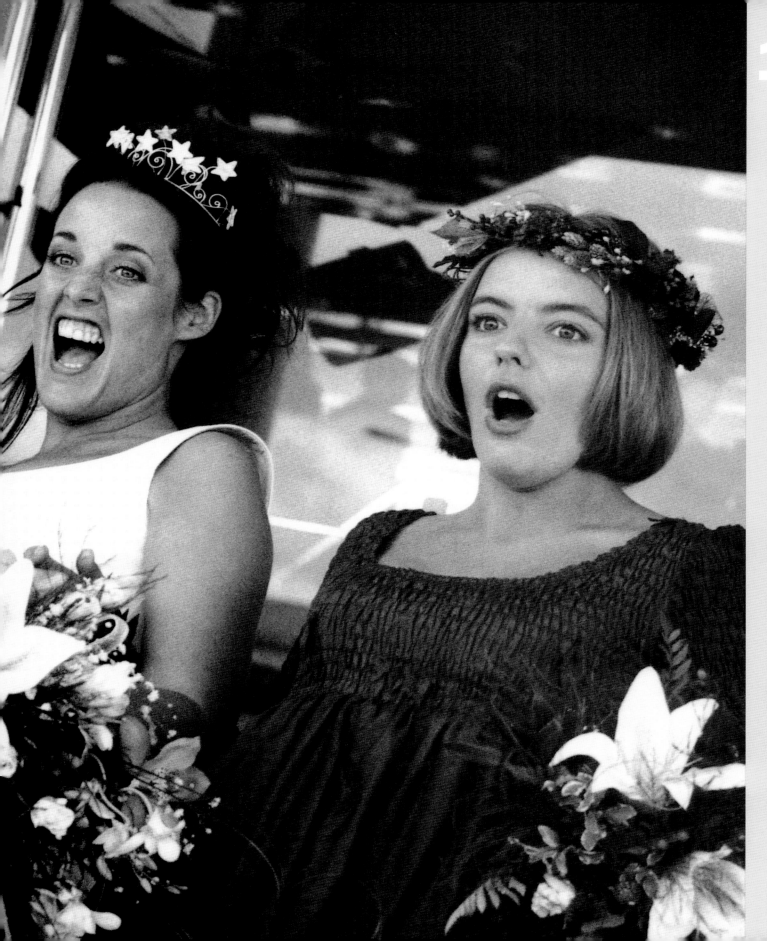

The images below are a more contemporary version of the 'church door' shot, and demonstrate how traditional and contemporary images can work successfully together.

Canon EOS 5, 75–300mm lens, Fujifilm Neopan 1600. Exposure 1/250sec at f/5.6

The traditional shot opposite of the couple in the church doorway is still very popular, and usually expected by both the couple and their parents.

Mamiya 645, zoom lens, Fujifilm NHG 800. Exposure 1/250sec at f/5.6

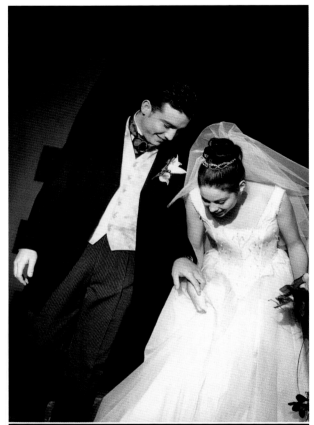

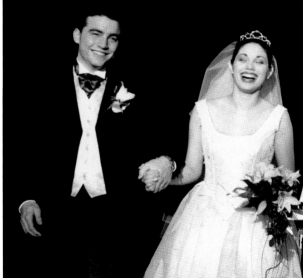

The wedding day is a landmark occasion in a person's life. This means that you have a responsibility to treat every wedding that you photograph as if it were the most important event of the year because, to the bride and groom, that's exactly what it is. They may have spent months or even years preparing for this moment, and it's up to you to complement their big occasion.

Today's wedding pictures should be a complete record of the event, and should have the feel of a storybook, rather than the appearance of something that has been stage-managed. Every picture taken on the day should, if possible, have a relaxed, natural and spontaneous feel about it, because today's clients are no longer prepared to pose statue-like for pictures. The main requirement for the modern couple is for a fun and honest record of the day as it really was, and the old principle of setting everything up for the benefit of the camera is now largely outdated. Be aware, however, that even for a photographer working in the contemporary style it is still important to include some of the more traditional images as many people still expect this, and the ratio of traditional and candid images is usually dictated through an assessment of the client's individual needs. Check carefully beforehand to make sure that you achieve the right mix of both in the portfolio that you ultimately deliver.

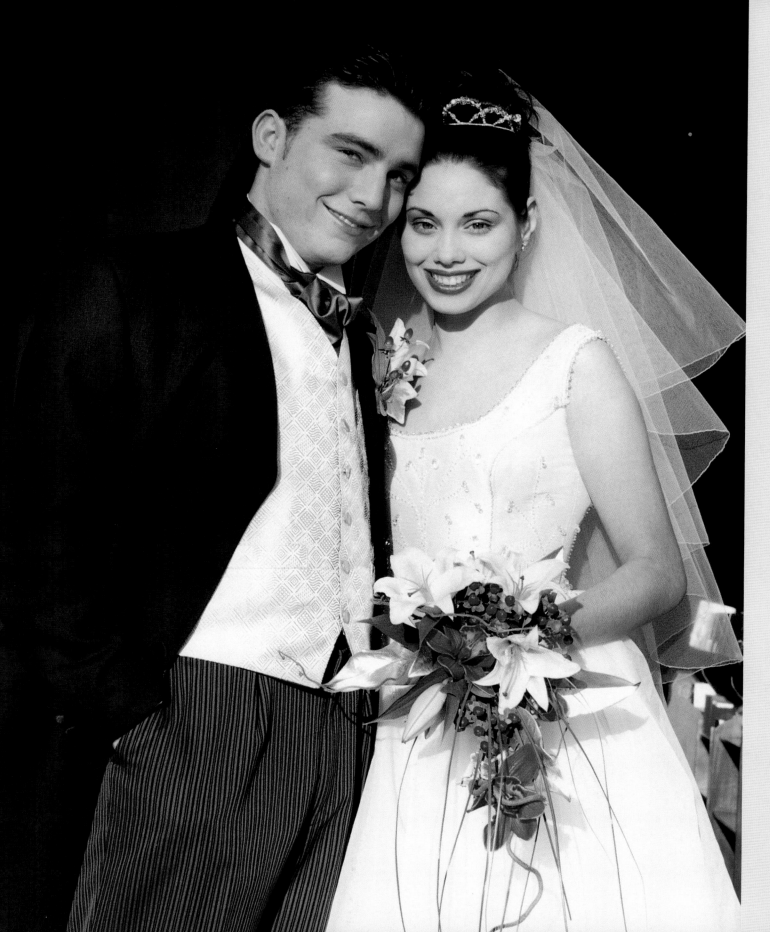

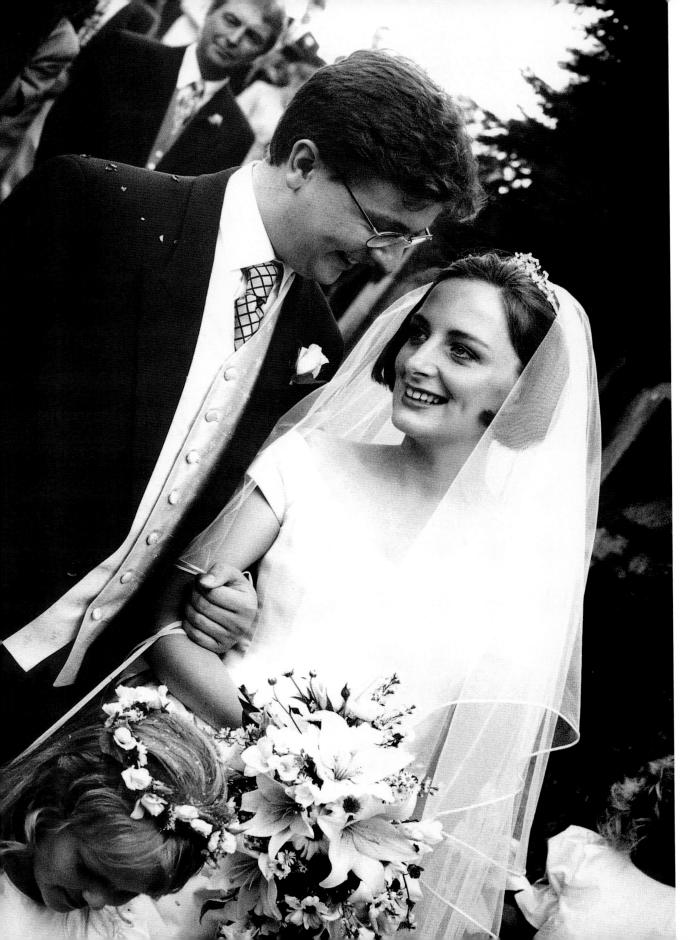

Formal pictures are a thing of the past – today's brides want to capture the fun and spontaneity of the day.

In years gone by the wedding photographer's job was to make a record of everyone in their finery and the requirement was often for pictures that appeared very set and formal. Today's lifestyle, however, is a far cry from the Victorian era during which this tradition started, but it has taken a long time for wedding photography to actually evolve to where it is now.

For many brides their perception of a wedding photographer is of someone who will take them away from their friends and family for hours to set up pictures that they don't really want anyway. Those who can challenge this way of doing things, and who can capture the spirit of the day through their pictures while interfering as little as possible, are the ones who find themselves in the most demand these days.

Wedding etiquette has changed dramatically over the years. Very rarely is a wedding a grand, formal affair – nowadays it is more of a celebration and a party. Contemporary wedding photography is about capturing the feeling and emotion of the day. People want to enjoy their day with as little interruption and stage management as possible. The pictures need to be realistic and the couple need to feel comfortable while they are being photographed. Gone are the days of holding static poses against the church doors: today's couples want their pictures to be natural, relaxed and spontaneous.

Your job is to get the best out of people, and if you can strike up a friendship with the couple you become a seamless part of their wedding, and people can relax and be themselves resulting in natural and spontaneous images.

Shooting candid pictures is about understanding people. It is not sufficient just to take snapshots: your work may feature a relaxed style, but it will still have to be of a high standard and composed beautifully if the pictures you produce are to look professional. The best results are achieved if you spend the necessary time developing a relationship with your clients before the wedding, so that you become their friend on the big day, and not an enemy who is hounding them through your camera. Your job is to get the best out of people, and if you can strike up a friendship with the couple you become a seamless part of their wedding, and people can relax and be themselves, resulting in natural and spontaneous images. If people feel tense and nervous, it will be very difficult to get them to do what you want.

You have to master the art of getting co-operation from your subjects – moving them into a shaded area, for example, so that the light is less harsh – without making it look as if you are controlling their every move. The only way this can be done is if you can win their trust, and the best way that you can do this is to cause as little interruption throughout the day as possible. When the client understands that you work quickly and efficiently, and yet still are capable of getting great results, you will find that they are happy to give you the freedom to do it your way.

These are not the kind of moments that occur naturally, but if the photographer can win the trust of the bride and groom then they will enjoy playing their part in photographs such as this, and will see it as something that's fun rather than embarrassing.

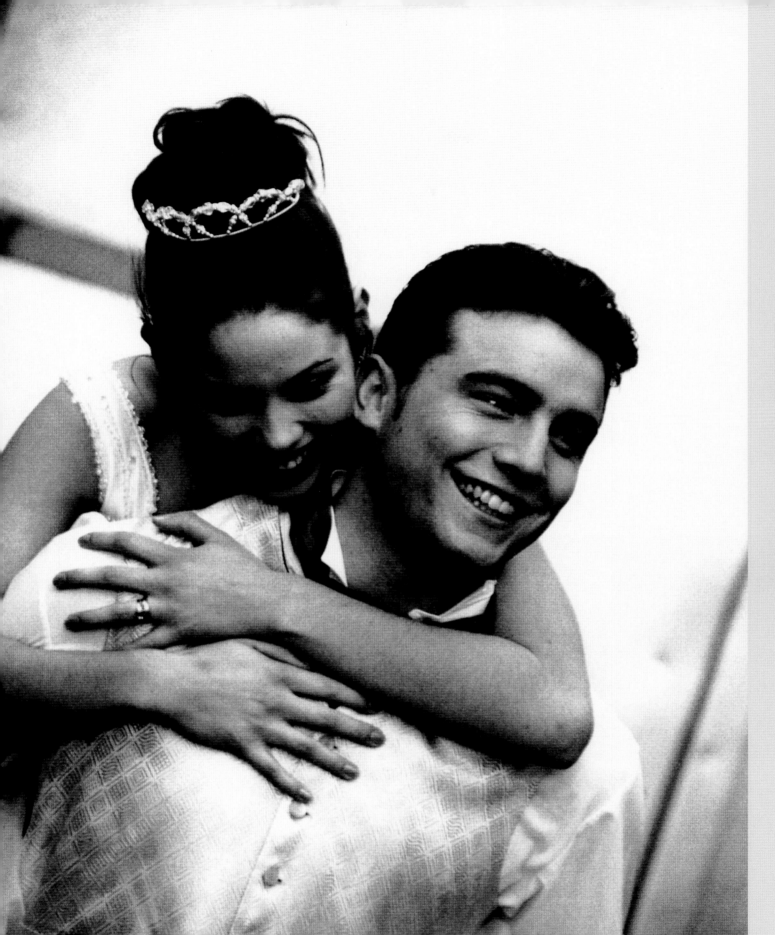

The planning and organisation that goes into most weddings is immense, with a wide range of people alongside the bride and groom getting involved and putting in an enormous amount of work to make the day as perfect as it can be. The wedding photographer has a duty to put just as much effort into making sure that everything runs smoothly from their end, because their pictures will ultimately be the only complete record of everything that happened. In my experience, photographs can make or break a wedding day.

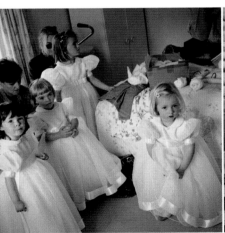
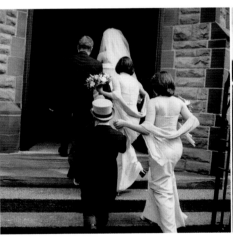
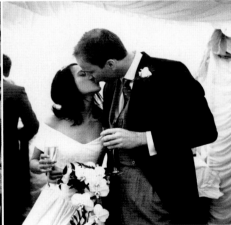

Wedding photography should capture the atmosphere of the whole day, from the last minute preparations on the morning through to the emotion and happiness of the service itself and finally the celebrations as the reception gives way to a party.

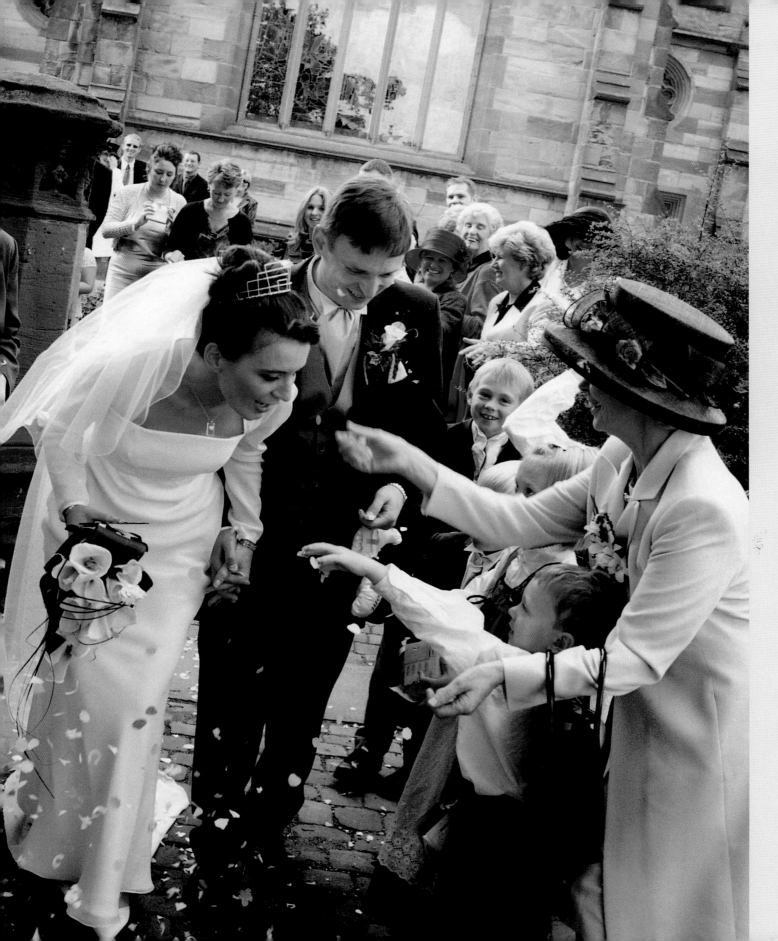

I consider it a great privilege to be able to photograph someone's wedding, because it can be one of the most inspiring, motivating and creative assignments that a photographer can have. Whether you see it like this, however, depends on whether you consider that it's nothing more than just another job, or whether you're determined to accept the challenge and to produce the very best results that you can from the occasion.

On the wedding day itself you'll find that so much is happening, and so quickly, that the only way you'll be able to cope is through careful planning well beforehand. Get this part right, however, and you'll find that you can really enjoy the day yourself, and if this happens it will show, and you'll find that those you are photographing will naturally respond to your enthusiasm.

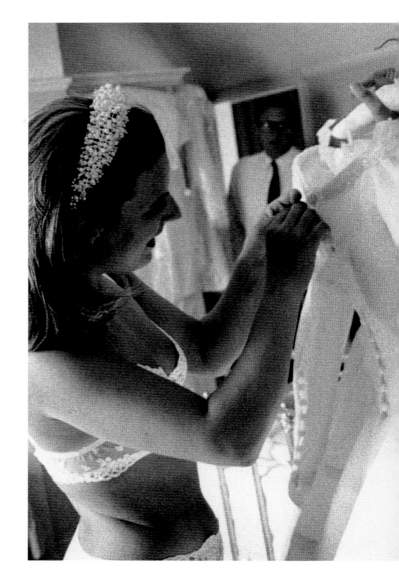

Shooting those early morning preparations at the bride's house is an essential part of your coverage, and these pictures help to build the story and to capture the growing anticipation.

Canon EOS 5, 75–300mm lens, Fujifilm Neopan 1600. Exposure 1/30sec at f/5.6

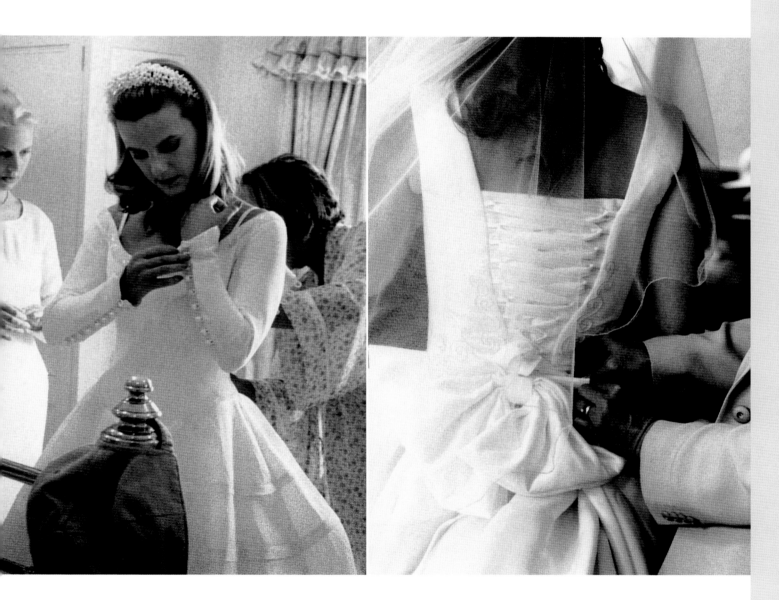

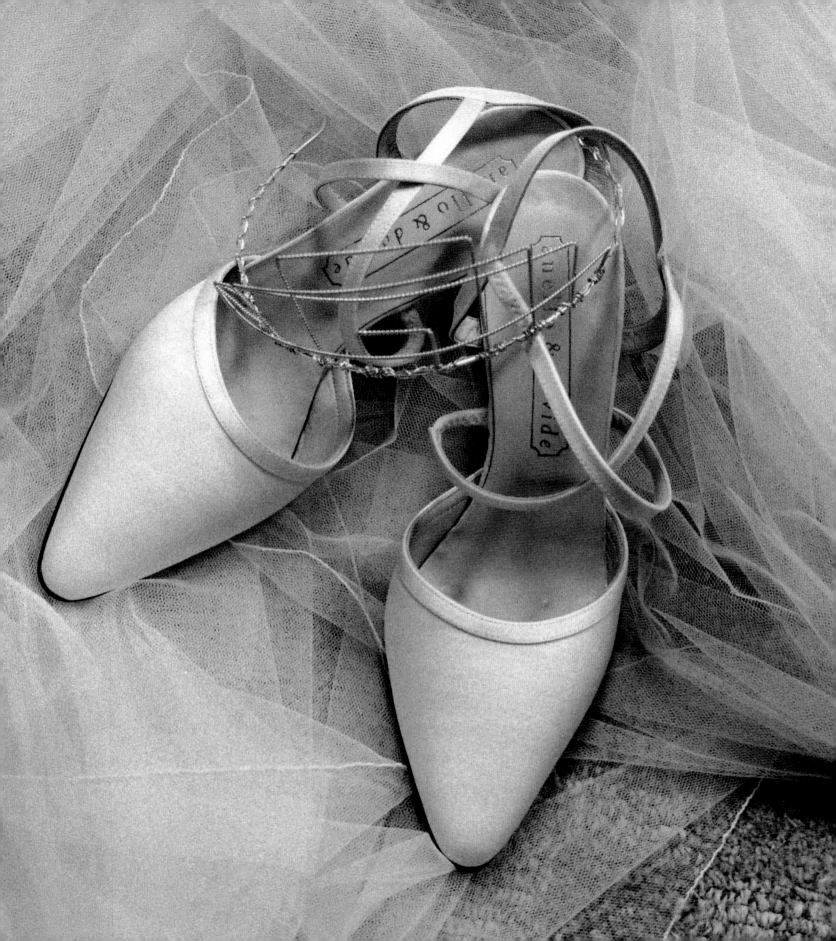

Wedding photography is not just about people, it's about capturing the detail. Every bride will have spent a great deal of time making sure that everything is right for her big day, and taking pictures of the back of her dress, the bridesmaids' shoes, the flowers and the cake will help you to produce a document that sets the scene and captures the atmosphere of the whole day.

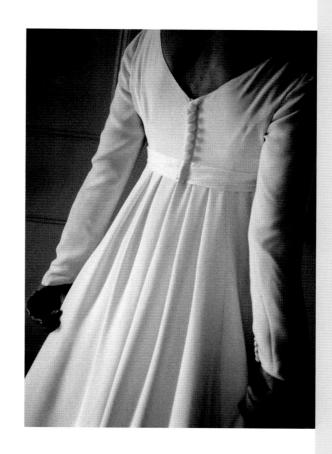

The bride will have chosen what she wears because she loves every little detail. Therefore it is important to photograph her shoes, tiara and dress before the actual wedding as you cannot be sure to get these pictures later.

Canon EOS 5, 75–300mm lens, Fujifilm Neopan 1600. Exposure 1/15sec at f/5.6

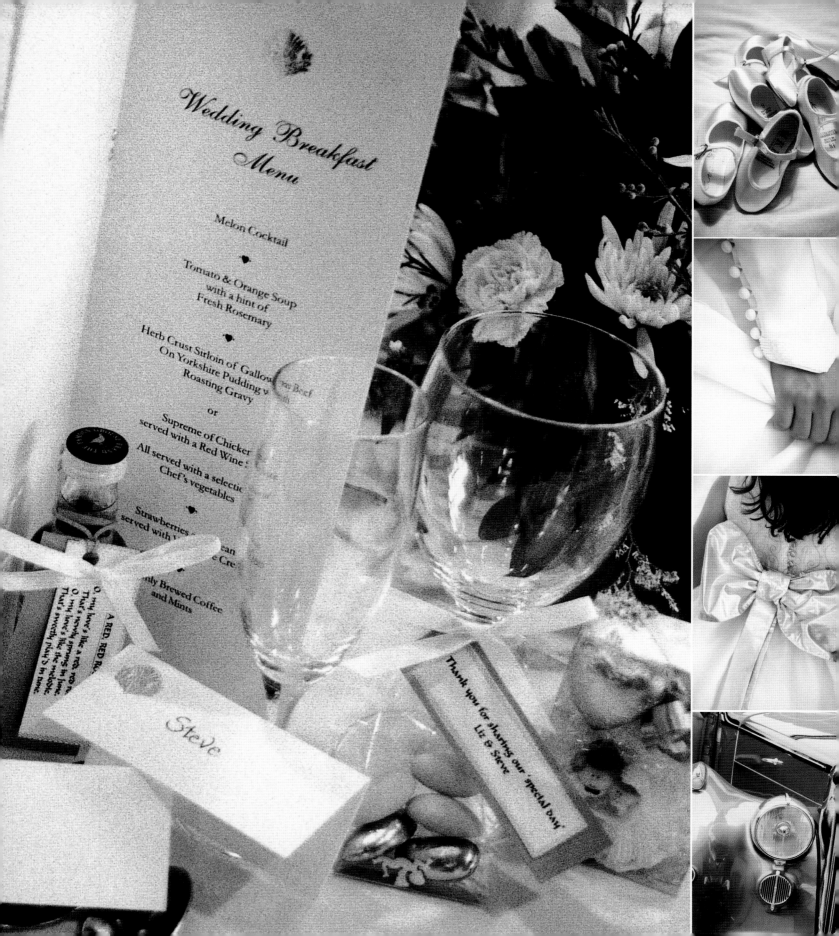

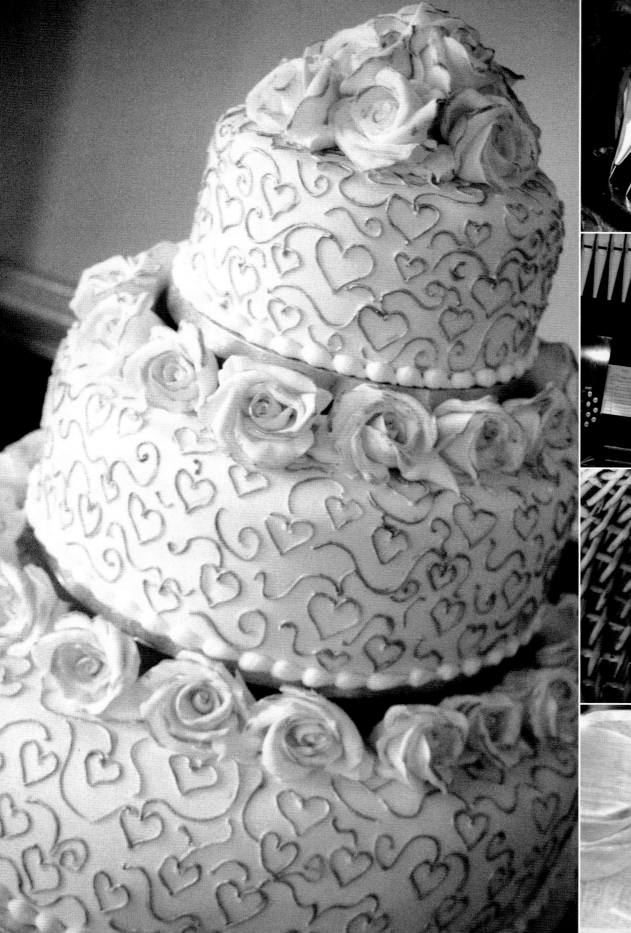

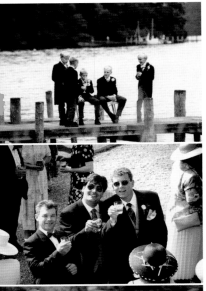

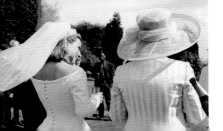

Creating candid pictures of wedding guests involves understanding people, and developing a subtle approach. Imagine if you were on location shooting grizzly bears! You couldn't just walk up to them and expect to get a good photo – you'd be more likely to get your head bitten off! If you're going to photograph people at a wedding you can't just impose yourself on them, you need to be able to relate to how they will be feeling on the day, and then act with appropriate sensitivity.

It's all about developing a relationship with your clients, so that they feel happy and comfortable with you.

It's a natural reaction to be guarded about looking at a camera – most people have usually had so many bad experiences that they tend to assume they will look awful in a photograph. Just watch the reaction of most guests once a video camera appears; everyone automatically turns the other way or ducks underneath it whenever it points in their direction. It is the same with a stills camera, and you have to act tactfully and discreetly so that people don't feel that you are intruding on, or invading, their space. This is why it is vital to do your preparation, and to build a rapport with the bride and groom before the wedding day.

In order to capture spontaneous moments like these, the photographer should be as unobtrusive as possible, so that people become oblivious to the camera.

If you're going to photograph people at a wedding you can't just impose yourself on them, you need to be able to relate to how they will be feeling on the day, and then act with appropriate sensitivity.

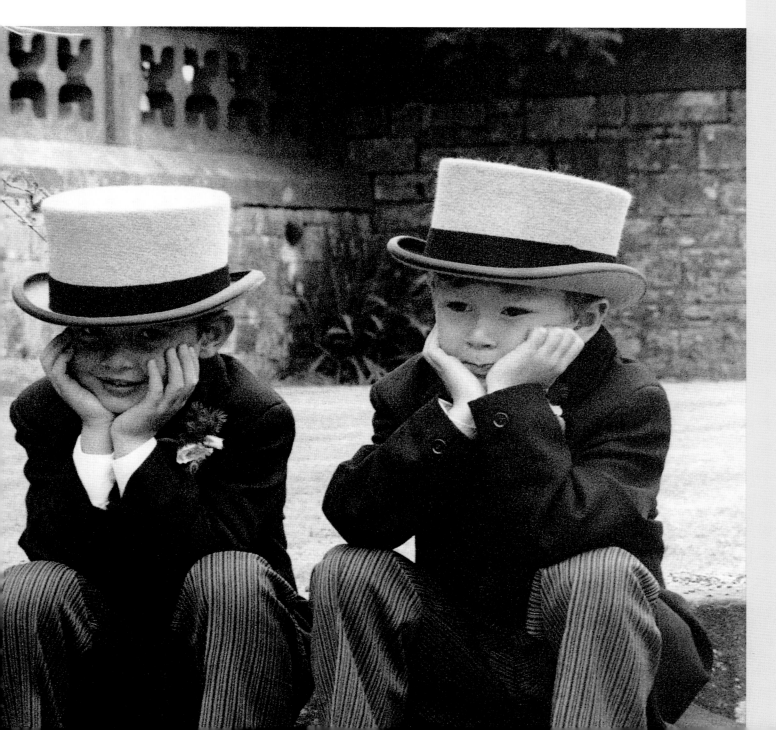

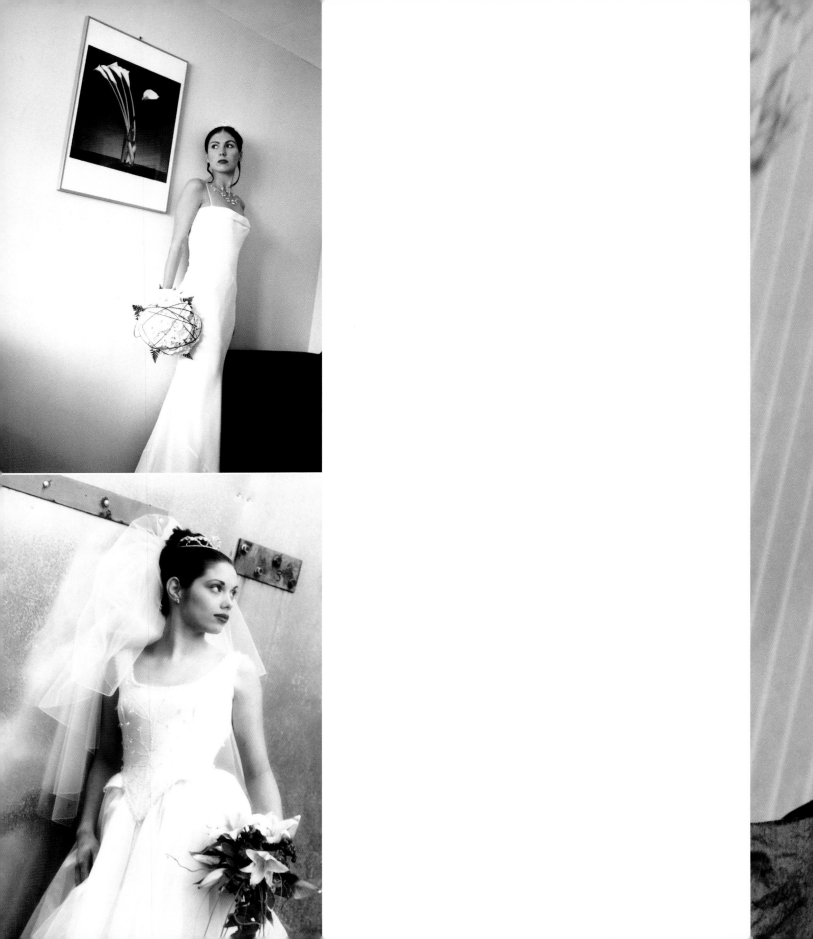

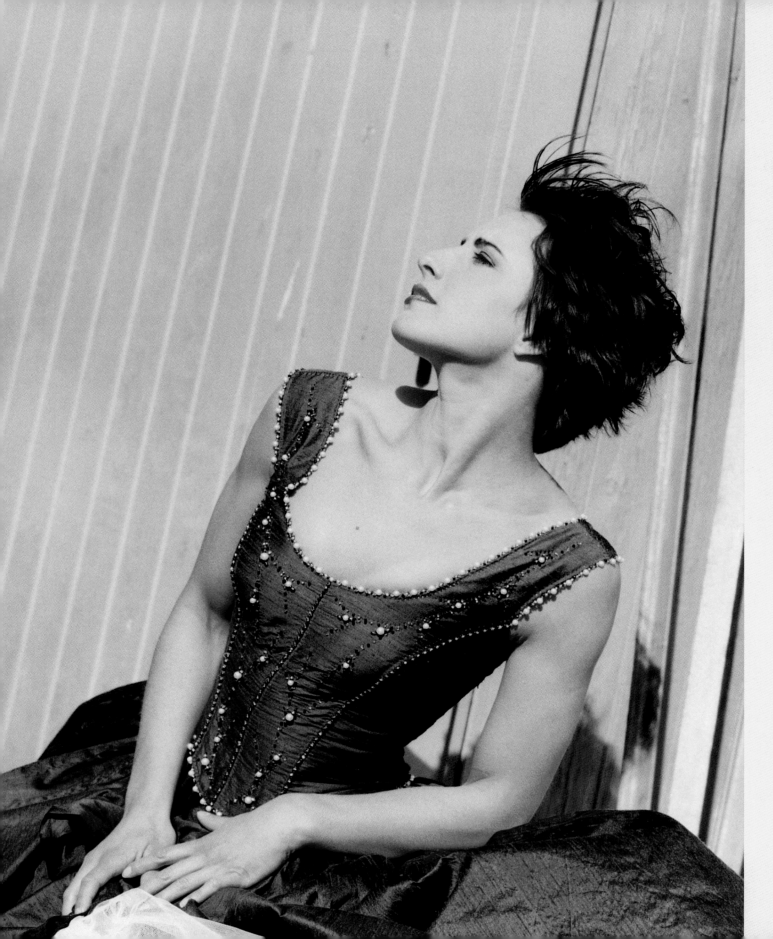

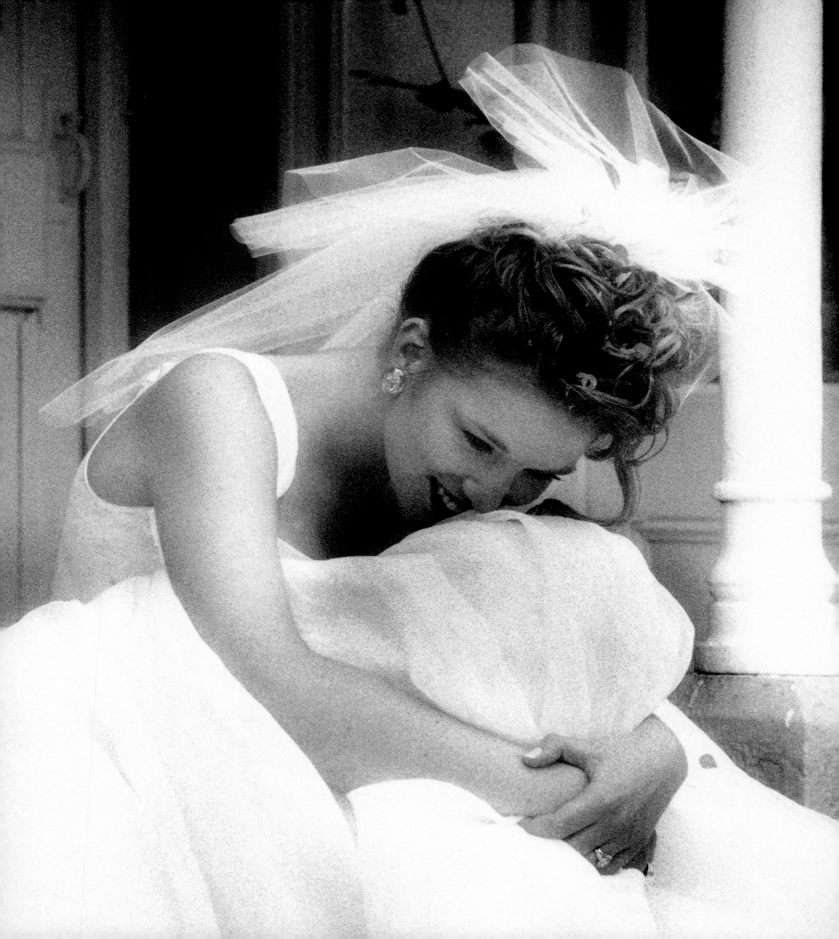

The key to successful wedding photography is the ability to capture how the bride feels as well as how she looks.

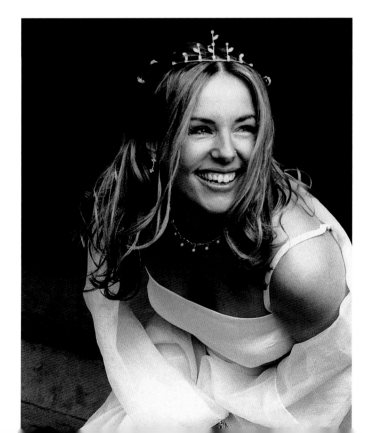

Pictures like this can be achieved at the reception when the bride will be relaxed after the anxiety of the church ceremony is over. This shot is part of a series of more composed shots and just happened as the bride reacted to the occasion. Using a 35mm camera with its automatic metering means the photographer is always able to take a spontaneous shot as it happens.

Canon EOS 5, 75–300mm lens, Fujifilm Neopan 1600. Exposure 1/125sec at f/5.6

To ensure they get the best possible results from their wedding day you need to develop a relationship with your clients long before the actual event. The ideal way to do this is to spend time getting to know them by offering a pre-wedding shoot.

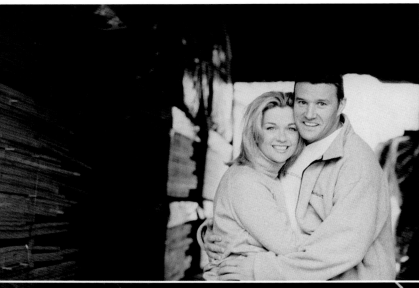

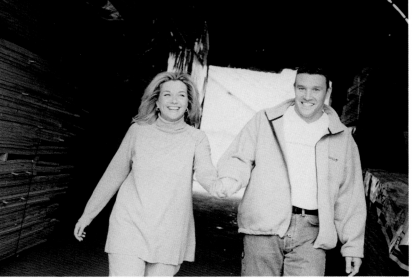

During your pre-wedding shoot the couple will learn to relax in front of the camera and to trust you.

Canon EOS 5, 75–300mm lens, Fujifilm Neopan 1600. Exposure 1/500sec at f/5.6

The pre-wedding shoot helps to:

Develop the relationship between the bride and groom and the photographer

Demonstrate how much fun it can be being photographed

Inspire confidence in you and your ability

Build trust enabling them to relax and not worry about having their photographs taken

Gain an understanding of your photographic style

Introduce new ideas of presentation in albums and frames

Provide an opportunity to experiment with hair and make-up ideas

Create an awareness of the variety and number of pictures that are likely to be produced on the wedding day

Build your reputation with their family and friends before the wedding thus ensuring that everyone will enjoy your company

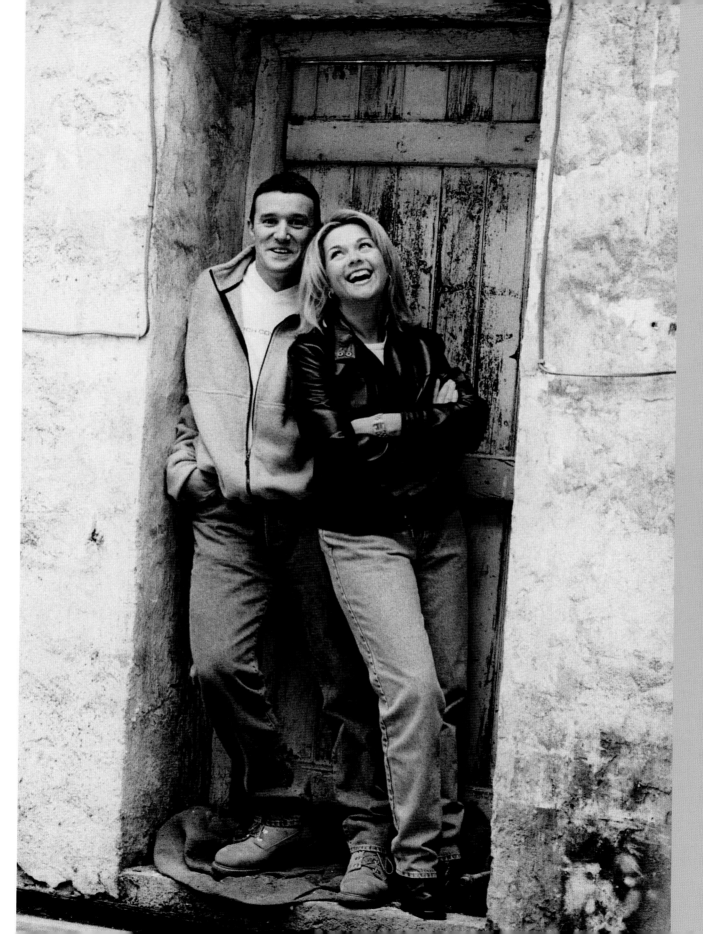

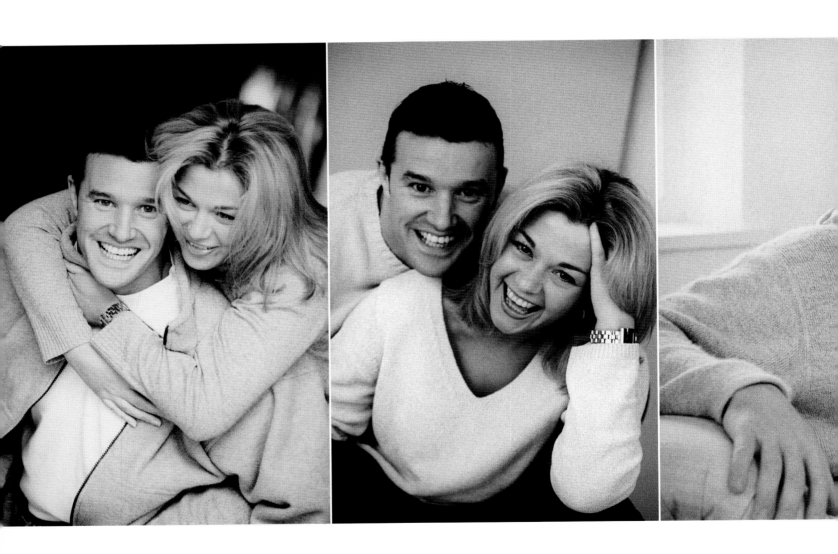

Try to take a variety of pictures that are spontaneous and sum up the intimacy between the couple.

Canon EOS 5, 75–300mm lens, Fujifilm Neopan 1600. Exposure 1/30sec at f/5.6

The idea of the pre-wedding shoot is to take pictures which show the relationship between the couple. The pictures should show them being close, happy, laughing and having fun.

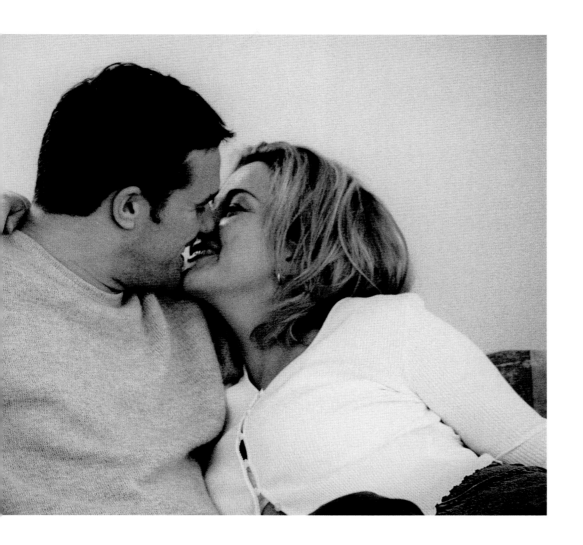

Most couples love black and white pictures which look candid and editorial, but don't forget to include some colour pictures as their parents will probably welcome the opportunity to have a picture of their child before they leave the nest!

An immense amount of planning goes into every wedding day and it is crucial that you are totally prepared so that you know exactly what is happening throughout the whole day, and are covered for every eventuality.

The only way your pictures can be relaxed, spontaneous and natural is if you are so well prepared before the wedding that on the actual day you can virtually just record what is happening and be relaxed enough to be ready for any unexpected fun shots that may happen.

It is essential to discuss all the details with the couple when they first book and again just prior to the wedding to check any changes.

What you need to know:

- **Is it a church or a civil ceremony?**

- **What religion or cultural background does the couple come from?**

- **Where will the bride be leaving from on the morning? Will it be from her home, her parents' home, or a hotel?**

- **How long will it take to get from the bride's home to the church?**

- **How long is the service likely to last?**

- **How long will it take to get from the church to the reception?**

- **What time is the meal being served?**

- **How many guests will there be?**

- **How many bridesmaids/ushers/best men?**

Tip:
It is also useful to find out whether the couple are having a video taken, and who is shooting it, as you may need to contact them beforehand simply to discuss arrangements and make sure that you both get what you want without getting in each other's way.

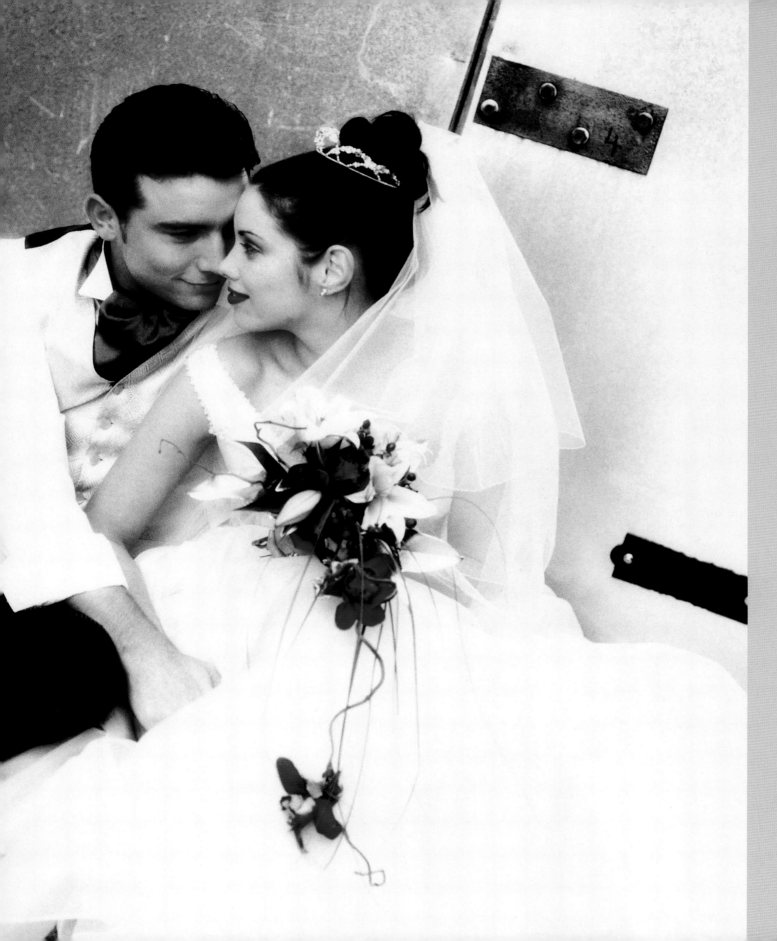

I usually enlist the help of my assistant
and the best man or ushers to locate
the people I need, and I can then set up
the groups with the minimum of
disturbance to the party.

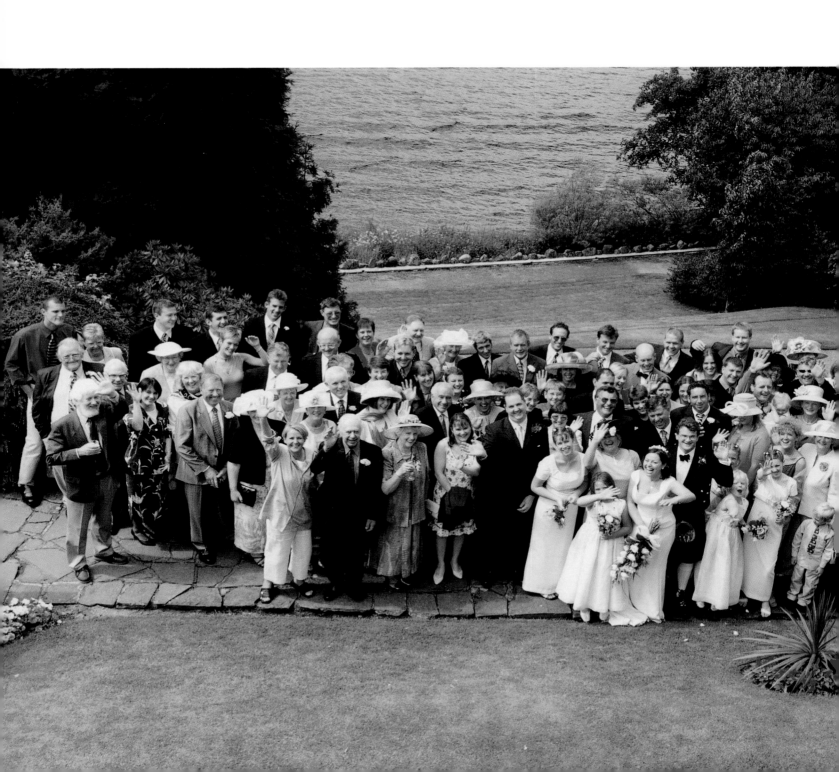

Although many weddings follow a similar pattern, each one will have its own individuality. This is particularly relevant where relationships are concerned. It is essential that you know who the key members of both families are.

It is vital at this stage to discuss group photographs with the couple so that they understand that if they require every relative photographing it will take ages and they are very unlikely to want to be held up with masses of groups on the wedding day. Many clients do not realise that it takes a long time to set up different combinations of groups and can be very boring for all the other guests.

I usually suggest that we only photograph immediate family and that it will take only 5–10 minutes to do this. I explain that if we photograph all the aunts, uncles, cousins etc it will take much longer, and most people do not like standing around. I usually solve the problem by suggesting we do one big group of everyone at the reception, and that I will be taking candid shots of most people anyway while they are otherwise occupied.

Putting all the guests together on one picture ensures everyone appears in a photograph and is much easier and quicker than taking lots of different combinations of groups.

The bride and groom often want pictures of themselves with their close friends and I find it is easier not to do these straight after the family groups, but to split them up and to do them later when everyone has had a drink and is relaxing.

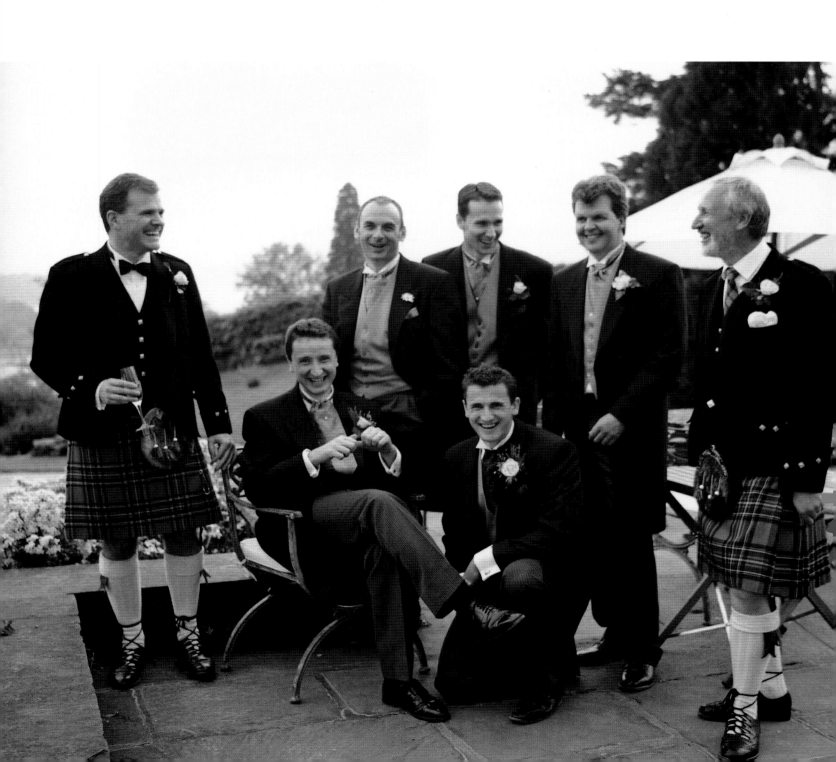

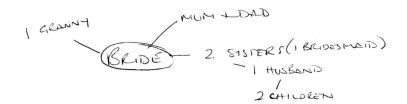

1 GRANNY

MUM & DAD

BRIDE — 2. SISTERS (1 BRIDESMAID)

1 HUSBAND

2 CHILDREN

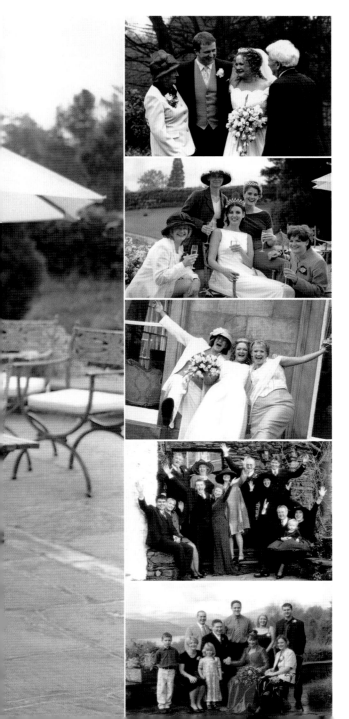

Today's couples often prefer candid photos to formal groups, but recognise that their parents like to have a record of their family on the day.

To keep the groups to a minimum I usually do just one group photo of each family, unless the bride and groom request them to be divided.

Possible problems:

Problems may occur when the couple have divorced or separated parents. Today, many couples have stepsisters and stepbrothers, and the variations can be amazing!

It is essential that you discuss these issues with the couple to avoid embarrassment on the day, as some parents will refuse to be in the same group as their ex! The couple will probably not have thought of the potential problems, and will be grateful that you have given them the chance to speak to their parents.

I usually suggest that the parents have one shot together with the bride and groom, and then an individual shot with their respective new partner.

NO GRANDPARENTS

MUM + STEPDAD

GROOM — DAD + GIRLFRIEND

1 BROTHER (BEST MAN)

WIFE

3 CHILDREN

Tip:
I draw myself a little diagram of family relationships as it helps to see the situation at a glance.

The picture opposite has been arranged quickly and then the subjects have been photographed while they are talking to each other, rather than looking at the camera, whilst the pictures below have been taken with a zoom lens without the subjects being aware of the photographer.

Today's couples often prefer candid photography to formal groups... The way around this is to arrange people first and then shoot candidly as they chat together.

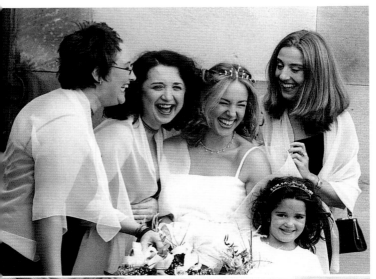

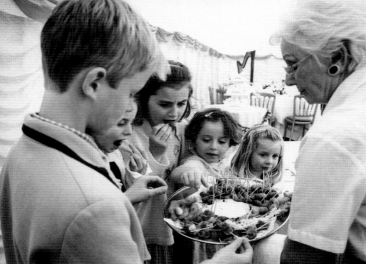

The term 'candid' is often misunderstood. True candids, which are taken without the knowledge of those being featured, can be very successful at weddings, but it is difficult to always achieve a decent picture of everyone in this style when so many people are together. The way around this is to arrange people first and then shoot candidly as they chat together. This will take a lot of the formality out of the picture, and it will give people something to do rather than looking at the camera.

Many people ask me to "just flit around and take people enjoying themselves" which sounds simple, but in fact is very difficult to achieve, because natural inhibitions ensure that guests will often turn the other way when they see the camera! The photographer has to build up a rapport with the people and if the guests have been impressed with your speed, efficiency and strength of personality throughout they are much more likely to relax and ignore the camera.

Tip:
Candid pictures are much more easily achieved by using a 35mm camera and zoom lens so that you can stand a long way away from your subjects and take pictures which they will probably not even notice you taking.

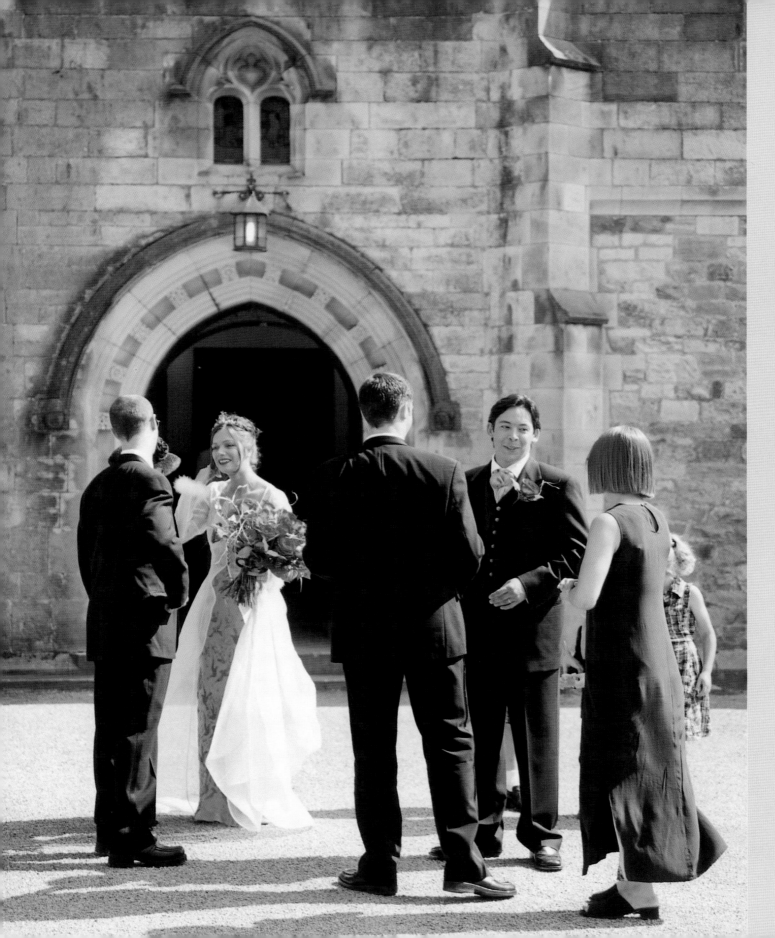

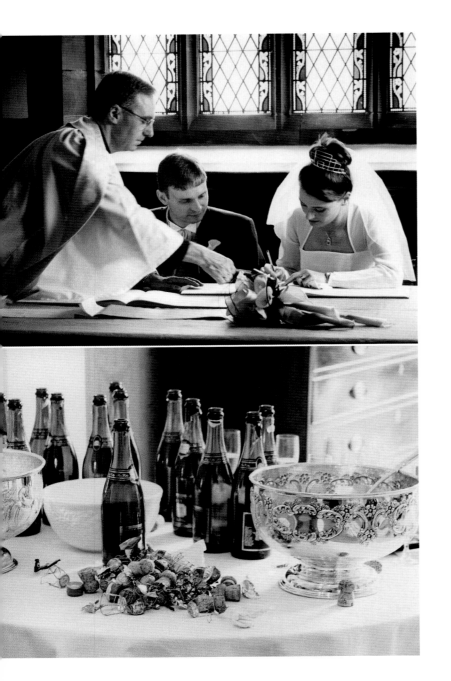

At home

Starting at the bride's home I want to capture the fun and excitement of everyone getting ready, whether they are still in their rollers, or ironing shirts! I often ask the bridesmaids to get ready first so that they can help to button up the bride's dress. This produces more flattering pictures than being in a dressing gown without make-up, which may look good from the photographer's point of view, but is often not the most flattering for the subjects. This is the time to photograph all the little details such as shoes, flowers, dress etc, then getting ready and finally taking the perfect shot of the bride before she sets off to church.

The ceremony

The second part of the day is often the most frantic part, where I need to be everywhere all at once and constantly thinking on my feet, watching for every little detail. The pace really speeds up now, and it's my job to make sure I photograph all the important people arriving and capture what the groom and his friends are doing before the bride arrives. I prefer to take candid black and white pictures in the church without being intrusive in any way, followed by very spontaneous colour and black and white shots of everyone chatting and throwing confetti outside the church.

The reception

I will usually take a few group shots at the church, but photograph most people at the reception when they are more relaxed and having a drink. I try to capture some of the atmosphere from the party; the couple socialising with their guests along with details of such things as place settings, cake and flowers.

Most weddings follow a structure that falls into three parts: the bride getting ready, the action at the church and finally the reception.

To produce a complete record of the day, it's important to cover every aspect. Black and white candid shots of the bride preparing herself are part of the mix and help to capture the atmosphere.

Canon EOS 5, 75–300mm lens. Fujifilm Neopan 1600. Exposure 1/30sec at f/5.6

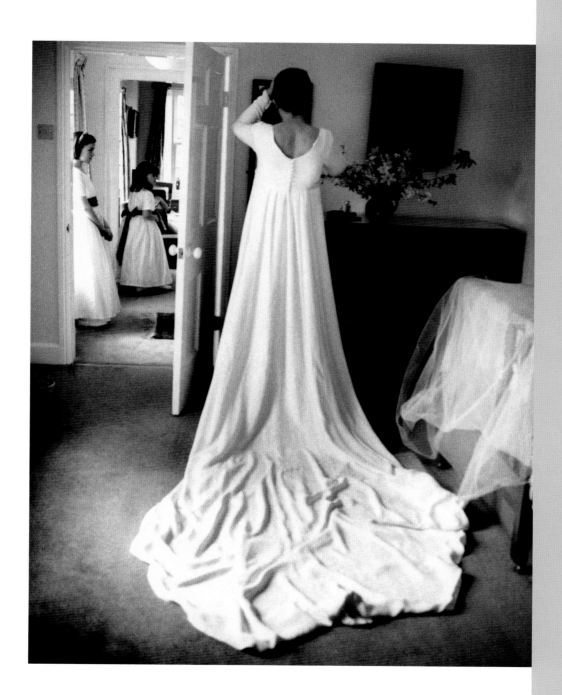

Tip:
If you see particularly
attractive or unusual flowers
or cars at a wedding, always
ask for details so that you
can then recommend them to
other brides. These elements
will enhance the backgrounds
and details of your pictures.

The photographer is only part of the day. There are many other people involved in the running of the wedding, who are all equally important, and it is essential to network with these key people, to ensure that everyone can work happily together. As well as ensuring that everything runs smoothly, there are other benefits as well, because if you work quickly and efficiently, and never hold up the proceedings, the hotel manager is bound to recommend you to other prospective clients, as will people such as the car driver and the vicar.

The process works both ways. I always recommend a marquee company that has consistently high standards, and it helps me too because, if the marquee looks inspiring, then it will make a great background to my pictures. The same philosophy applies to cakes, stationery, table decorations and flowers, and I'm happy to pass on names of people that I know will do a good job if my clients ask me to. I'll also send companies who have participated in the day a photo if I think it may help their future business. They appreciate the gesture and it gives them something to show prospective brides.

I've also been known to telephone ahead to the hotel manager where the reception is being held to let him know that the wedding is running half an hour late due to the late arrival of the bride, and to warn him not to put the potatoes on yet! Little touches like this can mean a lot, and will help you to build a relationship with people that you are very likely to work with again.

I've also been known to telephone ahead to the hotel manager where the reception is being held to let him know that the wedding is running half an hour late due to the late arrival of the bride, and to warn him not to put the potatoes on yet!

The equipment you choose for the wedding should be simple and practical. Carrying huge cameras and tripods around can be exhausting and affects how spontaneous you can be.

I only ever use a tripod when I am in the bride's home, simply to get the perfect shot of the bride before she leaves. I find this often has to be shot in her bedroom with available window light, and I am often working at 1/15sec.

I never use the tripod other than for this. Today's clients want a documentary approach and this can only be achieved with simple, hand-held equipment.

At home

Black and white: Canon EOS 5 with 35–75mm zoom lens, often with the camera's own flash. Fujifilm Neopan 1600 film.

Colour: Hasselblad with 120mm lens on tripod, using available light. Fujifilm NHG 800 film.

At ceremony

Colour: hand-held on Mamiya 645 with 35–70mm zoom lens, and built in automatic metering system. Fujifilm NHG 800 film.

Black and white: on Canon EOS 5, as before.

At reception

Colour: hand-held on Hasselblad, as before, to alter format to square pictures, which adds variety and interest to the shots.

Black and white: on Canon EOS 5, as before.

Film:

Although it can vary, at a typical wedding I would use:
4–5 rolls of 35mm Fujifilm Neopan 1600
5–7 rolls of 120 Fujifilm NHG 800
2 rolls of 120 Fujifilm Provia 400 (cross-processed)

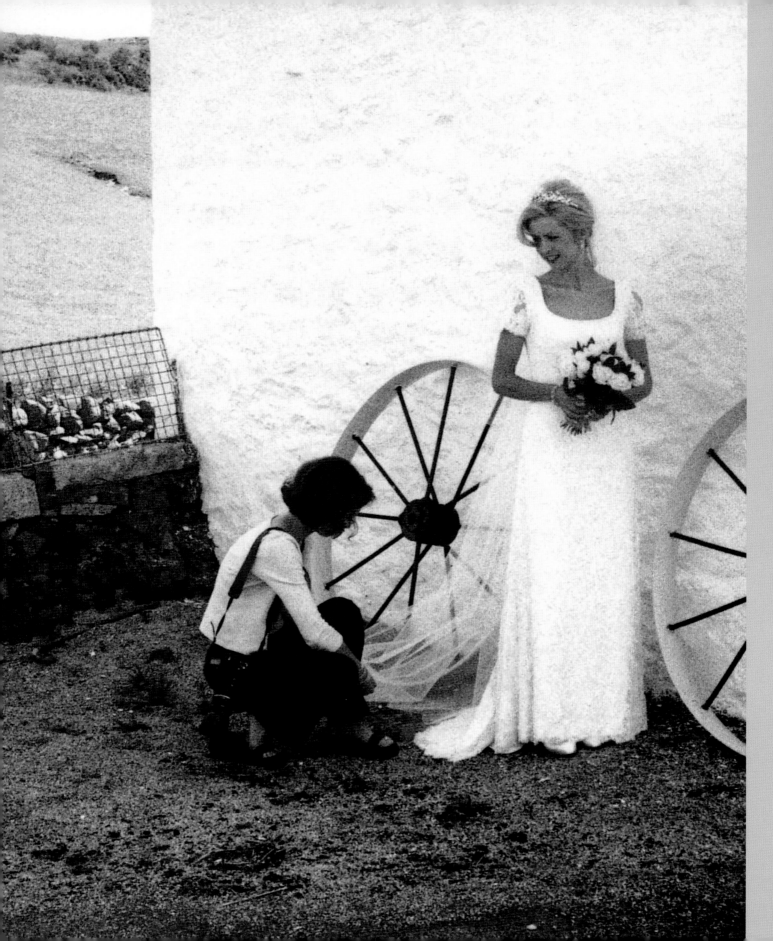

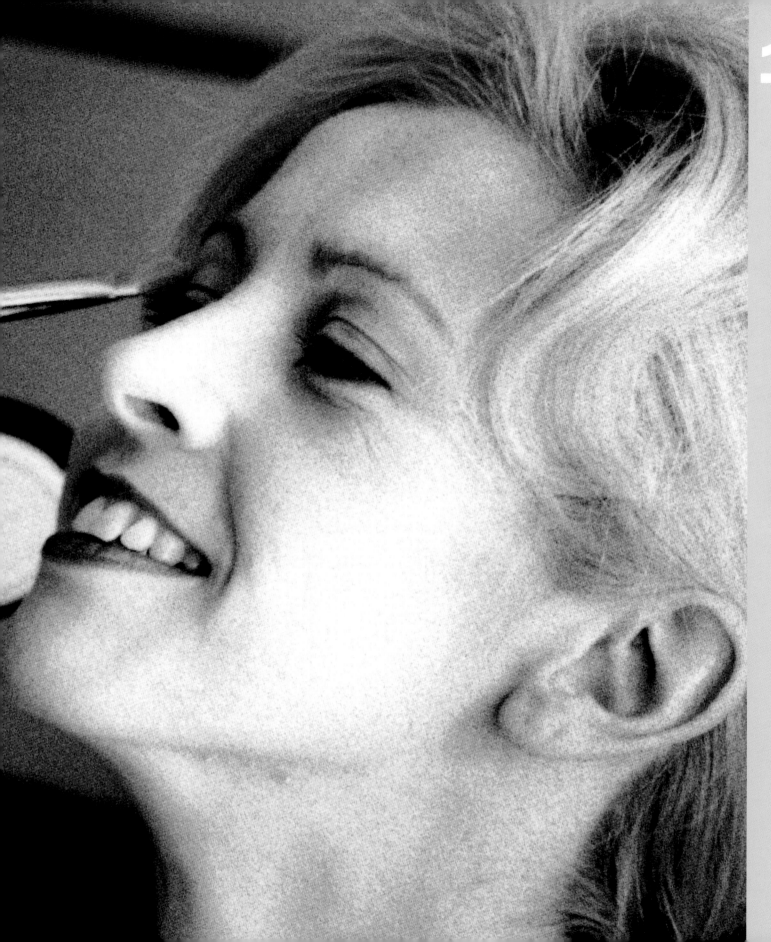

Traditionally wedding photographers were booked to take formal pictures starting at the church, but today's contemporary photographers recognise that the fun starts right from the beginning of the day. In order to take pictures like these, it is essential that you develop a good relationship with the bride from the start, which is why the pre-wedding shoot helps so much. Not many brides will let you photograph them in their dressing gowns without make-up, unless they really feel comfortable and relaxed with you.

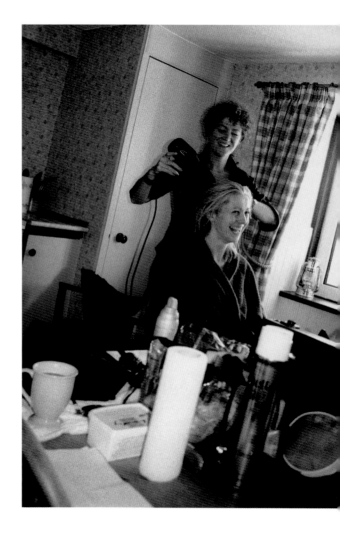

8.30 Lucinda starts to apply the make-up. Everyone is encouraged to be involved, by chatting, and drinking coffee and champagne! I love this part of the wedding when everyone is apprehensive about what is going to happen, and the excitement is mounting.

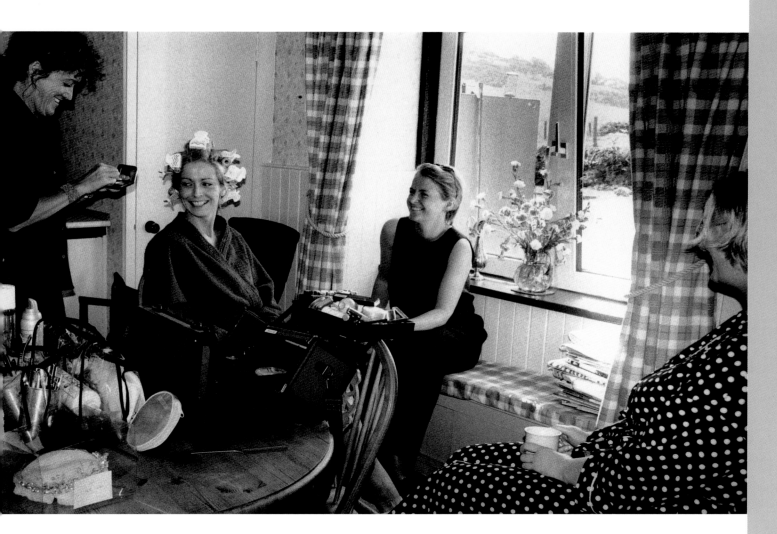

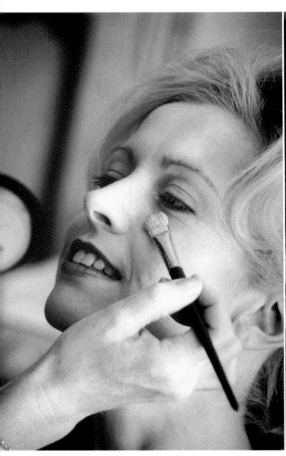

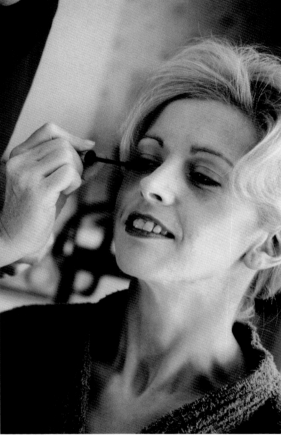

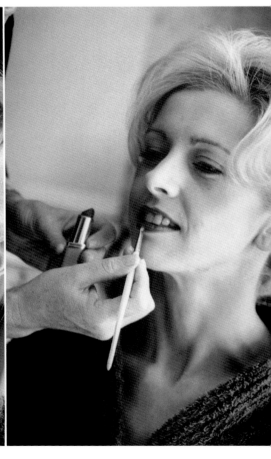

8.35 Lucinda applies foundation and concealer to even Liz's skin-tone and provide a base for her make-up to last all day.

8.55 Eyeshadow and mascara are applied to enhance her eyes and add a touch of colour to blend with the bridesmaids' lilac dresses.

9.15 Lipstick is applied using a fine lip-brush to define shape.

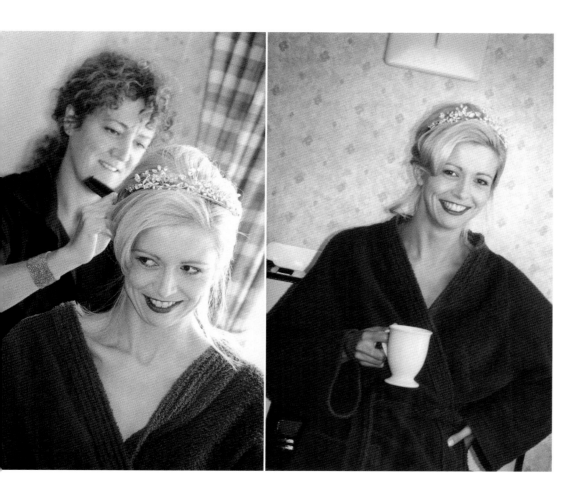

9.25 Lucinda styles Liz's hair to keep her tiara firmly in place.

10.00 Liz takes a coffee break!

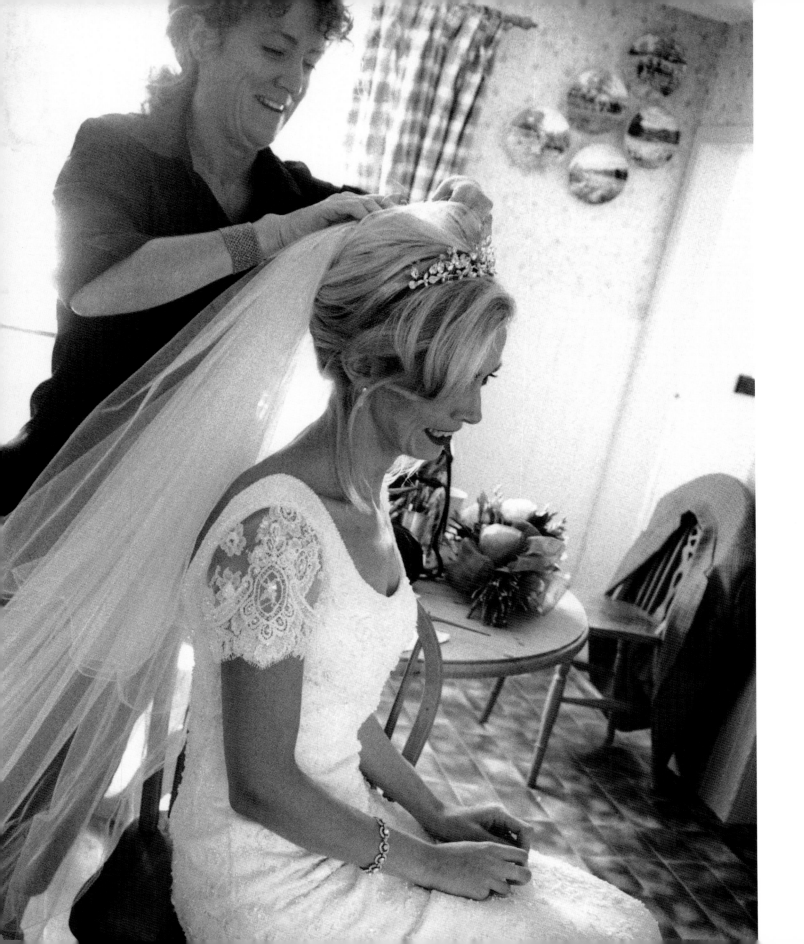

Always keep an open mind, and constantly think on your feet; there will be many more shots that will just happen and you need to be ready for them! The most successful pictures taken at home are the very candid ones which the bride often does not know are being taken.

It is not always possible to achieve all the shots you would like to take in the time allowed due to the many unforeseen circumstances that may occur, such as the bride being late back from the hairdressers and everything often happening all at once in the last half hour. However, the most important pictures are usually the candid "getting ready" shots, as any family pictures can always be done later in the day.

Depending on the situation I always try to take:

Detail shots, such as shoes, back of dress, presents, cards, flowers from the groom, jewellery etc. These shots can all be taken while the bride is getting ready.

Candid shots of people in rollers, make-up, ironing shirts, washing-up, drinking coffee and champagne.

Little bridesmaids dressing and sometimes being bribed into their under-skirts, ballet shoes and tights!

Older bridesmaids helping the bride dress including fastening cuffs, lacing back of dress, stepping into shoes – both close-up and wide-angle shots.

11.00 Liz is now in her dress and Lucinda completes the look by fixing the veil firmly into her hair.

The bride is ready and about to leave for the church, and already you have a series of atmospheric pictures that will tell the story of the early part of the day.

It is important to photograph the bride looking her best before she sets off for the wedding, as from this point on you are at the mercy of the elements.

It may rain or be windy, and although we are going to get some great pictures throughout the day this is a real chance to photograph her looking perfect.

If the bride and her family are all ready early, I will take some additional shots which will save me time later.

Suggested extra shots:

Bride and parents together, both formal and candid.

Bride and bridesmaids together, both formal and candid.

Bridesmaids individually, – particularly important if they are very young as they tend to tire easily later in the day.

Any opportunity such as this that will allow you to get ahead should be taken, because it all helps to relieve the pressure further down the line, and will contribute towards making the big day as stress-free as possible.

11.45 Liz is in the car and ready to set off for her big day!

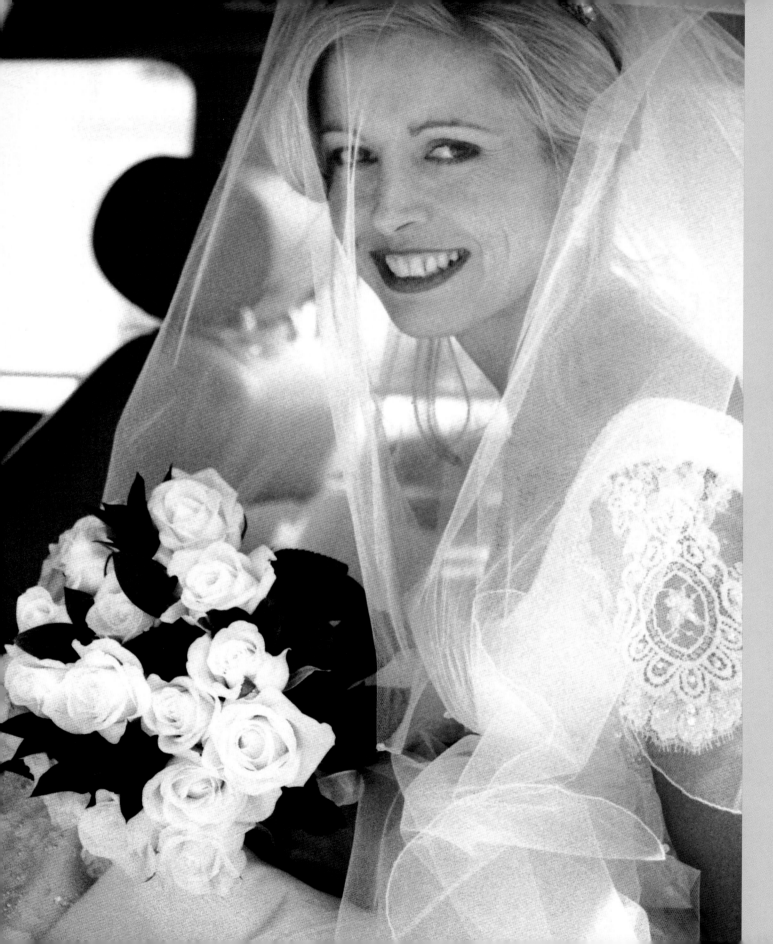

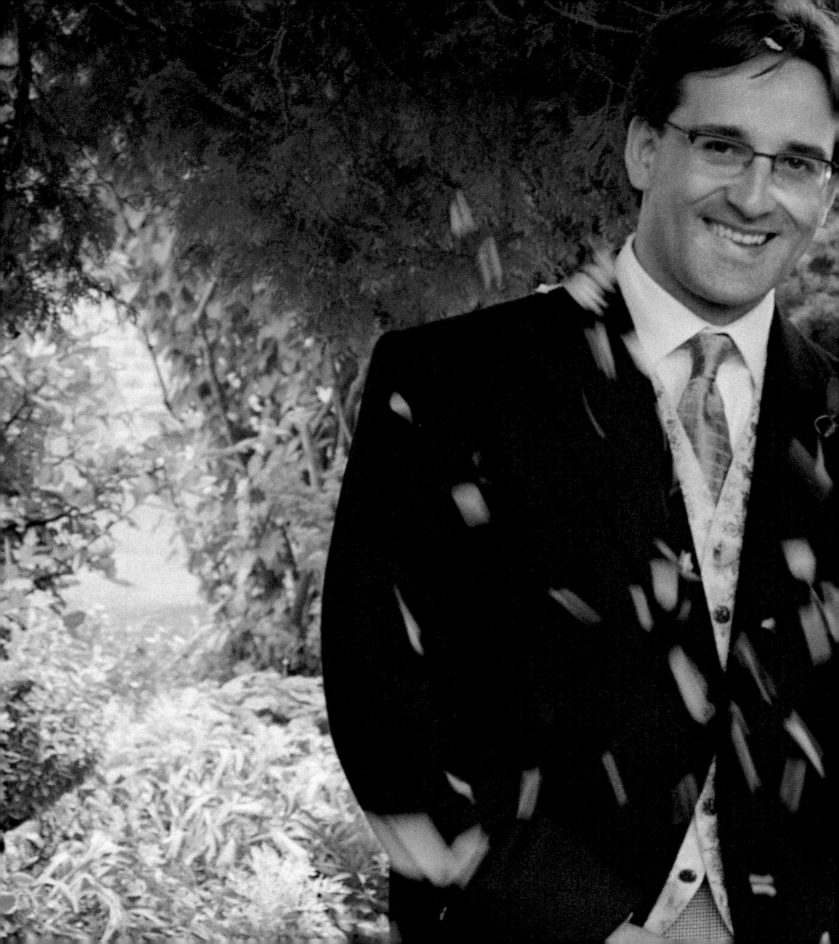

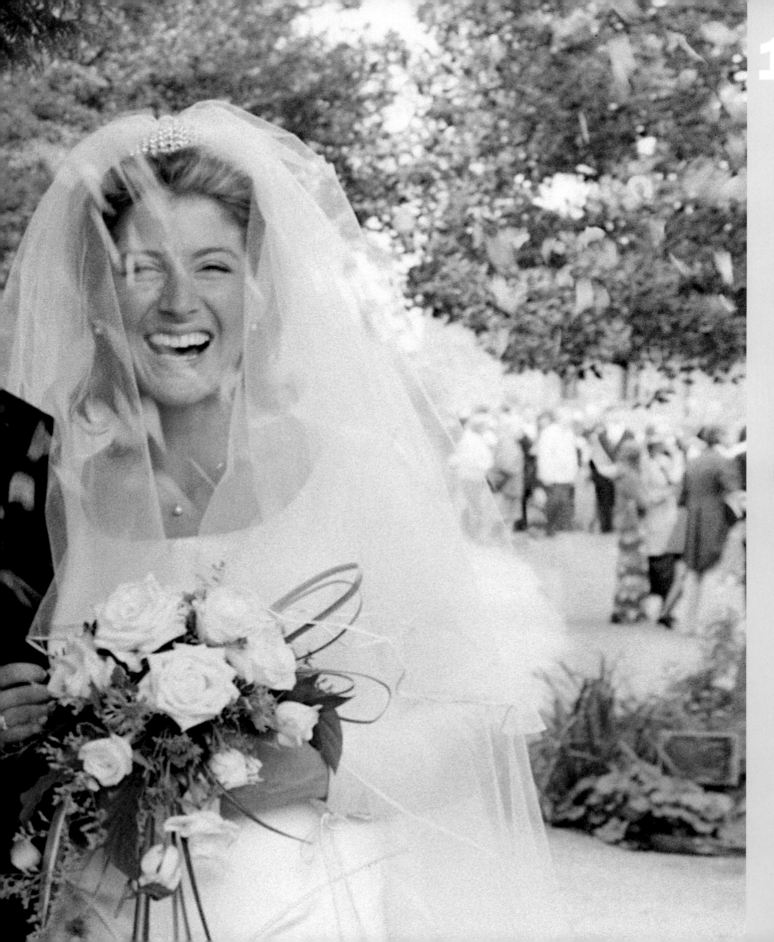

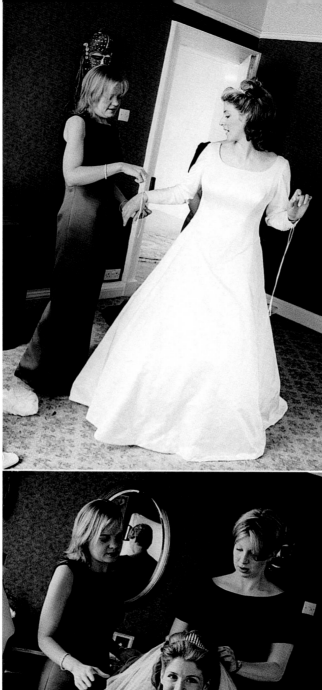

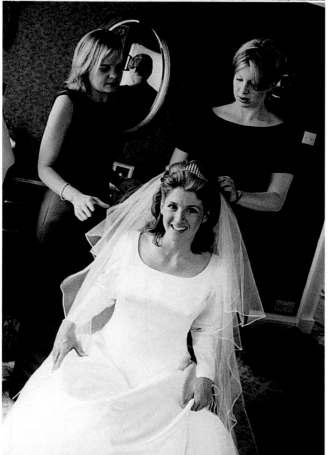

The wedding day scenario:

Studio to bride's home – 30 minutes
Home to church – 10 minutes
Church to reception – 20 minutes
Start time – 11.15am
Time of wedding – 1.00pm
Start of meal – 4.30pm
Number of guests – 150
Estimated number of pictures – 150–200

10.00 Meet assistant at studio and load car.

10.15 Leave studio for bride's home, allowing extra time for unforeseen circumstances.

10.45–11.00 Arrive at bride's house deliberately early, throwing everyone into panic!

Introduce myself and my assistant to the family – hopefully get a cup of coffee!

Wander around the house and garden looking for locations (although often shoot in the bedroom as usually run out of time if the bride is late).

11.15 Start persuading people to get ready as I have to leave for the church in one hour.

11.30–12.10 Photograph everything that is happening, from the bride getting ready to the more formal shots of the family.

12.15 Pack car and go to church – usually in a hurry!

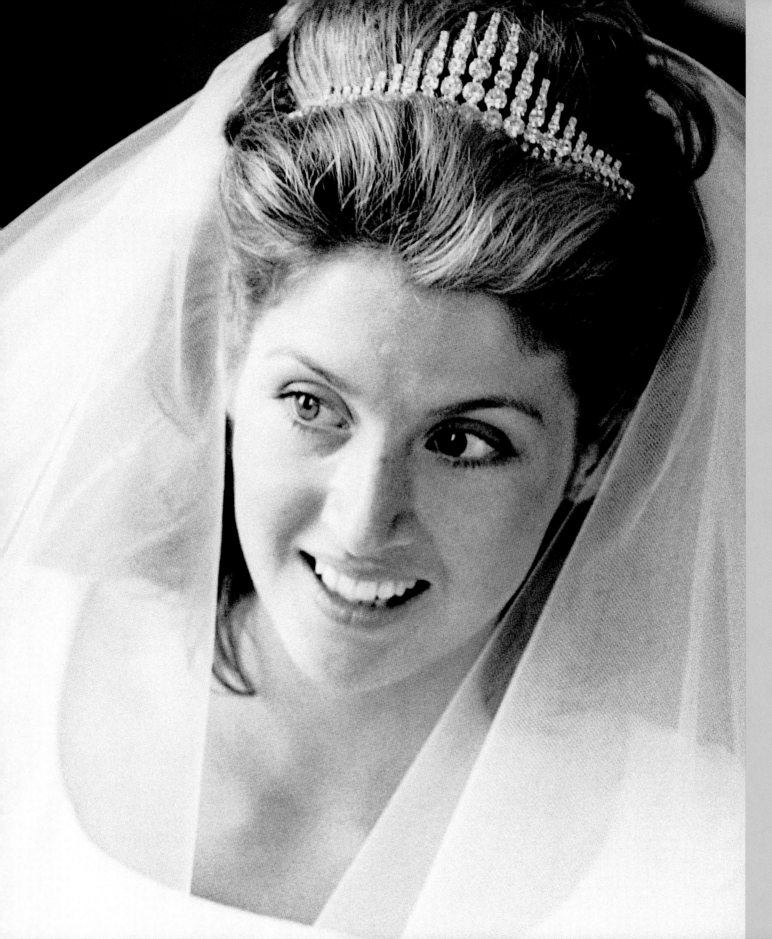

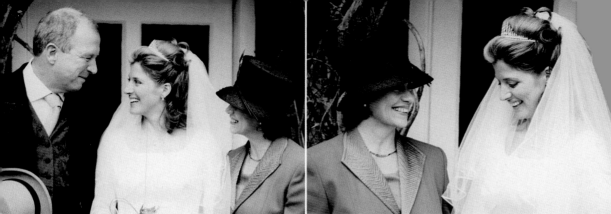

Preparation: the key word is <u>attitude</u>! I attend every wedding as if I am a guest, and dress accordingly.

I want to enjoy myself and feel part of the party. I need to be relaxed and focused on the format of the day, which is why I would never do another shoot before a wedding.

If everyone is ready in time, try to set up some pictures of the bride with her family before she leaves for the church, because this will take some of the pressure off later on. Ask everyone to start chatting so that their attention is focused away from the camera, and this will help you to produce more natural results.

Canon EOS 5, 75–300mm lens, Fujifilm Neopan 1600. Exposure 1/125sec at f/5.6

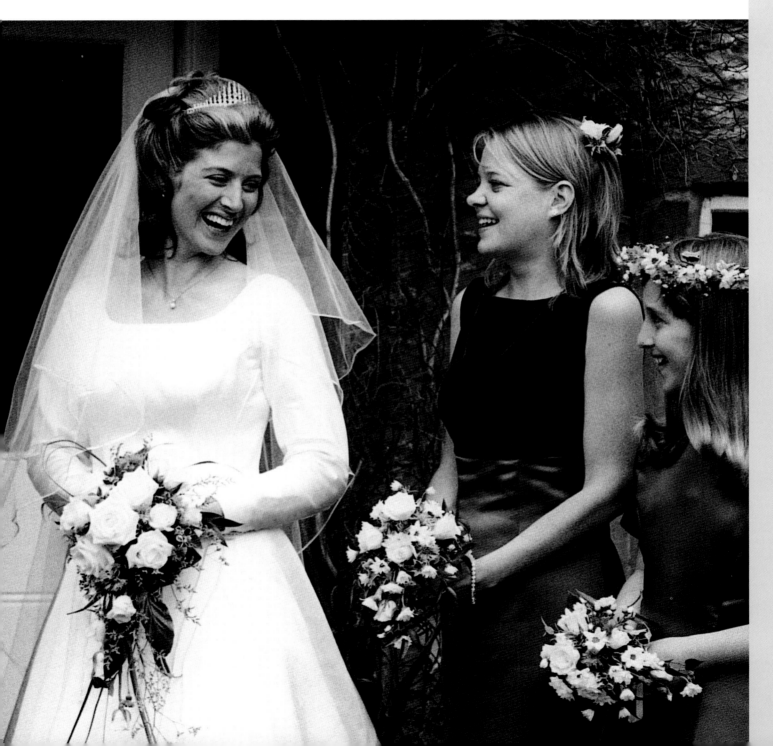

12.30 Arrive at church and park carefully making sure I won't be blocked in and can get my car out quickly after the service.

12.35 Leave equipment with assistant and go and find groom! If he's in the pub across the road, take photos as they leave for church.

12.40 Take photos of groom, best man and ushers chatting to people in the churchyard, candid pictures of guests arriving plus whole scene shots in colour and black and white.

12.50 Photograph bridesmaids and bride's mother arriving and mingling with guests.

Try to sum up the flavour of the day through your photographs. This picture of the groom and his best man setting off for the church included the pub in the background that they had visited beforehand, and these small reminders of the details of the occasion contribute greatly to the couple's enjoyment of the pictures.

Mamiya 645, 35–70mm lens, Fujifilm NHG 800. Hand-held, exposure 1/250sec at f/8

KINGS ARMS

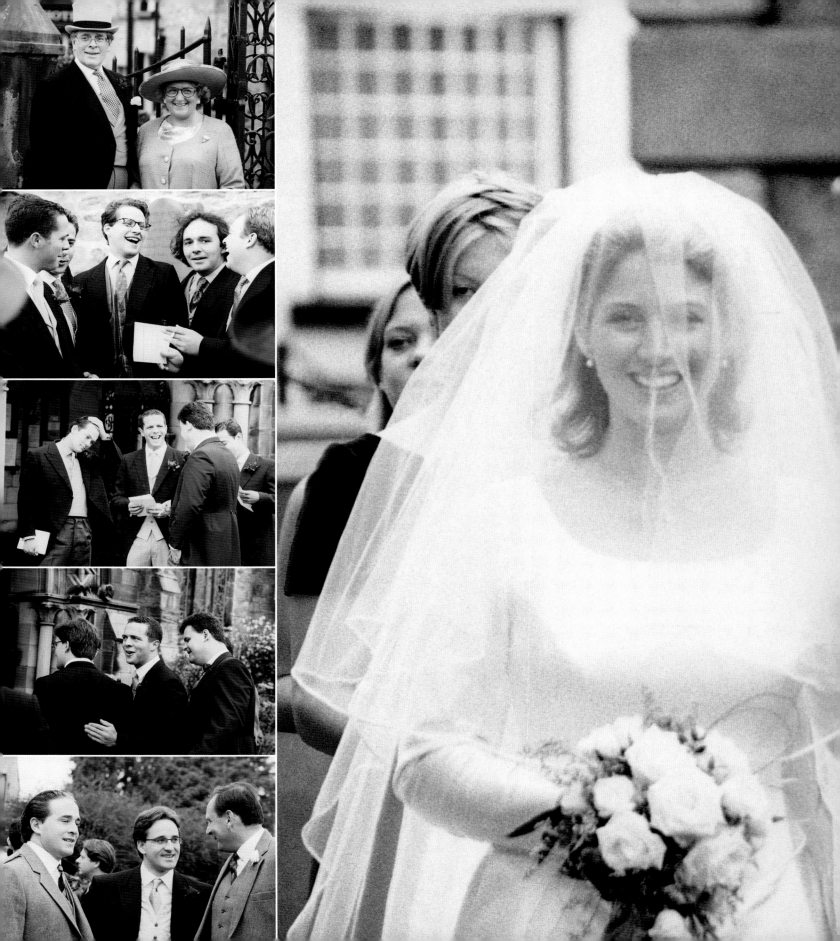

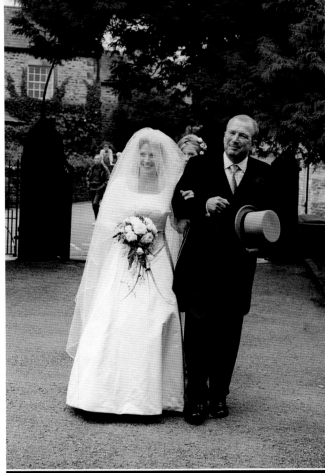

1.00 The bride arrives with her father. Assistant shooting black and white shots at this point while I am shooting colour, as it needs both of us to capture the action as it happens.

Colour and black and white shots taken as they arrive, and walk up the church path.

1.05 Arrive at church door – photos taken as it happens, while vicar is chatting to the bride and her father.

Candid snaps of bridesmaids tidying dress. The bride often looks back over her shoulder naturally – so be ready for it!

Those moments between a bride and her father as they arrive together at the church are very special and the pictures you achieve will be treasured, especially if they look spontaneous and relaxed. Look especially for the small details that will help to bring it all to life, and these will often occur when everyone but you thinks that the pictures have all been taken.

Mamiya 645, 35–70mm lens, Fujifilm NHG 800. Hand-held, exposure 1/250sec at f/8

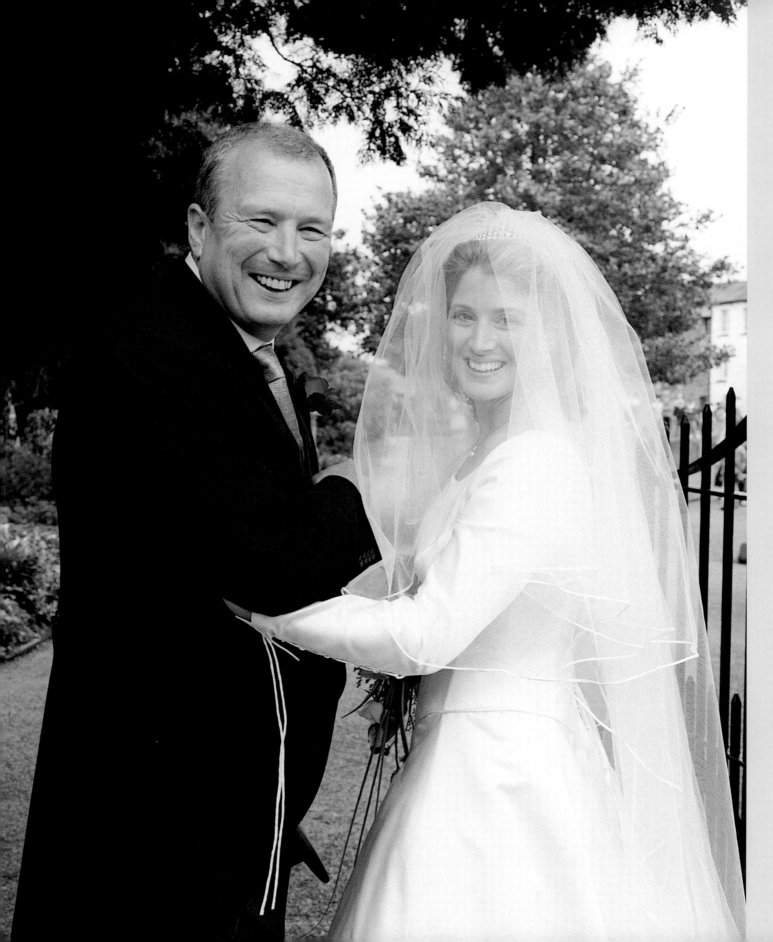

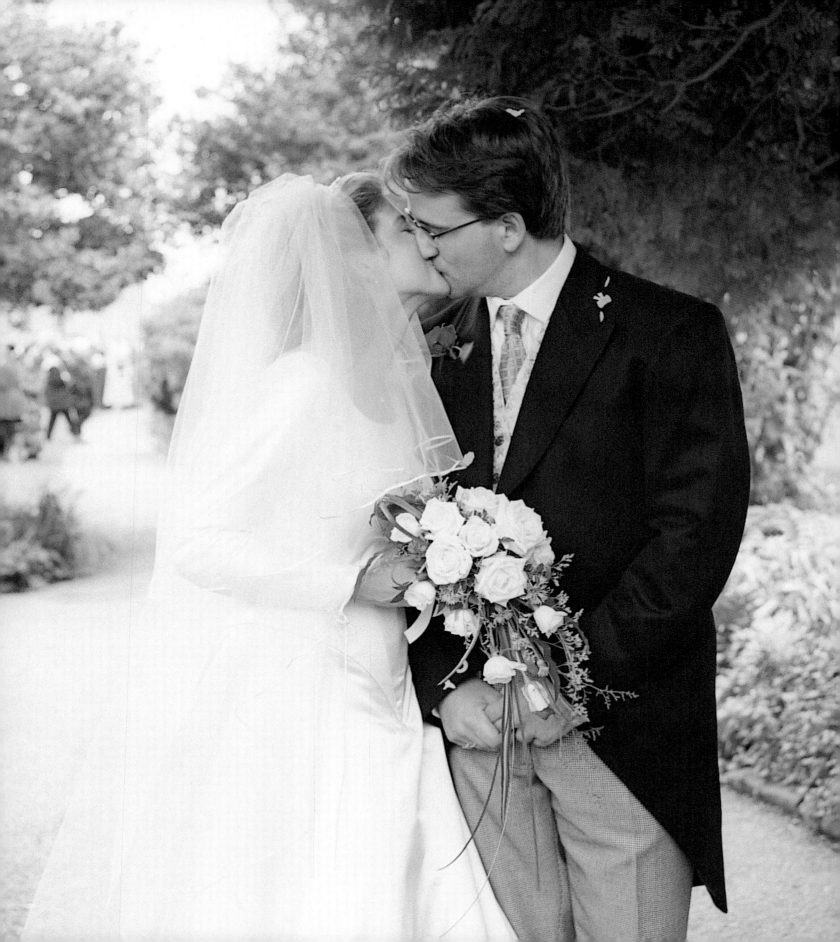

1.10 Take sneaky colour shot from back of the church with hand-held Mamiya 645 (no flash) during the first hymn so shutter cannot be heard (usually resting on a pew at 1/15 sec).

Candid black and white close-up shots throughout the ceremony using 35mm Canon with image stabilising lens, to prevent blurring at low shutter speeds (no flash).

1.35 Register shot taken candidly during actual signing, previously arranged with Vicar. No formal shot unless specifically requested.

1.45 Bride and groom walk down the aisle – one with flash (Mamiya 645 with Metz flash).

Discretion is the name of the game once the service is under way. The couple will want some record of the events inside the church and, providing that you work in a subtle way and reserve your flash for one picture of the new bride and groom walking down the aisle at the end of the service, you should be able to keep everyone happy.

Mamiya 645 with 35–70mm lens and Canon EOS 5 with 75–300mm lens. Fujifilm NHG 800 and Neopan 1600

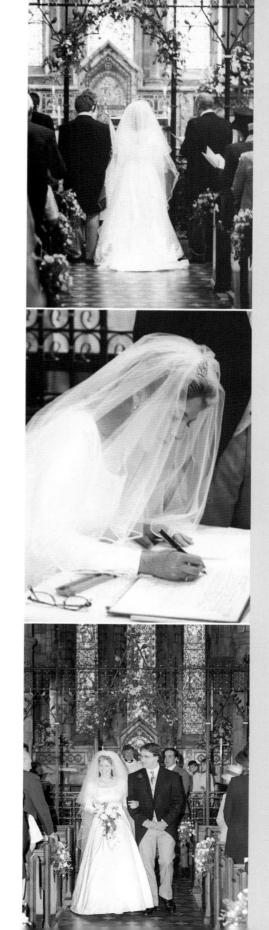

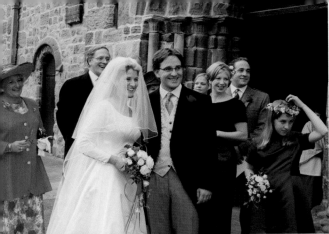

Many wedding photographers make themselves unpopular with guests by taking the bride and groom away from them for a lengthy period at the end of the service. I try to work instead in a candid fashion and my pictures of the couple being congratulated and showered with confetti by their friends and families are more natural and are always popular.

Mamiya 645, 35–70mm lens, Fujifilm NHG 800 set on automatic

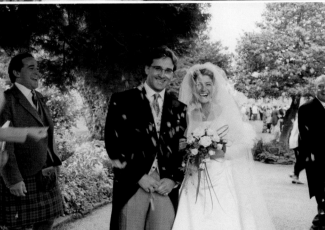

1.50 Church doors – stop for one minute to take colour shots in church doorway. Assistant shooting black and white at the same time to record the action as it happens, and without delaying the proceedings.

1.51 Allow everyone out of church so they don't feel trapped, as at this stage they are keen to congratulate the bride and groom and take pictures.

2.00 Take candid photos of bride and groom chatting and kissing people.

2.20 Capture everyone throwing confetti, usually at the church gates.

2.25–2.30 Send assistant to load car while I photograph bride and groom getting into their car and leaving for reception.

2.50 Arrive at reception and photograph bride and groom getting out of their car. Do formal shot at front of car if requested, but mainly black & white shots of the action as it happens.

2.55 Use this 10–15 minutes to photograph the bride and groom together, while the other guests are still driving to reception and parking their cars. This way I will not hold up the proceedings.

This is the point where I may use the Hasselblad to take some cross-processed shots, if the location is suitable.

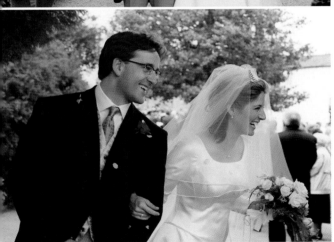

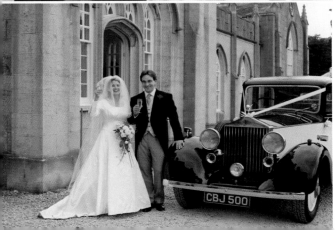

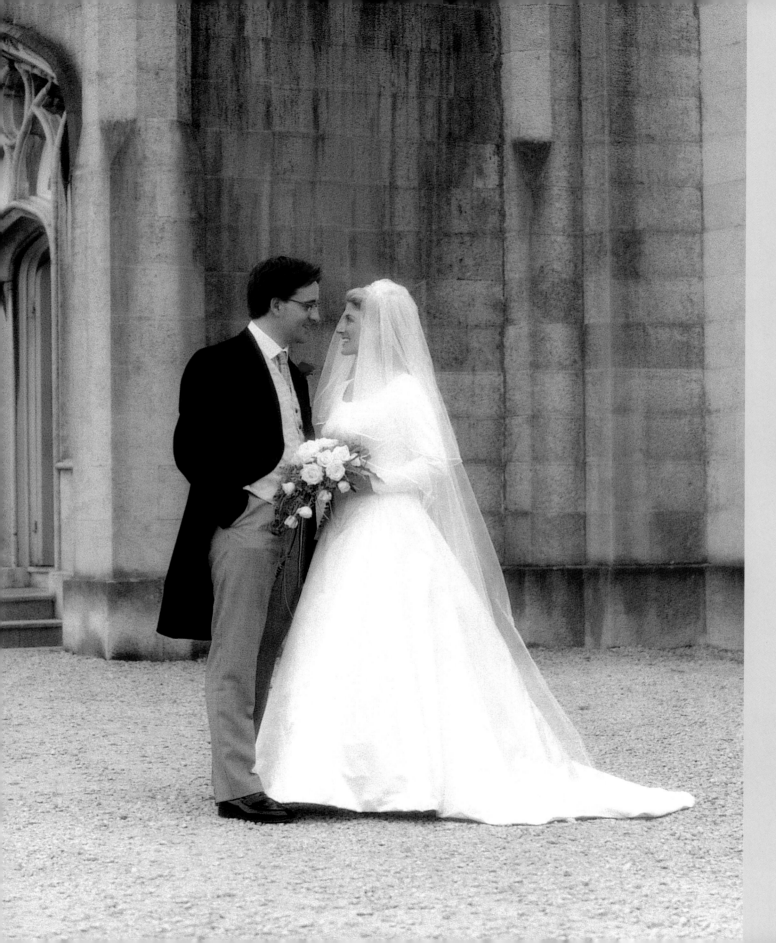

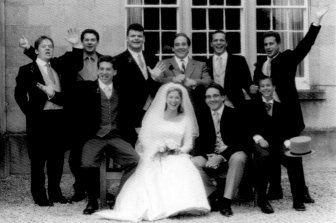

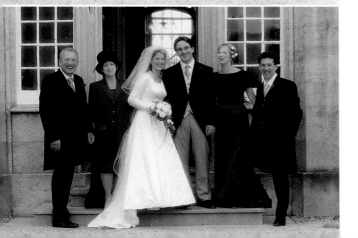

3.10 Let bride and groom greet their guests informally, while I take candid shots as it happens.

3.25 Inform the ushers/best man that we are going to do some group shots in five minutes and ask them to help find the various people we will need.

3.30 When the time feels right, I ask the bride if she would like to do some group shots now.

3.35–3.45 Allow ten minutes to do group shots – make it fun and let guests take their own pictures, so they become part of the experience.

3.45–3.55 Accommodate the various shots the bride and groom suddenly decide to have! Possibly do large group of everyone if previously requested.

4.10 Go to reception area without the bride and groom, and take detailed shots of cake/glasses/place settings etc, usually in black and white but also in colour for ultimate cross processing if they are very bright. I would take a shot of the cake with the bride and groom if requested, but find this is very rare nowadays.

Group shots can drag on and become terribly formal, so I try to encourage everyone to relax and to enjoy the process as much as possible. The days of everyone adopting a stiff pose for the occasion are thankfully long gone, and instead there's an air of celebration that adds to the atmosphere of the pictures.

Mamiya 645, 35—70mm lens.
Fujifilm Neopan 400 and NHG 800

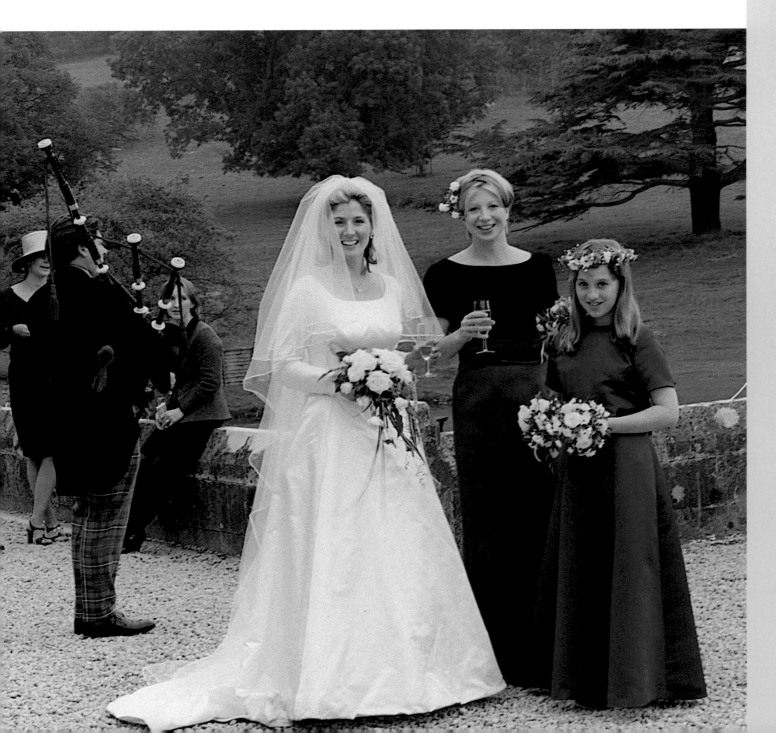

While the guests are chatting you may get the opportunity to take candid pictures of people which they will much prefer rather than posing for the camera.

Everyone is usually so preoccupied with congratulating the happy couple and in meeting up with friends and relatives that the last thing they want to do is to stop for a formal picture. Candids are much more fun in any case, and I simply move around the crowd and take pictures of the guests. The results are invariably happy and relaxed.

Canon EOS 5, 75–300mm lens, Fujifilm Neopan 1600. Exposure set on automatic

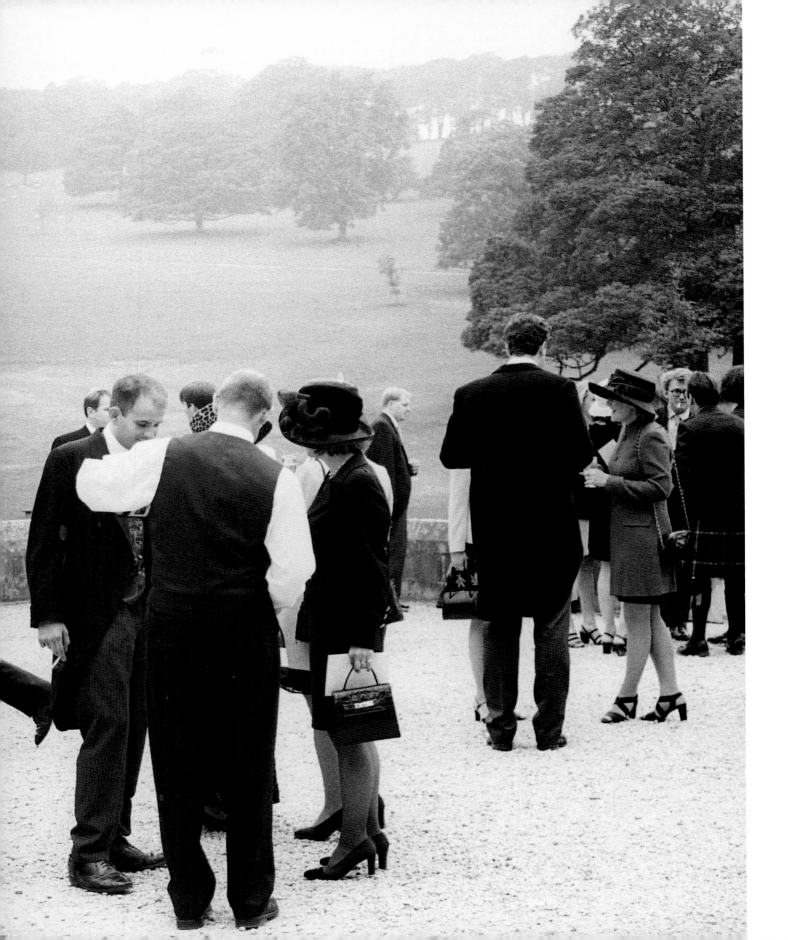

4.20 Have a drink and mingle with guests in case any other shots are suddenly requested. Take more candid shots of people chatting.

4.30 Leave when bride and groom start line up into reception, unless an agreement has previously been made to photograph meal and evening reception as well.

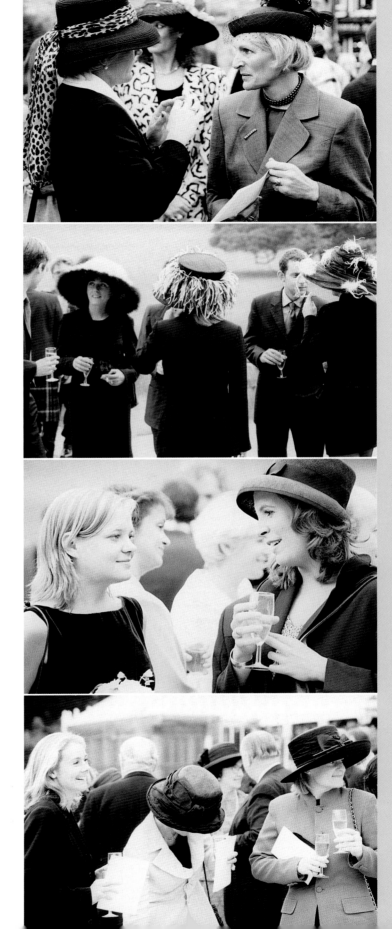

Everyone has their own memories of a wedding day, and informal pictures of the guests help to bring it all back. Most of the time those I am photographing are unaware that they're on film, and the pictures consequently have a natural and relaxed feel to them.

Canon EOS 5, 75–300mm lens, Fujifilm Neopan 1600. Exposure set on automatic

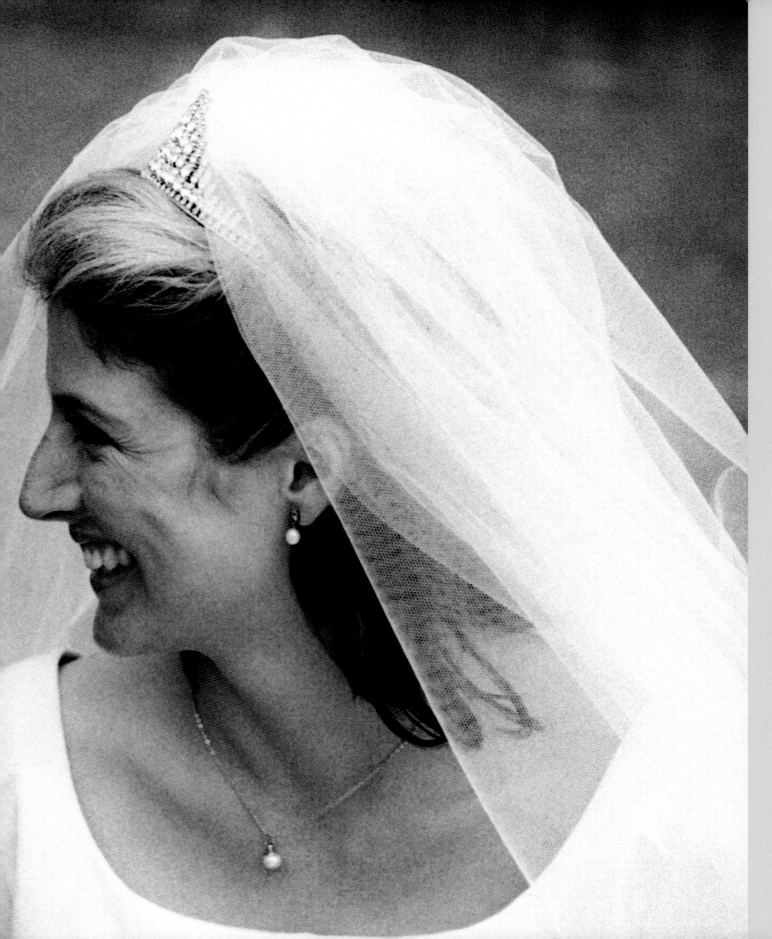

Checking the locations is an integral part of the planning and preparation that goes into shooting a wedding. If you are totally familiar with the venue then you will be able to relax and take your photographs much more quickly and efficiently.

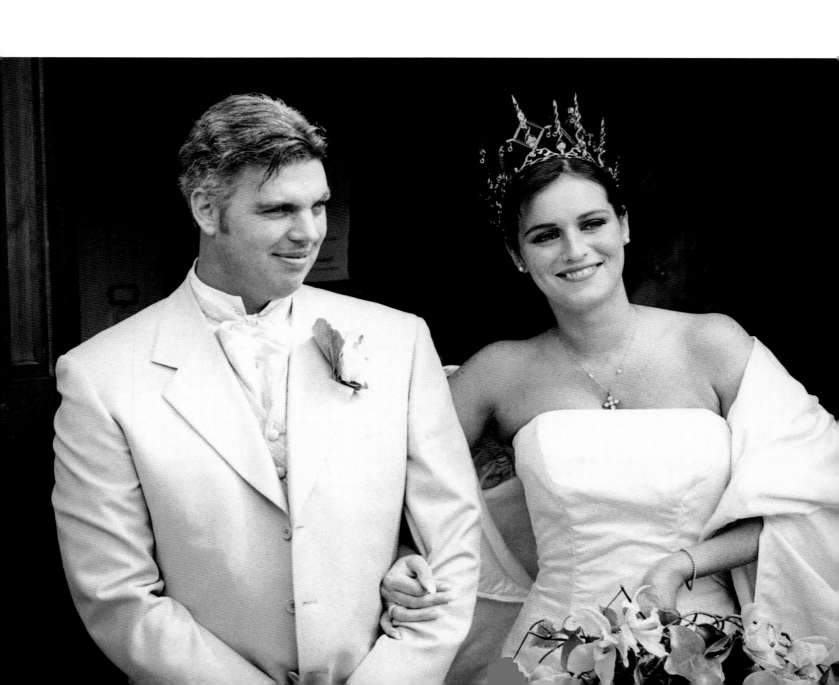

Not all locations are ideal for beautiful photographs. In cases where churches are not very attractive it is essential to try and take pictures which do not show the background. This shot establishes the scene, but at the cost of highlighting the modern church. The pictures below are taken in exactly the same place but great care has been taken to avoid showing the background, by cropping in tightly and shooting in black and white.

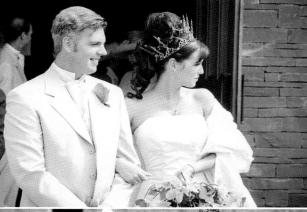

Know your location

It is important to know exactly what is available to you in terms of location. If the church is ugly your pictures will look unattractive unless you can crop carefully and avoid showing the whole background. The church doorway is ideal, as the background will go dark and enhance the subjects, as shown in the picture on the left.

In the case of very attractive churches, the problem can be too much choice, and it is important you pre-select where you are going to shoot, to avoid getting carried away and using too many locations! Look for places which other people may not think of, so that your pictures look different. For example, most of the guests will take their photos of the groom before the wedding in the church doorway, which means the couple will have seen lots of pictures like this – try to take yours at the gate instead.

If the bride's bedroom is small and dark, I will often take a few candid shots of the preparations and then ask the bride to put her dress on in the sitting room where there may be more light. This provides more space, a different background and adds variety.

Look for alternatives

If the bride and groom request special pictures on their own, try to select a different location from where you will photograph the groups or guests, to add variety to the wedding album. Always try to select locations which are very close – taking the couple away from their guests for a long walk is very unsociable, and everyone feels part of the proceedings if they can watch what is going on. It also helps you to work faster.

If the wedding takes place at home in a marquee, visit the bride's home two days before, to check where the marquee has been placed, because the previously lovely garden may now have been completely covered, and you will need to look at how much light is being blocked out by it etc. You also need to know where the action will be taking place, as there will probably be a plan as to where the bride's car will arrive, and where people will be mingling etc.

Making a contingency plan

The weather can make a big difference to where you are able to take your pictures. It is vital to know what you are going to do if it rains. Check whether there is a covered porch at the front of the hotel, or a conservatory you could use for small groups or pictures of the couple. Many photographers use the interior of the church, but this often produces very austere backgrounds. Most couples will prefer natural shots taken as they rush out of the church under umbrellas – it is not essential to have perfectly posed shots under beautiful trees any more, so don't panic if you can't get them!

Look for different locations depending on the time of day – where will the sun be?

If you have checked out the locations carefully before the wedding, you will have the confidence on the day to decide quickly where to take your pictures in any eventuality.

The reality
This picture shows the reality of the stubble
and mud, together with bare trees and houses
in the background.

Winter weddings can present a special
challenge because, with the leaves fallen from
the trees and vegetation died back, the scenery
will often be very bare and unattractive.
However, even these circumstances can be
used to advantage and, through careful
positioning, a picture can be created based
around something that, at first glance, appears
to be unusable. In the examples here I used
what, essentially, were just tufts of grass in a
ploughed field, to provide interesting pictures.

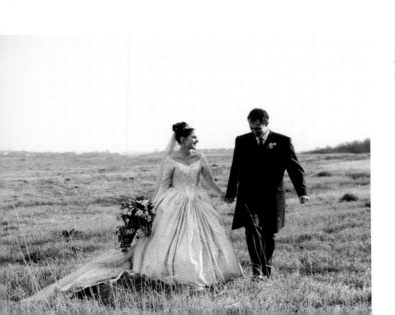

Use black and white to unify
I asked the couple to walk towards me while I
crouched down behind a few strands of long
grass. The result was quite subtle, but by
including the grass in the foreground I was
able to create the illusion of a much healthier
crop, which in turn helps to take the eye away
from the spartan nature of the field behind.
The use of black and white film ensured that
the rather jarring contrast between the green
grass and regular patches of bare red earth
could not be seen.

Creating an illusion
A combination of careful cropping, and a
repositioning of the couple behind the only
tuft of grass in the field, created the illusion
that they were standing in a field of long
grass. I cross-processed the film to bring out
the colours and to give the grass a richer
appearance than it really had.

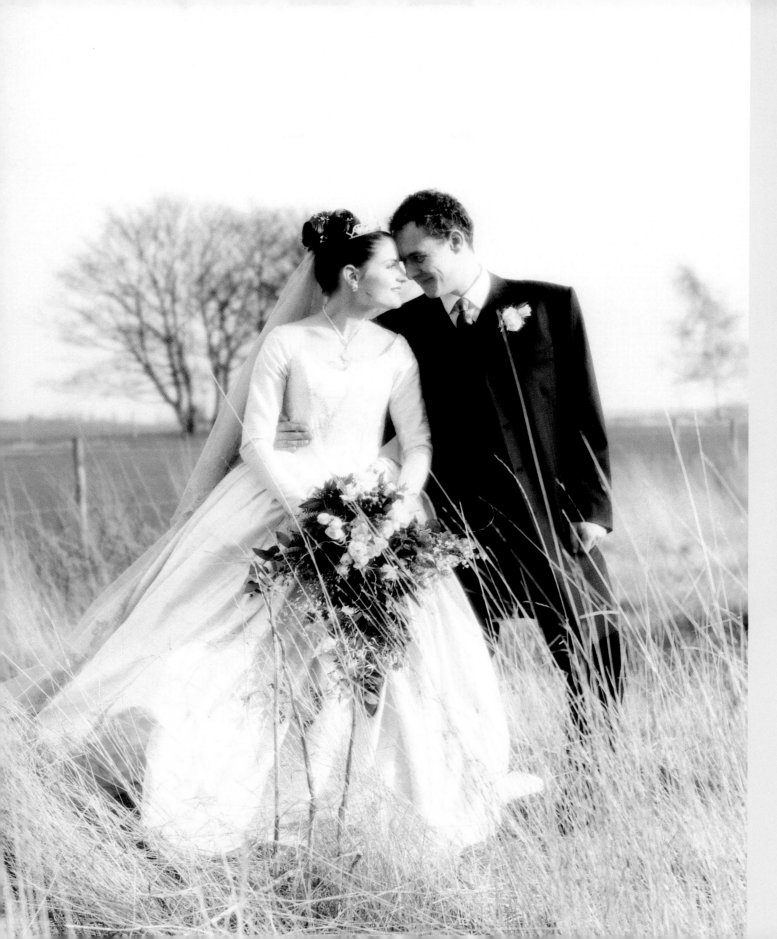

Working with bright sunlight

On a bright sunny day, when people are out in open spaces without much shade, I often try to make sure that they are positioned so that they have their backs to the sun. This prevents harsh shadows on the faces, and allows the subjects to be comfortable, but it does create exposure considerations that have to be addressed to avoid major problems. A camera that automatically calculates exposure for you will be fooled by the light streaming into the lens into setting a reading that will give a dark and extremely unflattering result. It's essential that the faces of your subjects should be correctly exposed, so this is where you should be taking your reading from. Either walk up close to them and take a reading from a hand-held meter held close to them or invest in a spot meter, which will allow readings to be taken from very precise areas of the scene. Setting this exposure will cause the background to bleach out just a little, but this can be a pleasing effect and, as a bonus, you'll find that sunlight will just touch the edges of your subject's clothes and will create an attractive sheen there. If you look closely here you can see sunlight just catching the groom's forehead, the bride's shoulder and the arm of the lady throwing confetti.

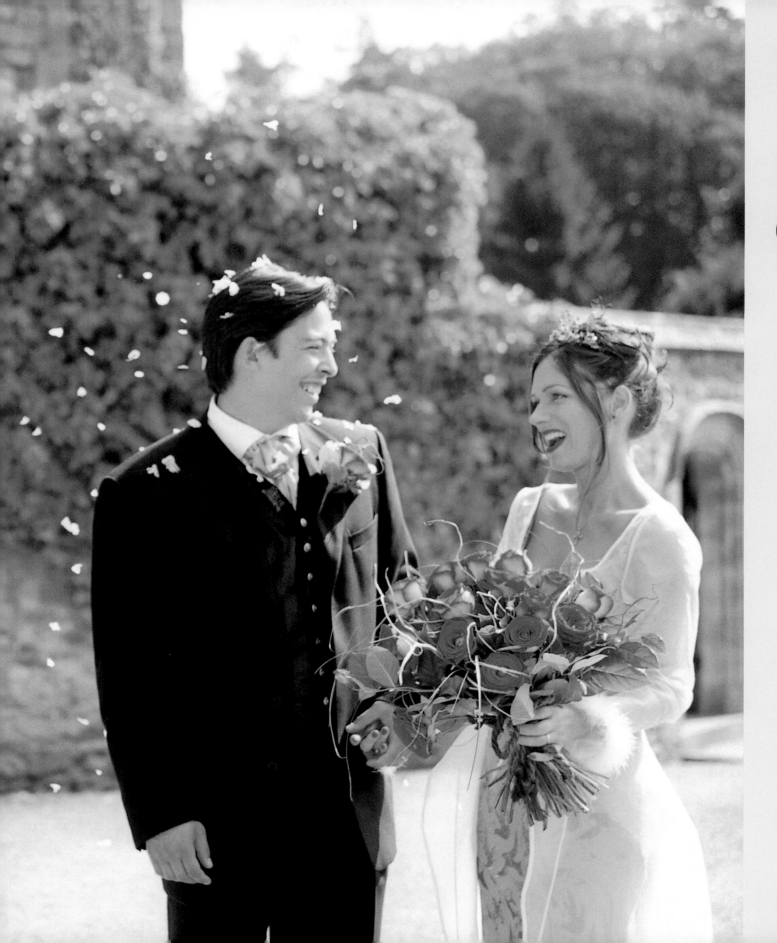

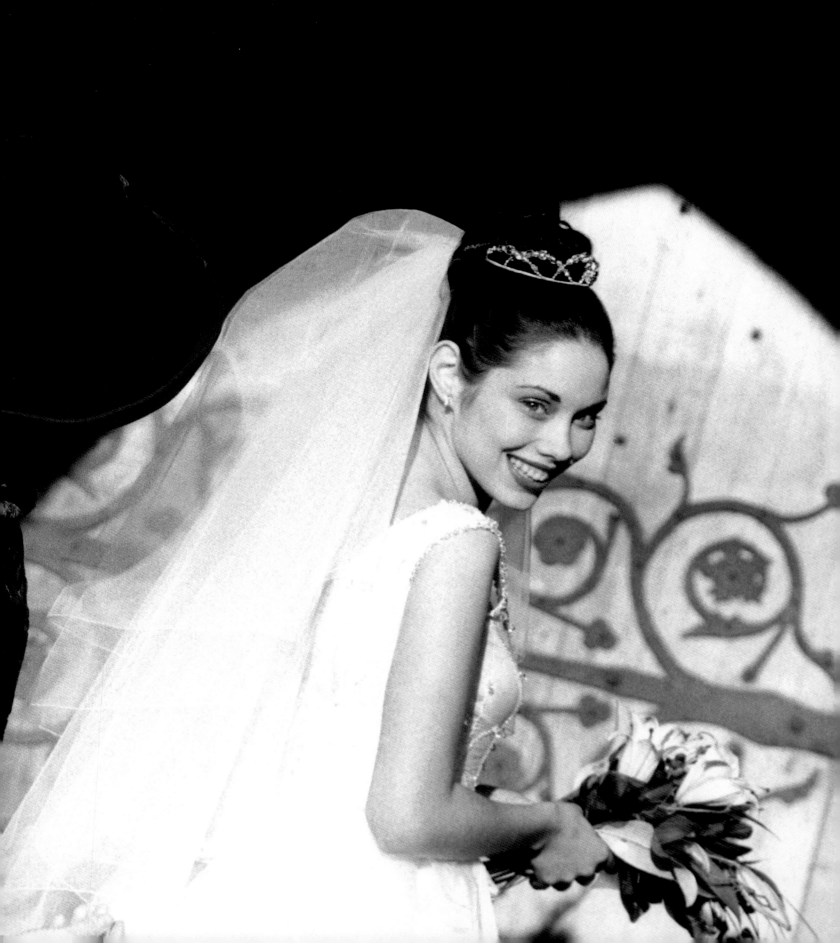

Using tone and contrast

The light in the doorway is directly on the bride and the door behind her, which has led to a stunning mixture of tone and contrast. Because the light is so low, the porch roof of the church has cast its shadow across the whole of the top area of the picture, which has led to the creation of an interesting and unusual frame around the bride.

Use your light meter

The light again was very low here, which has created strong modelling on the faces. Metering directly from this area of the picture has ensured that the couple's features are correctly rendered, while the shadows in the background have been darkened down still further, making the contrast within the picture all the more striking. Taking pictures under these kinds of conditions is very risky, because as the bride and groom move around the churchyard the light may change dramatically from one area to the next, and so constant meter readings are essential to ensure success.

Although I rarely photograph people in bright sunlight, occasionally it can look amazing if the photographs are taken later in the day when the sun is very low, and is throwing deep and exaggerated shadows across everything. The extraordinary quality of light you experience at this time can make the pictures really glow.

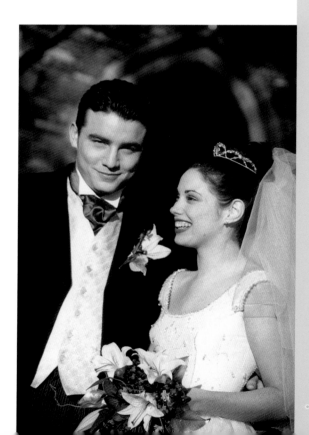

Using a leafy tree

Every bride wants their wedding day to be bright and sunny, but often these are not the best conditions under which to achieve flattering photographs. Harsh shadows may end up being thrown across the face, while the bride might find herself squinting against the light if it's particularly bright.

The simple process of placing the subject in the shadow of a large leafy tree makes it possible to soften the light that falls on the face, therefore creating a far more pleasant picture, whilst the sunlight that's still being thrown around the subject serves to enhance the picture.

Utilising a stone arch

I used a slightly different effect for the groom, standing him underneath the stone arch of the church gateway so that he fell under its shadow. This served to even out the light, and gave me a result that was a vast improvement on what could have been achieved by simply standing him in the direct sunlight. The impression of the lovely sunny day that characterised this wedding is still preserved, however, through the light that's falling on the background, and the shadows that are being thrown there. The shape of the arch, meanwhile, makes a strong frame for the subject.

Capture any opportunity

At first sight it appeared that this little bridesmaid would have to be photographed in direct sunlight, but then I realised that she would be shaded for a moment by the chauffeur as she stepped from the car. That was all I needed, and you can see if you look closely at her shoe how small the area of shadow that I had to work within really was. An instant later and the bridesmaid would probably have been squinting in the sun.

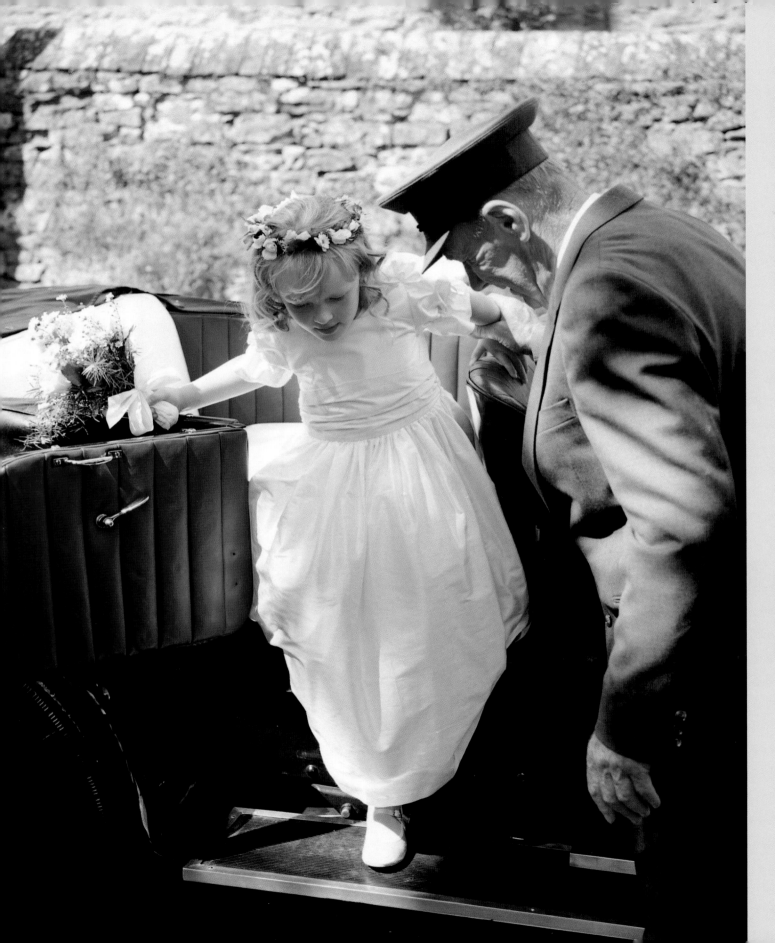

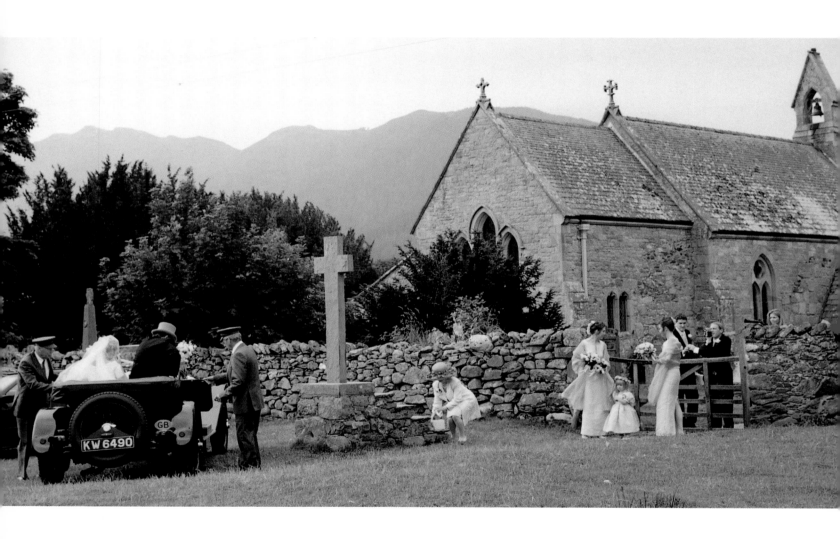

Soft and even light

Most people think a bright sunny day is wonderful for photographs. However, my job is much easier if the weather is dull, because I can take pictures wherever I want without searching for trees to shade the sun. A cloudy, overcast day provides very soft and even light, which is particularly flattering when photographing people. The harsher contrast that will be created by strong direct light can produce dark shadows around faces and eyes, while the exposure difference between the brightest highlights and the deepest shadows will become very difficult to handle.

Flexibility

Shooting on a dull day gives me the flexibility of working in a candid style and shooting pictures wherever I want. The cloudy sky creates a soft light that allows the picture to be taken from many different angles, because the light will be very even.

Enhancing the atmosphere

Even a foggy day can provide a striking image. The background detail in this picture has been filtered out by the mist, giving an unusual and ethereal feel, whilst enhancing the subjects in the foreground.

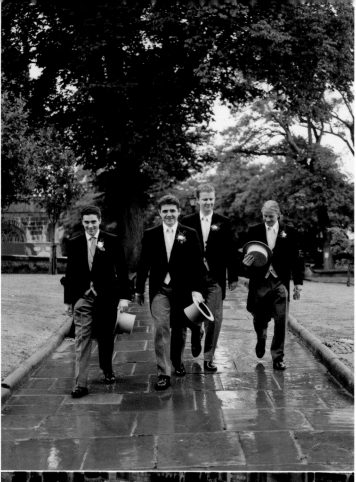

Making rain work for you

Every bride hopes for a sunny day, but unfortunately it can sometimes rain. On most wet days pictures can be captured in between showers but occasionally the weather can be so bad that it seems impossible.

Pouring rain should be seen as a challenge, not a nightmare. It is possible to take some fantastic pictures in the rain because people are totally natural, and shooting in the rain will result in unique and spontaneous images, provided you work quickly and efficiently.

The bride and groom still have to walk to the car, and this gives the photographer ample opportunities for capturing the atmosphere as they walk down the path. There is no reason why they cannot stand under umbrellas chatting to people. They will be so happy, they won't notice the rain!

I will be completely soaked, but that is a small price to pay to make sure the couple get the pictures they want.

It is important, however, that my assistant keeps my camera covered with an umbrella as much as possible to avoid the equipment getting too wet. Breakdowns on the day caused by rain are the stuff that nightmares are made of.

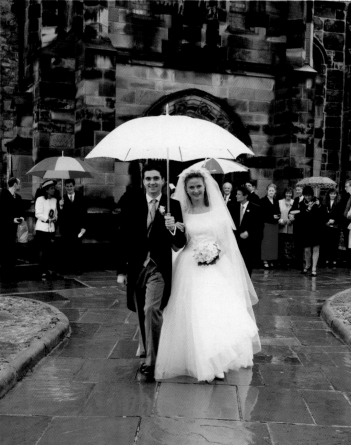

Tip:
Take your own white umbrella with you because it will be invaluable on occasions such as this. Don't be afraid to politely exchange your umbrella for any brightly coloured umbrella the bride and groom may be using, because they will thank you for it later. A white umbrella enhances the pictures by reflecting light back in to the faces, rather than shading them as a dark umbrella would do. Make sure the umbrella does not have logos on it, as these may also spoil your pictures later.

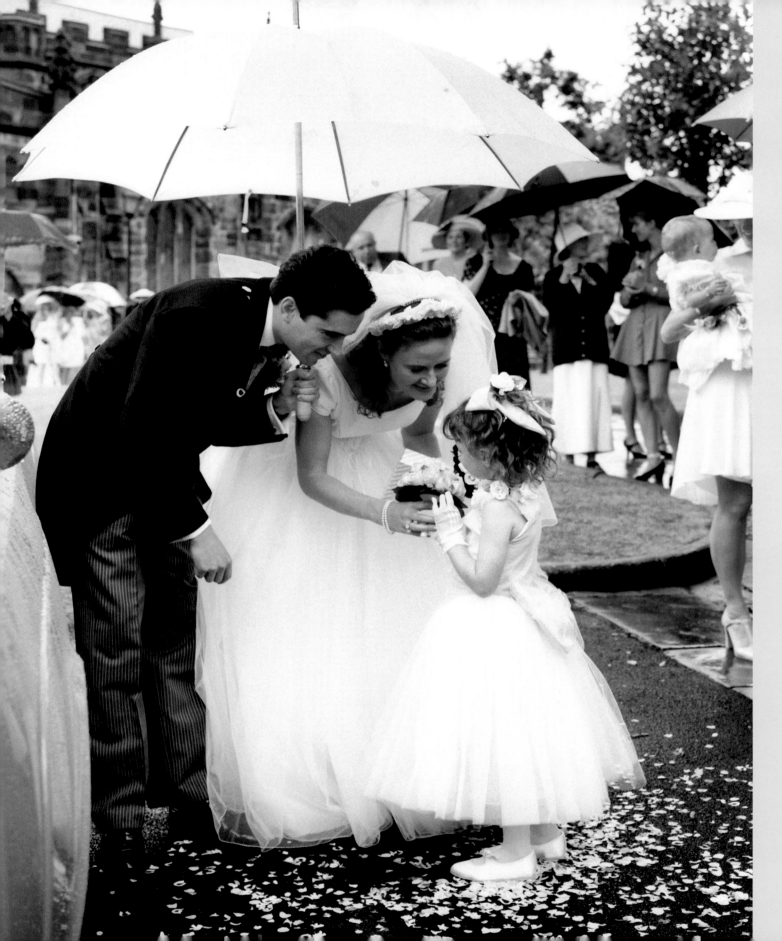

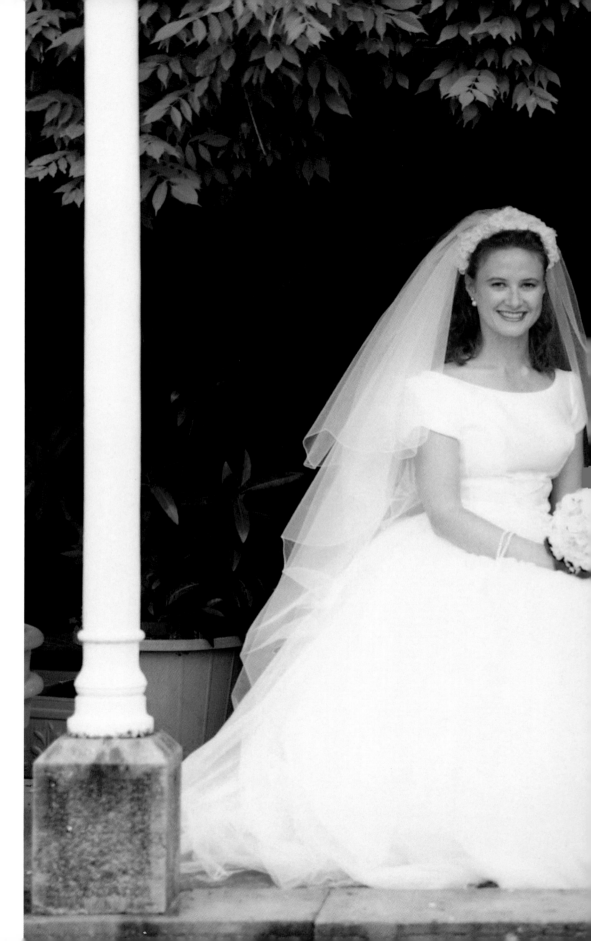

Find some natural cover

Group shots can be especially challenging when the weather is poor. Everyone will have made a special effort to look their best for the day and if the rain is falling they will be doing everything they can to stay dry, and will not be happy about being made to stand outside for photographs.

Because natural light is much more flattering than using flash indoors, I will always try to take the pictures outside if possible. Many receptions have a large covered entrance and this is where I would choose to do the group shots. I usually take several small groups rather than one large one in order to keep all the guests out of the rain.

For this picture, my assistant ferried members of the family out as and when they were needed. With the help of umbrellas held out of the frame, to prevent rain sweeping into their faces, I was able to produce results which were much more flattering than they would have been had they been shot inside.

As always the photographer got soaked standing outside, but at least the groups looked good!

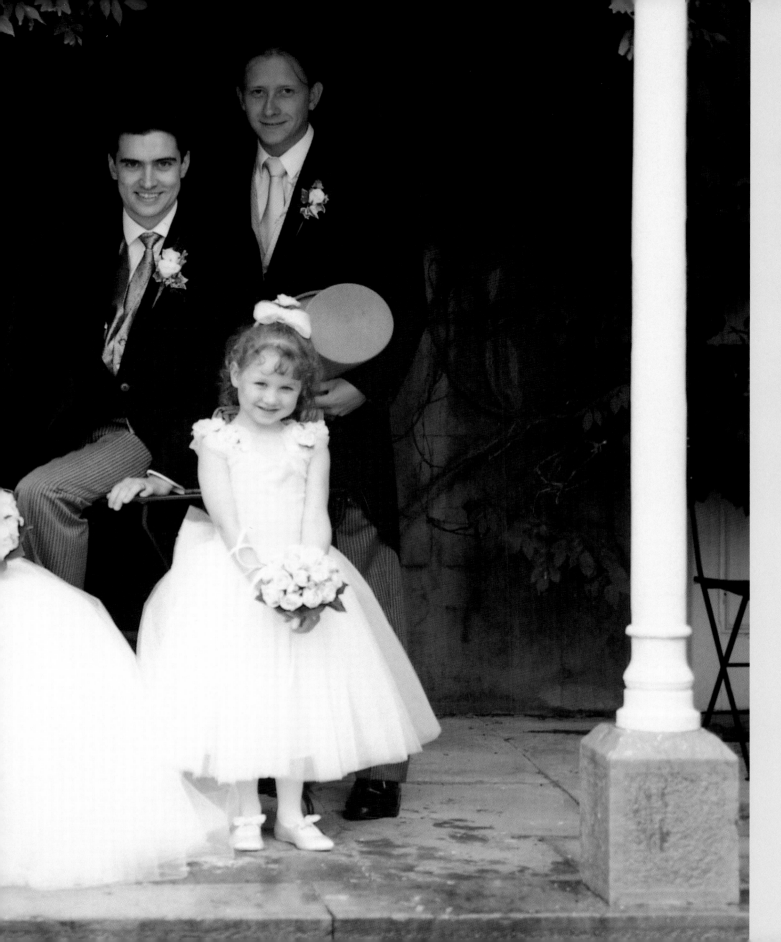

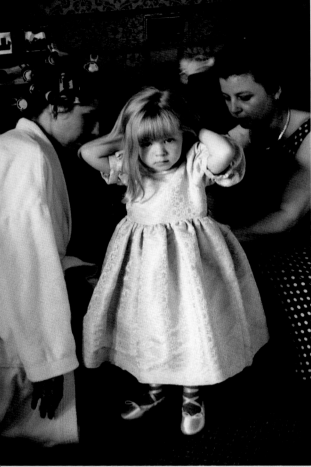

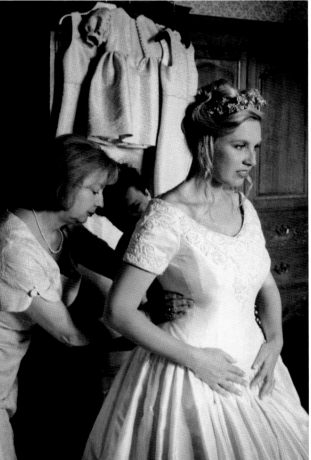

Hand-held 35mm

I find natural light much more flattering for photographs, and therefore hardly ever use flash at weddings.

These pictures are all shot by hand-holding my 35mm Canon EOS 5, with a 35–70mm zoom lens, which enables me to take both wide and close shots within moments of each other.

Occasionally, if the bride's bedroom is very dark, I will use the small pop-up flash on the camera, because it is very unobtrusive.

If I have a choice, I will ask the bride to get dressed facing the window, allowing the light to fall on her naturally. The light will be much more flattering if the bride is standing several feet away from the window, rather than close to it.

Fast film

I always use Fujifilm Neopan 1600 black and white film to give me the extra exposure I need to work in the available light in the bride's home. This film also has the added advantage of grain which gives the pictures texture and adds to the contemporary feel.

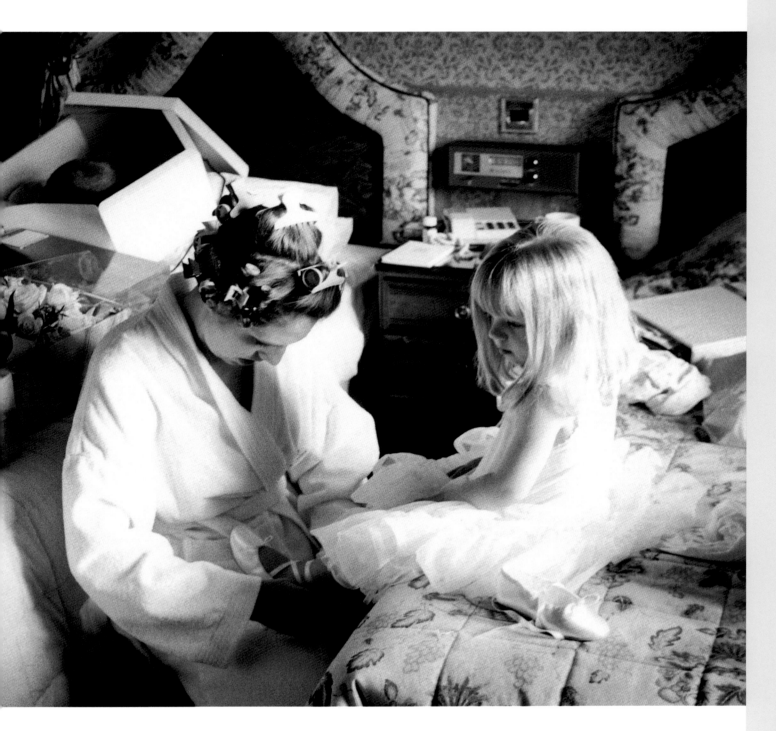

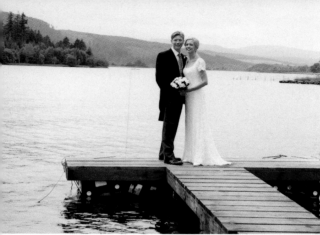

Conventional processing

The above shot has been taken on conventionally processed negative film (Fujifilm NHG 800) and establishes the scene down by the water's edge.

Cross processing

By taking another picture on transparency film (Fujifilm Provia 400) and cross processing it in C41 chemistry more conventionally used for negative films, the image can be given a strikingly different look as the colours are enhanced dramatically.

Cross processing will make strong colours more vivid while washing out the whiter areas of the picture and the results can be highly effective when seen among the overall mix of wedding pictures that you produce.

You will still need, however, to shoot some conventional colour pictures as well, because most brides want to see the detail in their dresses, which cross processing cannot provide.

It is essential to practice this technique before you introduce it on a wedding shoot, because these images can be difficult to print when taken under certain lighting conditions.

Tip:
I find that cross processing for wedding pictures is most effective either in very strong even light, or very soft light. On very dull or wet days, it can give very unflattering results if the lighting is patchy or shadowy. It is essential in this case to use a reflector to even the light out, and this is unfortunately often impractical on a wedding day when you do not want to be encumbered by equipment.

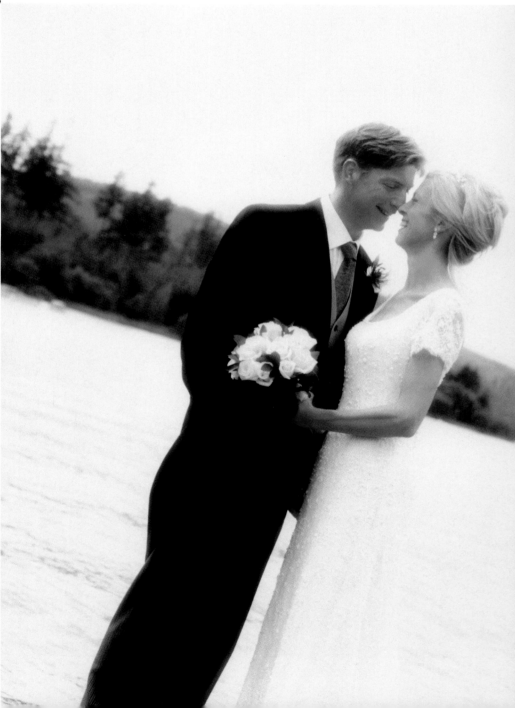

Many of today's clients want to look like the pictures they see in magazines, and the vivid colours and unusual angles that appeal to them can be reproduced by tilting the camera and cross processing the film.

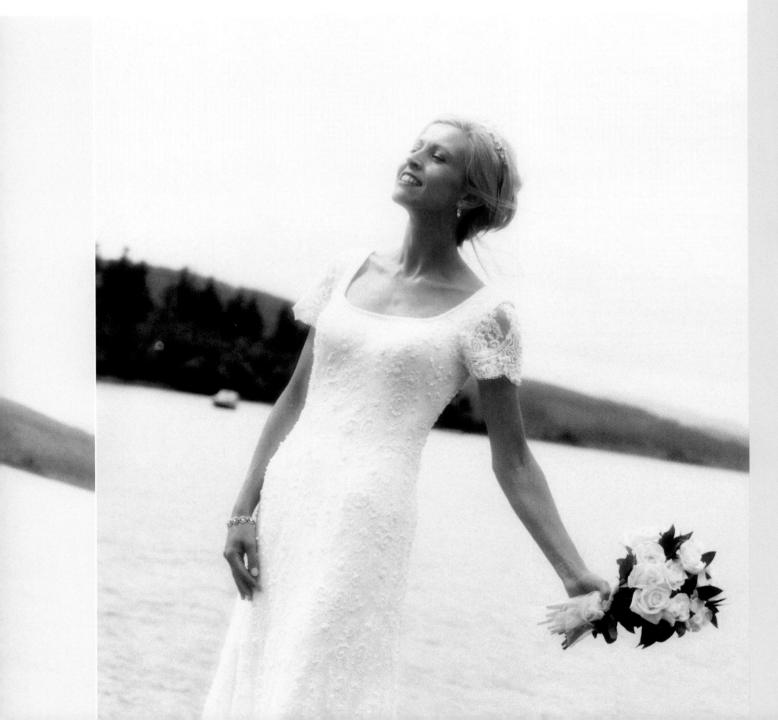

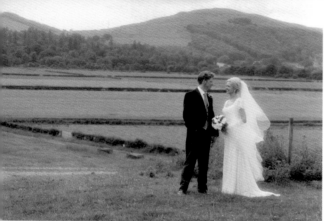

Conventional

The above image has been shot on a Hasselblad medium-format camera with soft-focus filter (Hasselblad softar 1), and Fujifilm Neopan 400 film. This created a moody romantic picture for the couple who requested pictures shot on their family farm. The picture deliberately includes the meadows in the background which have so much sentimental value.

Contemporary

By simultaneously using my 35mm Canon EOS 5 with 70–300mm zoom lens, I can take completely different pictures of the couple without actually moving them. This means I can work much more efficiently and produce a variety of different results.

I use Fujifilm Neopan 1600 film, as the grain gives the pictures a more interesting feel, and allows me to hand-hold the camera at low shutter speeds without camera shake resulting. Using the zoom lens at f5.6 throws the background completely out of focus creating interesting shapes and enhancing the couple themselves, resulting in a much more contemporary image.

Black and white pictures are in huge demand these days from couples who are looking for a contemporary feel in their pictures. Modern films are ultra fast allowing for the camera to be hand-held, which creates a much more spontaneous feel.

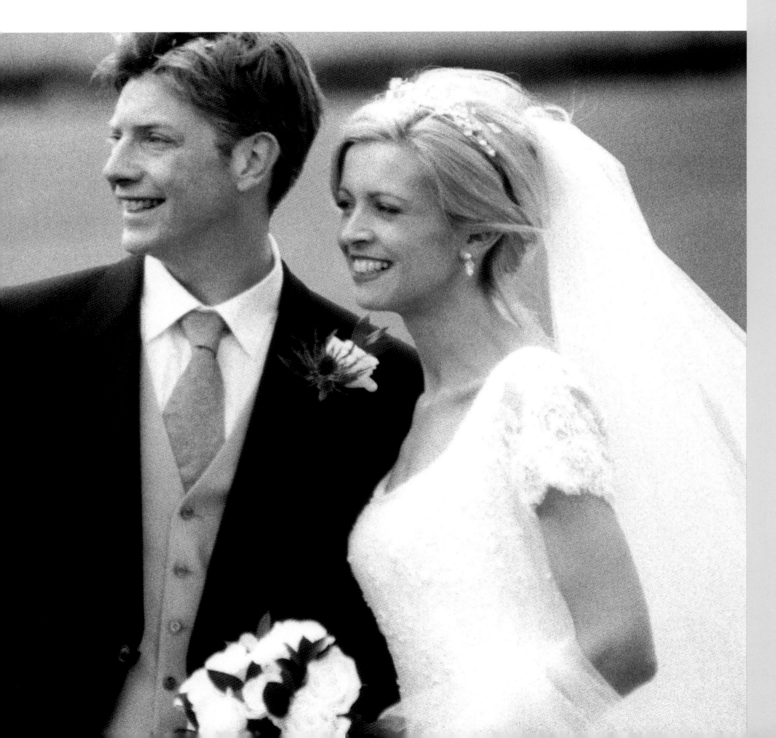

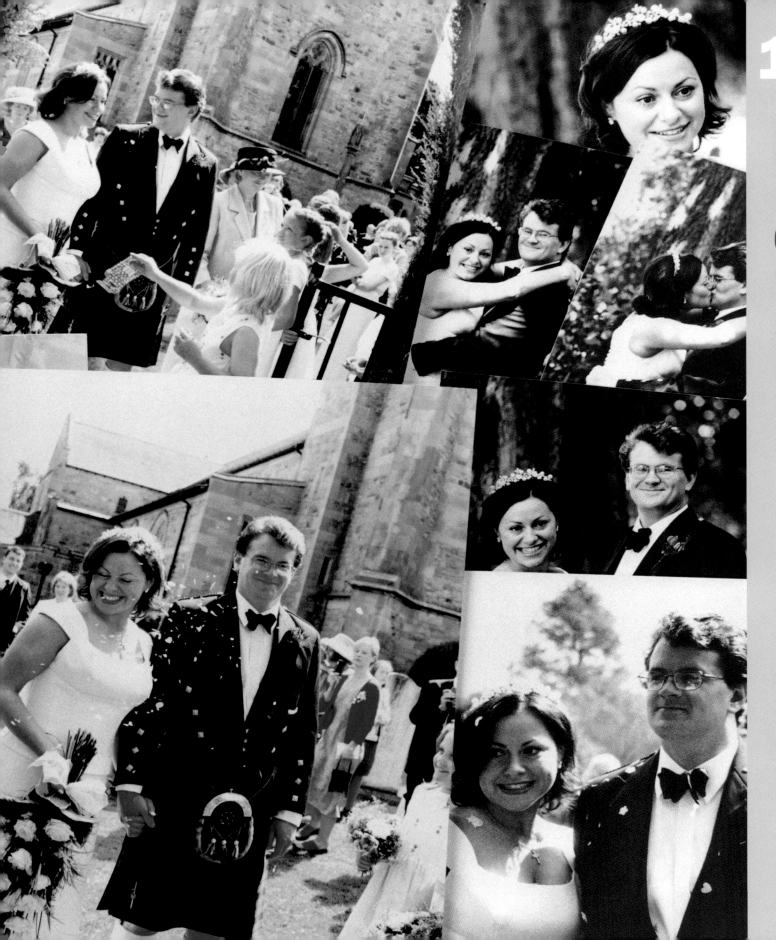

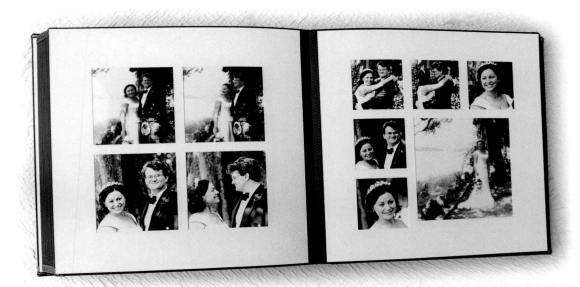

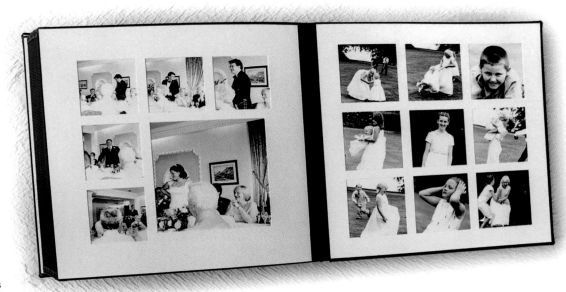

The wedding album is the record of the big day that will be treasured for years to come, and producing a balanced selection of pictures to fill its pages is one of the great skills of wedding photography.

It's likely that many of the pictures that you took on the day were produced with the ultimate aim of running them together as a series, but at the proof stage it's worth looking for others that also work well together, perhaps as smaller images that can be used to complement one larger main picture. Sort everything into chronological order so that your pictures start to tell the story of the day in a logical way, and you've then got the basis for your wedding album.

What you're looking to achieve is variety and a good cross-section of candid-style pictures of the essential characters of the day plus as many guests as possible. You'll have covered all the important stages of the wedding, such as the bride preparing at home, the arrival at the church of bride and groom, the service itself and the group shots afterwards, and you'll need to use a selection of pictures from all of these, perhaps mixing black and white and colour where appropriate, or toning black and white pictures for extra effect. Alongside these pictures, however, there will be a need for general shots, informal pictures of guests mingling and talking. These images will say so much about the day and everyone's enjoyment of it, and they are a vital part of your coverage.

Don't forget to also include pictures of the details, such as close-ups of the flowers, the cover of the service sheet or the back of the bride's dress. These are images that will work beautifully when used in the album alongside the more mainstream pictures, and they will help the atmosphere and flavour of the day to be more completely captured.

Cropping
When you're producing your wedding album don't be afraid to crop images quite dramatically if necessary, if by doing so you can create something that is tighter and stronger. Have a couple of L-shaped cards handy for the moment when your proofs arrive. Used in combination they can be held over a print to show very quickly how any other crop that you might choose to use would actually look and it can be quite staggering how much a picture can be affected by even just a small adjustment. Try to crop into formats that are consistent, however, so that they don't fight one another on the pages of the album. A page of square prints can look highly effective, while one that features a mixture of sizes and shapes is in danger of looking messy.

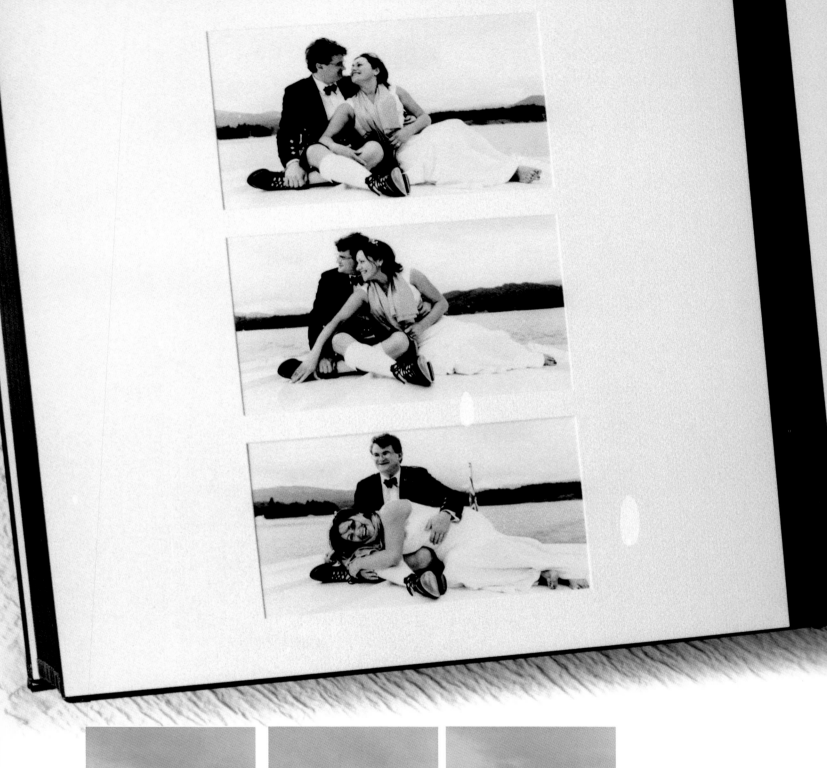

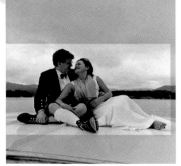
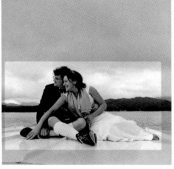

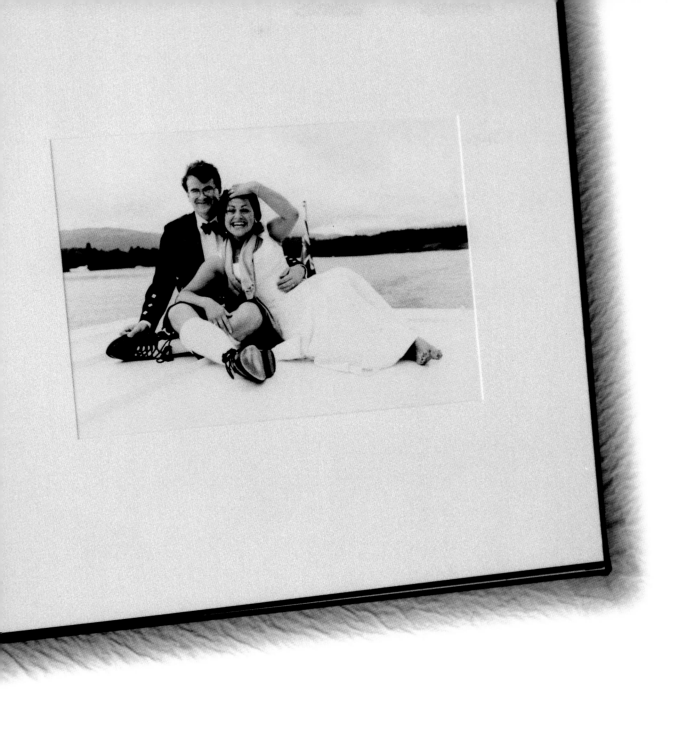

Using a sequence

A single image can work well in an album, but often a sequence can be far stronger. These are pictures that are planned to the extent that you are shooting with the idea in mind of using several together, so you'll need to get your subjects relaxed and to shoot plenty of film. Encourage plenty of movement so that there's a good variety of expressions to choose from, and if you can get the couple laughing while you're taking your pictures then so much the better!

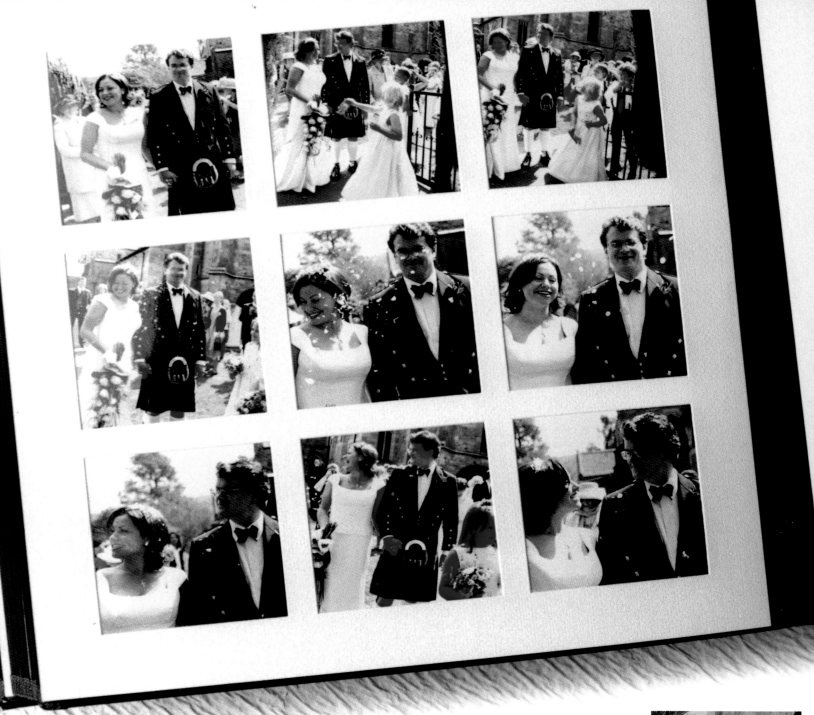

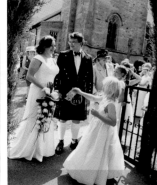

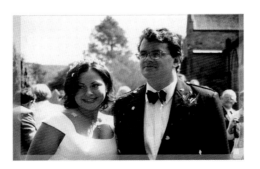

Using a strong format

Applying a square format to a series of candid pictures of children playing at a wedding created the basis for a montage that eventually appeared in the newlyweds' album.

With candid shots

Candid pictures look wonderful in an album and I often set up situations that are designed to give me images that I know will subsequently work well together. On this occasion there was an open area close to the reception that attracted the children, and I encouraged them to come over and play together. Once children get involved in games, the last thing they're going to worry about is being photographed, and I knew that the results would be happy and relaxed.

I shot with my Canon EOS 5 and 35–70mm zoom, which gave me the flexibility to move around my subjects and to work in a candid style. Later I laid out all the pictures, made a selection of those that I felt were working well together, and cropped them down from a rectangular format to one that was square because I felt that this gave them greater continuity. The rigid pattern that they formed across a page was full of impact, and together the pictures represented a side of a wedding that is often overlooked by photographers.

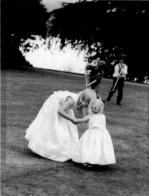

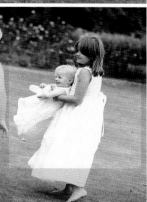

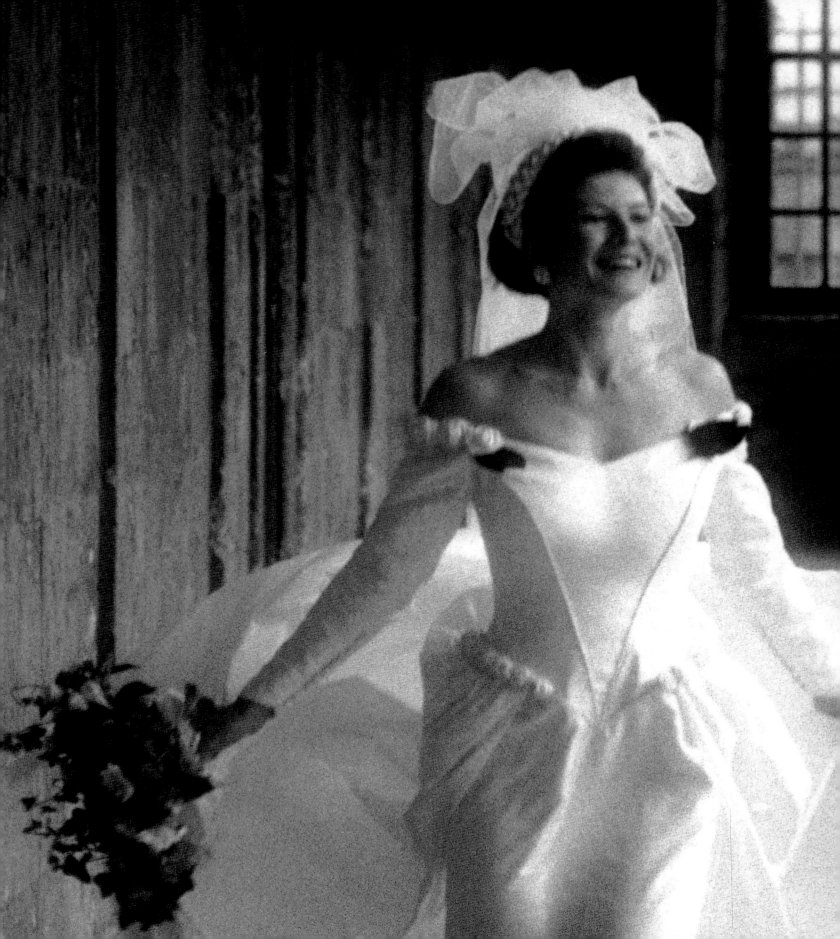

You can promote your services in all the best places but the best form of advertising is still the personal recommendation, which will only come from those who have found your services to be highly professional and capable of delivering a high quality product.

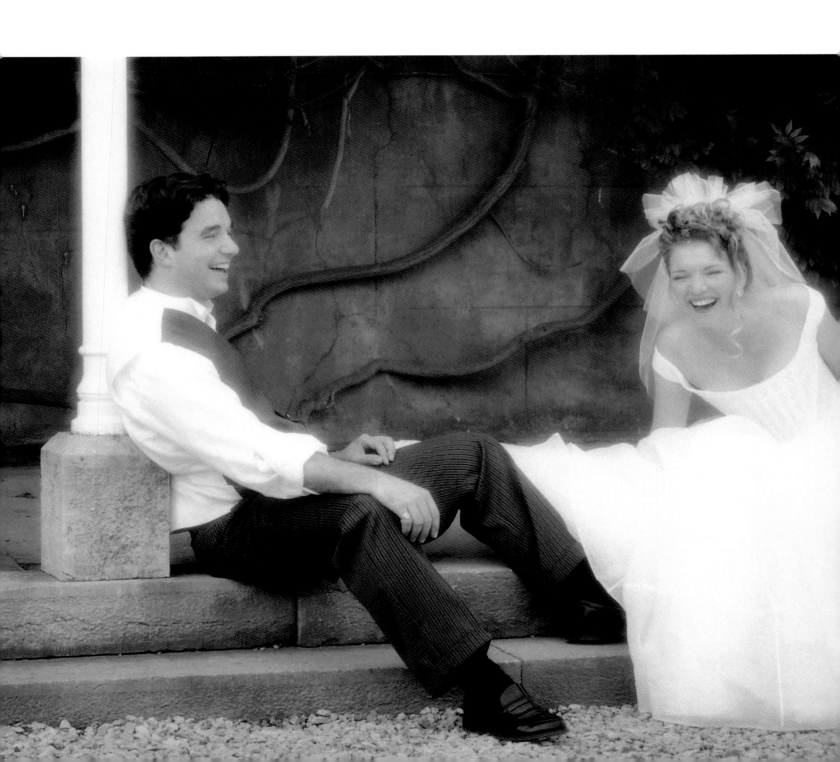

The best form of marketing and advertising is your reputation and the endorsement of your product by existing clients. The ultimate marketing approach is to give clients a high quality experience, from the time of their initial contact through to the moment when their album of images is delivered and beyond.

These are some of the points that are key elements in the building of a reputation:

Attention to detail – You should offer a high level of service to reflect the marketplace that you are targeting.

Telephone manner – The telephone is often the first point of contact, and a friendly but professional manner should be maintained.

Consultation – A personal consultation is essential to develop a relationship with the client and to allow a mutual understanding to be achieved.

Pre-wedding photo shoot – This heightens the level of trust and reinforces the client's confidence in the photographer.

The wedding day – How you conduct yourself on the wedding day itself will be crucial in terms of client satisfaction, while it will also give you the chance to build your reputation with others who are attending the wedding who may be potential clients of the future.

After care – It is crucial to ensure that the consistency of care continues after the clients have collected their photographs as you are hoping to develop a long-term relationship and to become their personal photographer.

Not only do you want to provide a top quality service, you should be aiming to make every aspect of your business appear highly professional, so that you have the confidence of your clients from the moment that they first contact you. Some of this is certainly down to the look of the studio, and whether it appears bright, modern and welcoming to personal callers, but another crucial element is the strength of the image that you're promoting. It's essential to spend time and money on getting the details right and you should be building a brand personality for your studio that is consistent throughout your stationery, from your letterhead and brochure, though to your web site.

Although it's not a cheap option, you should endeavour to keep your literature as up to date as possible, and to have it well designed, professionally written and printed to a high standard. If you collect any awards these should be highlighted, along with a simple statement about the service that you aim to provide and a selection of pictures that illustrate your style. This is your opportunity to sell yourself to potential clients and if you are aiming to provide a service to the upper end of the market then you'll have to meet high expectations at every level of your business.

A well designed web site is essential as it is an international communication tool which is invaluable to the future expansion of your business. As most photographers now have a web site, your own should reflect your personality and professionalism and contain elements which are unique and individual to you.

Every aspect of your
promotional material should
reflect your brand image,
from your letterhead through
to your brochure and web
site, because many potential
clients will judge your
professional standards on
the information that
they see.

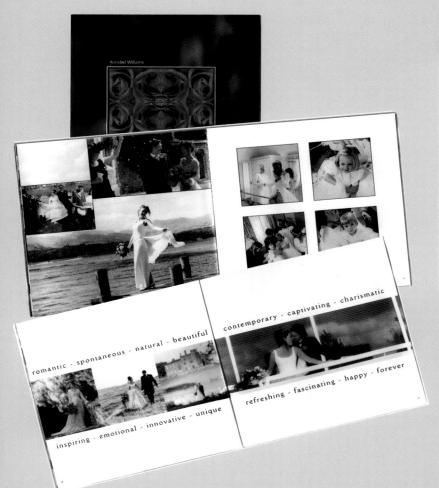

"I started to build my web site when my office was going through a quiet period and I had a little time on my hands...I started with a minimal investment in some cheap software, but ultimately found that this was a false economy because this turned out to be extremely limiting." Glen Smith

www.uq.net.au/~zzglesmi/wedding.html

Glen, who is based in Brisbane, Australia, felt the need to set up a web site because of increasing competition in the wedding photography arena, and it had become clear to him that this was a way to keep up to speed with changing market requirements. His web site is clear and concise starting with a selection of five small images that are designed to convey the full range of wedding styles that he can offer.

It moves on to a resumé of his achievements as a photographer and then to personal endorsements from satisfied clients. There follows a sequence of 11 thumbnail images and afterwards a selection of 14 photographs from a recent wedding. There are links to hot tips on how to choose a wedding photographer, further information on Glen's credentials and a Gallery of a further 14 wedding images.

What was your motivation for setting up this web site?
"I started to build my web site when my office was going through a quiet period and I had a little time on my hands. I was paying for an e-mail site through the University of Queensland, and this provided me initially with five megabytes of disc space, later raised to ten, which could be used to accommodate a site, and it seemed to me that I might as well make use of this opportunity. It was something I was very keen to do and, although I was fairly knowledgeable about computers and had done a lot with Photoshop as well as other digital work, it was much tougher than I had envisaged to get started. I estimate that I spent hundreds of hours getting my site to the stage where I was happy with it: I started with a minimal investment in some cheap software, but ultimately found that this was a false economy because this turned out to be extremely limiting."

What have been the benefits to your business?
"My first wedding commission through the internet came a few months after I set up my web site, and in the first year I had 12 wedding bookings that came directly through this route. I have had one from as far away as New Zealand, but most have been bookings that are more local to me. Because of the vast distances travelled in Australia I give clients my internet address and they can access my work immediately without having to come to see me personally. Younger couples, especially, are happy to do business by this medium because they are more comfortable with computers and it could be that many of the people who are accessing my site are using their office facilities."

How has your web site evolved?
"I now have about 80 images on the site and am still only using eight megabytes of the ten that are currently available. I have put in a huge amount of work since I started out creating the right key words for my site so that people can find me easily and quickly. If I had just the word 'wedding' listed, then I would struggle, because there are so many other listings that are covered by this. I've added other categories such as 'photographer', 'Australia', 'Queensland' and 'Brisbane' to narrow things down a little, and this has helped me to be found more readily. I've found that these keywords are vital if you are to have your site accessed by those you hope will go on to become your clients."

"The fees that I can charge for my work have justified the cost of setting up the site initially: the new site is costing me between £5000 and £8000, but this compares to one-off advertisements in magazines which can cost £2500 a time. A web site is accessible for 24 hours a day as well, and I consider it's very good value." **Gordon McGowan**

www.gordonmcgowan.co.uk

Not only has he received 30 prestigious wedding awards to date, but Scotland-based photographer Gordon McGowan is also the holder of a Golden Web Award for the quality of his web site and since winning this prestigious prize hes started to develop a new and even more state-of-the-art site. "I will have two web sites in operation," says Gordon. "One will be a static site and the other a moving one." With both sites running Gordon hopes to cover every angle of the marketplace, appealing to the more traditional couple as well as the trendy young things that are only impressed by fast moving wizardry.

Even the static site features the odd touch of trickery, such as the software that allows the user to create the impression of waves by moving the cursor over Gordon McGowans name, and there are descriptive words that gently evolve onto each page of the site. There are over 60 images on Gordon's Gallery section collected under a series of different sub-headings: 'Creative', 'Digital', 'Contemporary' and 'Fun'. There's also a profile page, awards details, advice and contact information. Even straightforward information pages such as these have a life of their own, appearing to split apart and reform over a period of time.

What was your motivation for setting up this web site?
Gordon was quick to see the potential that a web site would offer his business, and was on-line some time before many of his rivals. "I like to embrace new technology and this is the way forward. This is a visual age and the site has incorporated my ideas and helped me to publicise my business to a wide audience."

What have been the benefits to your business?
The web site has helped to give Gordon an international profile and he feels that it has aided him to win bookings from couples travelling to Scotland for their weddings from such diverse countries as Australia, America, Hong Kong and Gambia. "I am the most expensive photographer in Scotland but this is not a problem for couples travelling from overseas as they expect to pay a lot more for their wedding photography, particularly those coming from Australia. The fees that I can charge for my work have justified the cost of setting up the site initially: the new site is costing me between £5000 and £8000, but this compares to one-off advertisements in magazines which can cost £2500 a time. A web site is accessible for 24 hours a day as well, and I consider it's very good value."

How has your web site evolved?
Gordon keeps up to speed on web site development, and is considered by many to be a market leader. It is his own ideas that are interpreted by a webmaster and developed into the site. "This new site will be very much in your face," says Gordon, "and it will feature contemporary graphics as well as dance music. We suggest at the opening sequence that you turn your speakers up really loud to get the full benefit!"

"**I set out to make our site as interactive and as comprehensive as possible and now I feel that people are drawn to our site because they are physically comfortable sitting in their own homes and are free to look at our work in their own time.**" **Joseph Raymens**

www.beyondimages.com

Set up by Joseph Raymens, the owner of the Beyond Images Photographic company in the US state of Oregon, the www.beyondimages.com web site has turned out to be a huge success and is currently gaining over 1,700 hits in a typical quarter. Although not dealing exclusively in wedding photography the site has an extensive interactive wedding section and the company feels it is very important to its business to be able to offer a complete wedding package.

To achieve this criterion a diary of available dates is featured, along with images of wedding albums, a comprehensive list of names and addresses of related businesses, a wedding chat zone where users can ask for help and information and details of an on-line bridal magazine. There is also a feature of the moment where brides can sometimes view bridesmaid dresses and accessories and at other times hand-blown glass cake tops. If Beyond Images hasn't extracted enough information at this point then there is a very comprehensive order form.

With all this and 12 static photographs available to view maintaining this site is labour intensive since it requires continuous development and updating. However, even with the level of detail regarding a couple's wedding that Beyond Images requests, the company does not feel that the web site is a substitute for a personal meeting with its client.

What was your motivation for setting up this web site?

"It was set up for advertisement purposes. We were aware that many photographers had a basic web site at the time and I knew that I wanted to offer prospective clients more than they had. I set out to make our site as interactive and as comprehensive as possible and now I feel that people are drawn to our site because they are physically comfortable sitting in their own homes and are free to look at our work in their own time. They can contact us via the web site when they are ready to make a booking."

What have been the benefits to your business?

"We have now really started to be found by people. It has taken a lot of work but now we are getting bookings continuously through our web site. It is a great way to make initial contact with people."

How has your web site evolved?

"It started off very much as a learning process. I knew a little about the setting up side when I first sat down, but I very much learnt as I went along. It started off looking a little uncomfortable but it has gradually evolved and now I feel that it has quite a professional look."

"Noticeably my office is now a much quieter place. I now get more e-mails than telephone calls and it cuts down on a lot of time. Clients can browse the site, look at my photographs and then telephone if they like what they see. About 20% of my clients have booked without us even having met." **Stephen Swain**

www.stephenswain.com

Stephen Swain is one of a new breed of Britain-based wedding photographers who have moved away from what Stephen describes as a "tacky, stiff and staunch" style and on to a more contemporary approach of reportage or documentary style wedding portraiture. He is a high achieving photographer averaging 60 weddings a year and this is reflected in the Gallery section of his web site where there are over 60 diverse photographs available to view. The site opens with a hugely engaging photograph of a bride enjoying a moment of hilarity with her three bridesmaids and a summary of Stephen's credentials. There follows a personal endorsement from the Editor of the influential British magazine Wedding and Homes and 16 thumbnail pictures.

Lastly is the menu where viewers can find out more about Stephen, look at his Gallery, discover how to contact him and then click on links to connected service recommendations.

What was your motivation for setting up this web site?

"I view it very much as the ideal medium for a photographer and was also aware that many other photographers were promoting themselves via the internet. I did not view it as an option, it was just something which had to be done."

What have been the benefits to your business?

"Noticeably my office is now a much quieter place. I now get more e-mails than telephone calls and it cuts down on a lot of time. Clients can browse the site, look at my photographs and then telephone if they like what they see. About 20% of my clients have booked without us even having met. I firmly believe that had I not gone on-line when I did I would now have less work than I do. It has also been incredibly useful for clients who have partners working abroad, because they can look at the site simultaneously and agree that they like the photographs while sitting in different parts of the world."

How has your web site evolved?

"I set it up myself with the help of my wife Marija who had the technical expertise. I wanted to keep it simple so that the links are very obvious. We only update the site about once every six months as the one-off nature of the business means that it does not go out of date quickly. I advertise the services of other people that I have worked with and whom I feel offer a good service and in many cases this works as a good reciprocal arrangement. One tip I do have is to put the web site in your own name as this makes it easier for people to remember you."

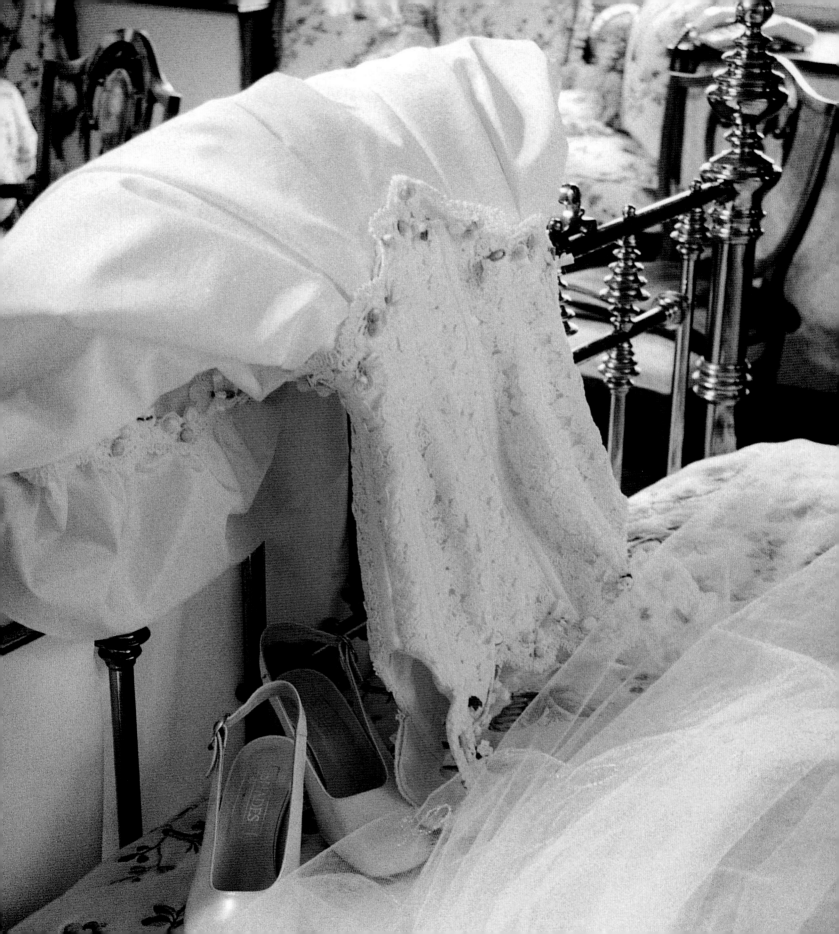

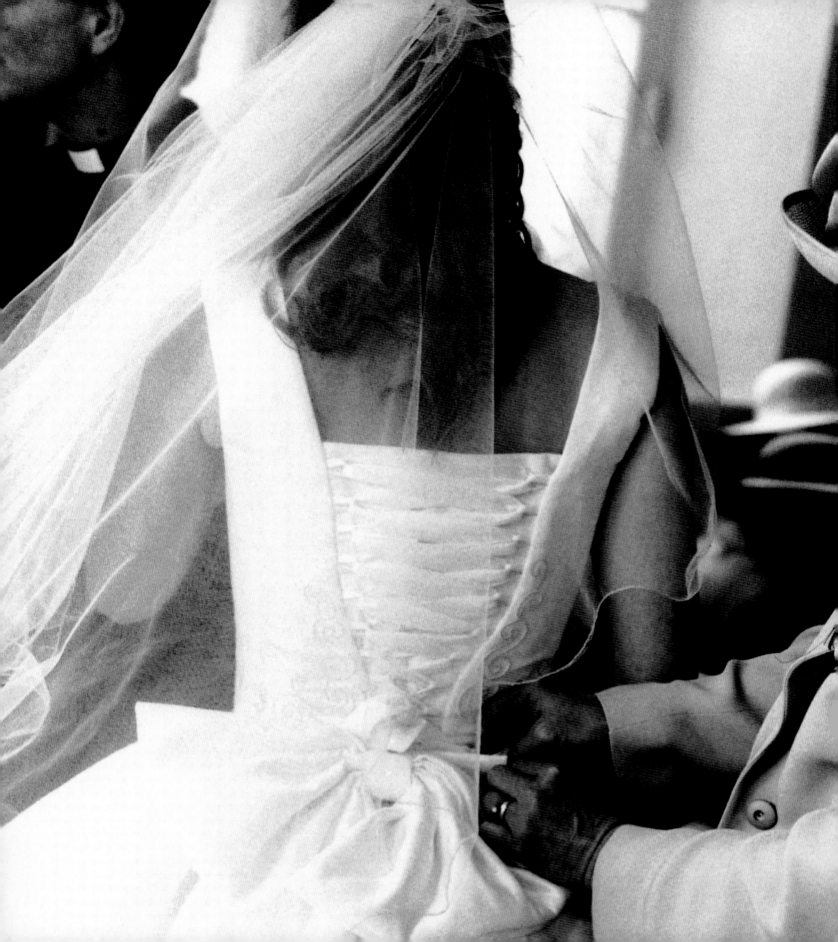

Wedding Breakfast
Menu

Melon Cocktail

♥

Tomato & Orange Soup
with a hint of
Fresh Rosemary

♥

Herb Crust Sirloin of Galloway Beef
On Yorkshire Pudding with
Roasting Gravy

or

Supreme of Chicken
served with a Red Wine

All served with a selection
Chef's vegetables

♥

Strawberries and Cream
served with Ice Cream

Freshly Brewed Coffee
and Mints

A RED, RED ROSE

O, my love's like a red, red rose,
That's newly sprung in June.
O, my love's like the melodie
That's sweetly play'd in tune.

Liz

Steve

Thank you for sharing our 'special day'
Liz & Steve

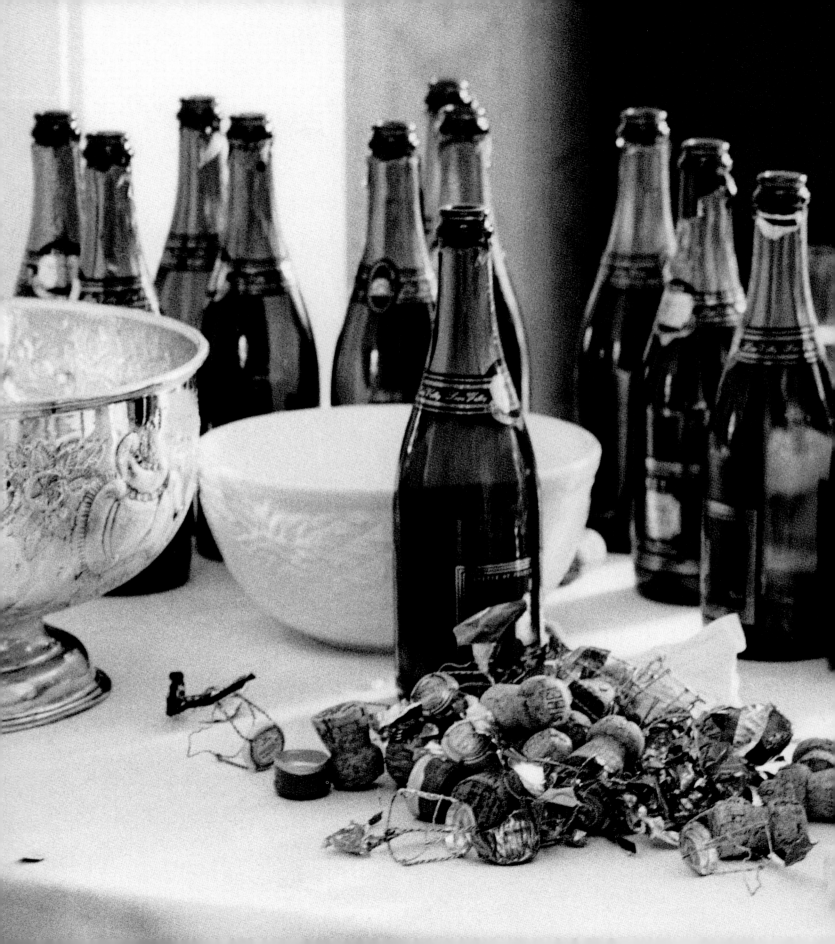

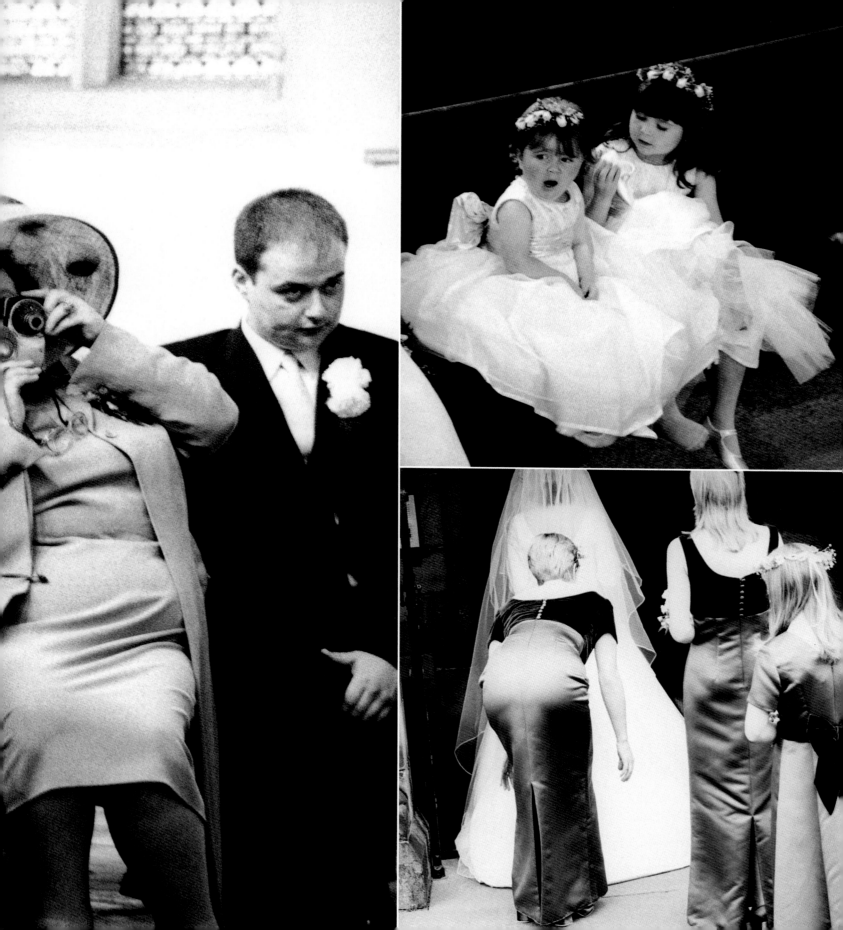

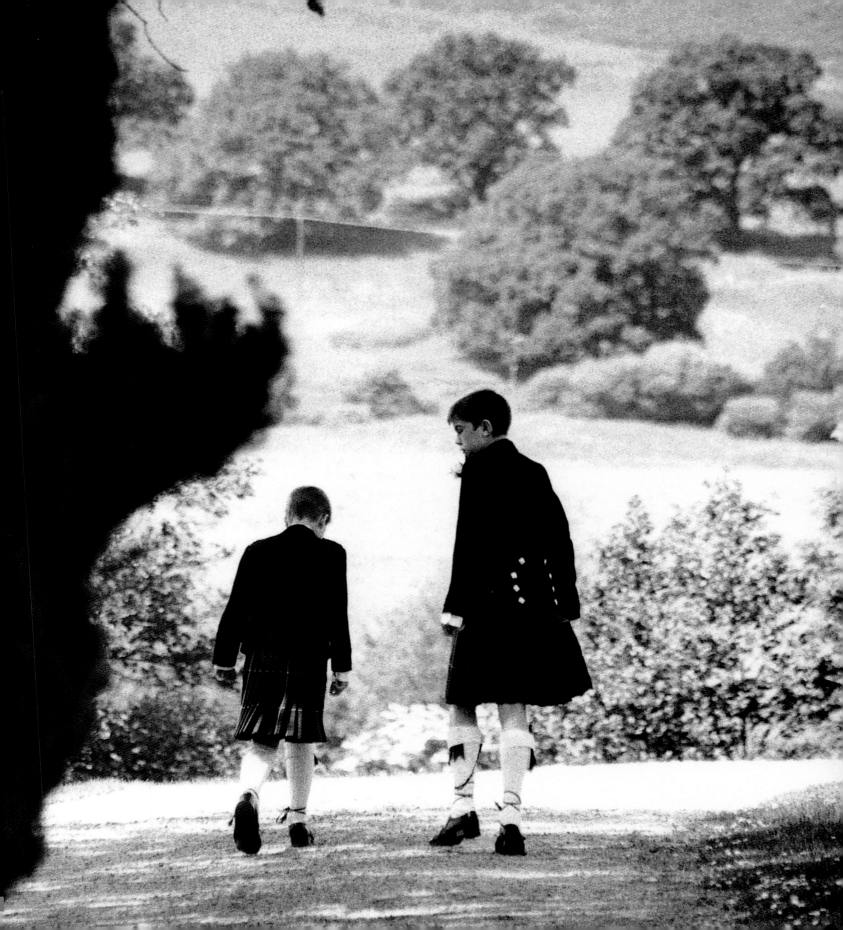

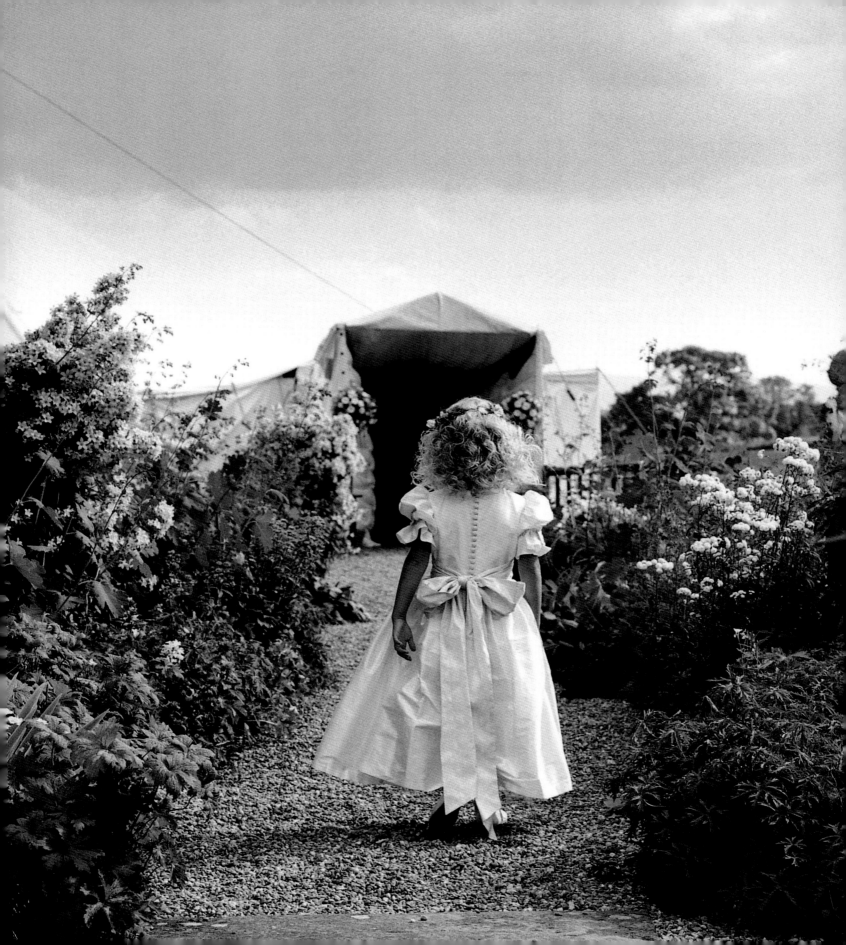

acknowledgements

With thanks to all my wonderful clients who were happy to let me use their images; Manchester Colour Labs, UK, for all their excellent printing; and Queensberry Albums, New Zealand, for designing the perfect wedding albums!

Many special thanks to Jane, Kate, David, Polly, Lucinda, Sandi, Catherine, Fiona, Lisa and Joanna for all their support and assistance.